SIMPLE SCENE
SENSATIONAL
SHOT

ARTISTIC PHOTOGRAPHY
IN ANY ENVIRONMENT

SIMON BOND

ILEX

First published in the UK in 2012 by
I L E X
210 High Street
Lewes
East Sussex BN7 2NS

Copyright © 2012 The Ilex Press Limited

Publisher: Alastair Campbell
Associate Publisher: Adam Juniper
Creative Director: James Hollywell
Managing Editor: Natalia Price-Cabrera
Editor: Tara Gallagher
Specialist Editor: Frank Gallaugher
Senior Designer: Kate Haynes
Designer: Lee Suttey
Colour Origination: Ivy Press Reprographics

British Library Cataloguing-in-Publication Data
A catalogue record for this book is available
from the British Library

ISBN: 978-1-908150-63-9

Printed and bound in China

10 9 8 7 6 5 4 3 2 1

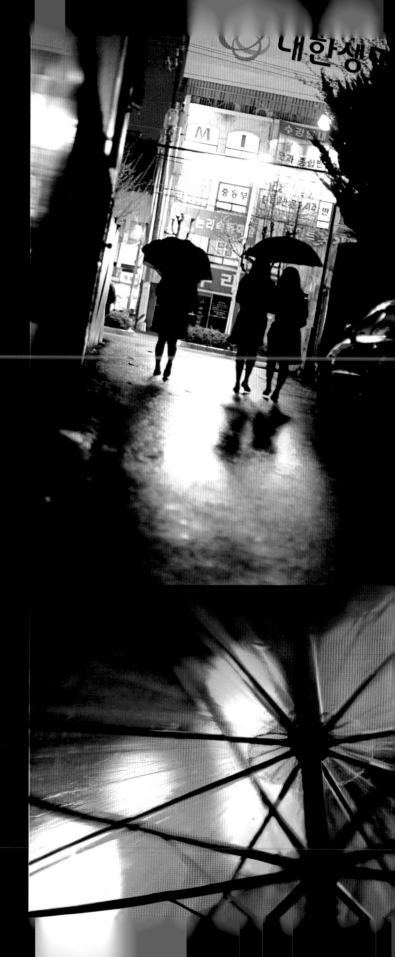

Introduction

This is just about one of the most clichéd things I could say, but right now, wherever you are in the world, you are surrounded by many potentially amazing photographic opportunities—all you have to do is see and not just look.

I witness many people looking without seeing, but with this book I hope to change the way that you view the world, giving you a perspective that allows you to see things. For example, until I became "serious" about photography I never really noticed just how beautifully made a lot of movies and TV programs are. A good videographer will be adept at using bokeh, time lapse, tilt-shift, or close-ups, to name just a few techniques. The more you see, the more you will realize that your favorite TV dramas and movies utilize the exact same techniques that you can use as a photographer to create stunning scenes.

But let's get off the couch and stop watching TV—it's time to get some proper exercise for your eyes. Just as your body will deteriorate if you don't head to the gym on a regular basis, so too will your ability to see a photo if you don't dedicate yourself to getting out there and taking pictures. While you might not start out taking the greatest photos in the first few months, do not give up trying—the eye needs to be trained, and there really is only one way to do this.

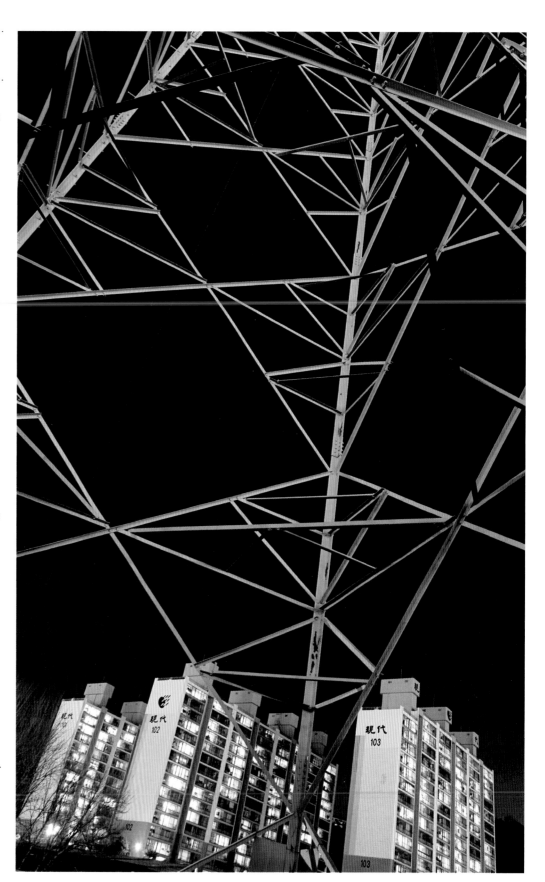

ELECTRIC ANGLES
The lines and geometry created by an electricity pylon can be used as a striking design element.

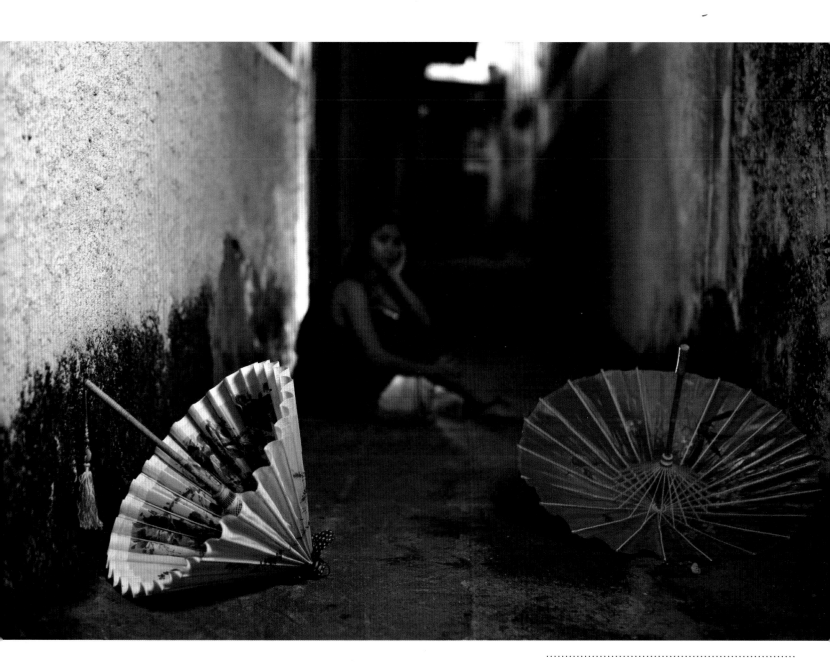

LOST SOUL

This photo shows a woman seated on the ground, with two umbrellas abandoned in the foreground. The woman sits rather like Cinderella after midnight has passed.

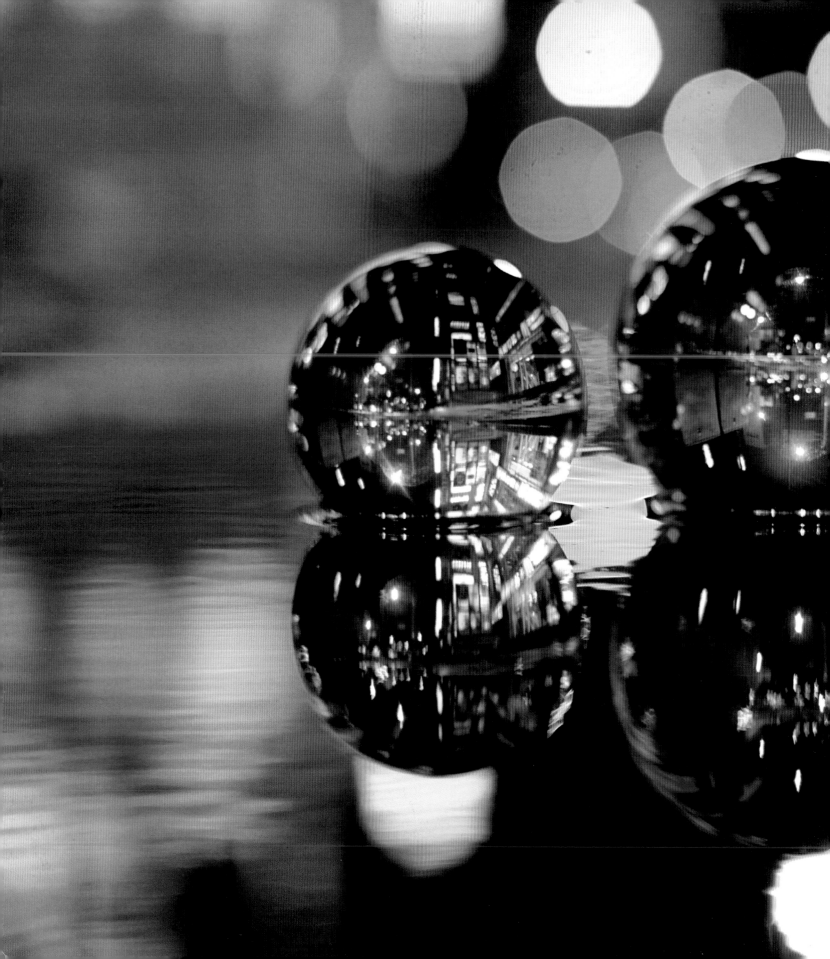

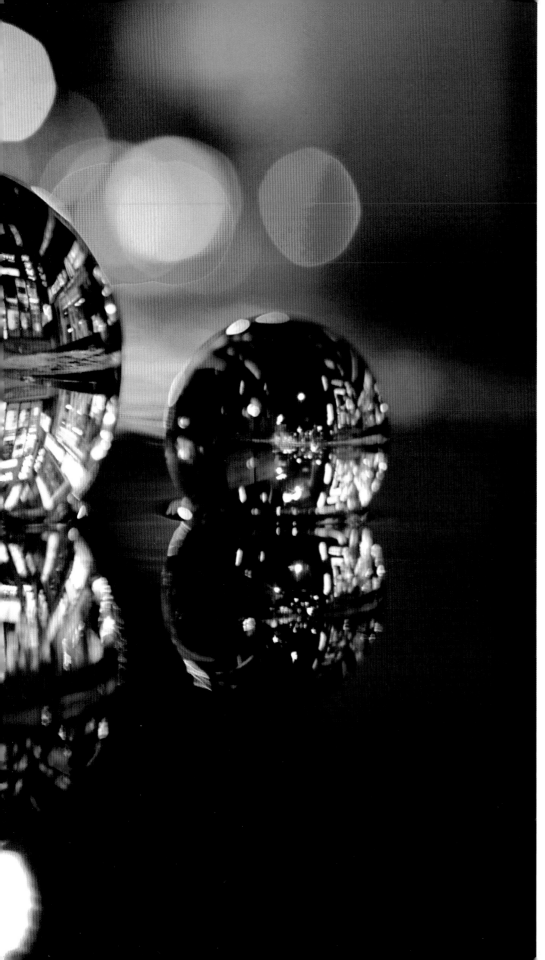

Once you're out of the house, look around for photo opportunities. You don't need to look far. Your front door could make a good frame for a portrait. Or how about that brick wall you pass by every day and don't really notice anymore? That wall might have great texture and repeating patterns that could be used as a background or an abstract shot in its own right.

A little farther down the street you might get to that electricity pylon that you thought was an eyesore, but look closer: Is there an angle that will enable you to take a striking shot using the pylon's natural geometry?

Then there's that puddle again. It's just a puddle, right? Wrong! Water can create great reflections, and when used correctly will make a super shot.

This is just the start, and despite traveling only a few yards from your house you should already have your eyes wide open, starting to see the beauty in the world around you.

AS DULL AS DITCH WATER?
With a little creativity this puddle was turned into something altogether more colorful.

BASICS: EQUIPMENT

Cameras

The camera I generally use these days is Canon's EOS 5D MkII. Some people will say that this is Canon's best camera (at least at the time of writing), but I fervently believe the quality of the images is more about the photographer than the camera they use. The inevitable question is: "if you're so sure, why don't you sell your big, heavy camera, and use a compact digital camera instead?" This is a valid question for sure, and it's one that I hope to answer over the coming pages.

Anybody can use a camera to take a photo, but how do we create images that really stimulate the eye? A lot of the time a good photo will have two important elements: it will tell a story and it will focus on the subject, without allowing the viewer to be distracted by other details within the photo. My feeling is that you can divide photographers into those two categories as well—storytellers and minimalists. A great photographer will combine these elements into one cohesive photograph, but do you need an expensive camera with a premium-price lens to do this? The simple answer is "no." Neither storytelling, nor focusing on the subject,

is dependent on the camera, which is why it is the photographer and not the camera that is the most important factor in photography.

In addition, photography often utilizes design elements such as minimalism, repetition, contrast, shadows, silhouettes, and reflections to create striking photographs, sometimes using more than one of these in the same image. Whatever camera you're using, be it an expensive digital SLR or the camera built into your cellphone, these elements are there to be captured. So again it is more about the photographer than the camera.

The other thing that the photographer has that a camera doesn't is a brain, and the human imagination is an amazing thing. I could be visiting a new city, or perhaps attending a festival, but I'll have planned in my mind the type of shots I'm anticipating taking prior to getting there. In other words, a little forward planning helps focus the mind on the task in hand and, as a friend of mine once said, good photographs come when planning and spontaneity collide.

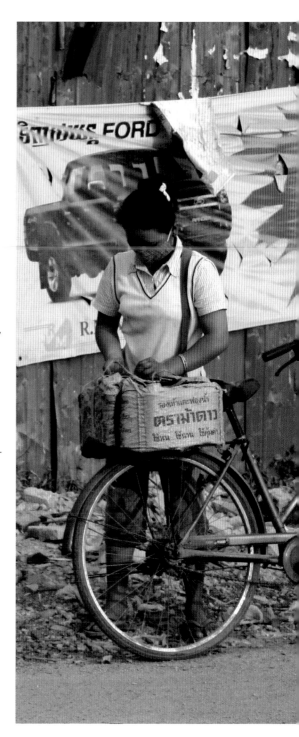

STORY AND SUBJECT MATTER

In this photograph the woman preparing her bike provides the story. We can imagine she has a hard life because of the context provided by the background.

As a composition it has three strong lines running through the background, and there are no other elements in the scene to distract from the cyclist, giving it an almost minimalist quality.

DIGITAL SLR VERSUS IPHONE

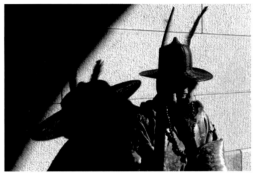

The interest in this photograph of a guard in traditional costume is provided by his shadow, and the way the shadow at the left frames him. In this instance there is very little to choose between an image produced by an iPhone and one taken using a digital SLR camera. The image is striking as a result of decisions made by the photographer, not because of the equipment used.

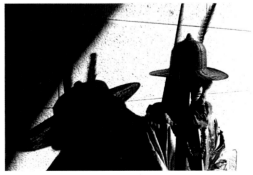

13

So let's return to the earlier question: why have a digital SLR camera at all? The simple reason is that a digital SLR camera gives you more options when taking photos. Depending on how you utilize those options it can enhance your photographs and make it easier to achieve a "clean" image. A digital SLR allows you to adjust the exposure to the finest degree, thanks to full control over the aperture, shutter speed, and ISO, which in turn means that you can work under a variety of lighting conditions that would challenge less sophisticated cameras. The ability to change lenses on a digital SLR (or nonreflex interchangeable lens camera) also gives you a big advantage over a camera with a fixed lens, as you can attach a wide-angle lens to achieve dramatic compositions, or fit a super-telephoto to shoot a subject at a distance.

However, the advantages that a digital SLR camera gives you will count for nothing if you don't know how to properly use it, and this is again why it is about the photographer and not the camera. Those photographers who don't exploit bokeh and don't require long exposures are likely to get great photos with a compact digital camera, and be very happy with the results. In fact, I sometimes use my iPhone to take photos, simply because it is a challenge to be limited by the parameters of a less elaborate camera and to see what kind of photographs can be produced.

Above all, you should be taking photos even when you don't have a camera with you (although a good photographer should always have their camera with them). You don't need a camera to look around, and it can be a useful exercise to compose pictures in your mind, thinking about what it is you want to achieve from a scene, and then perhaps returning with your camera to take the photograph you have envisaged.

DESIGN ELEMENTS

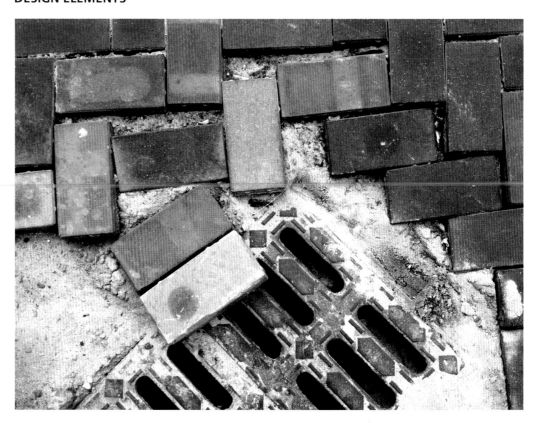

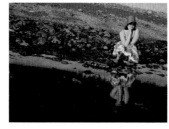

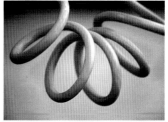

Any type of camera can capture the design elements that could make a photo interesting. Here is a selection of images, some taken with a digital SLR and others with an iPhone—does it matter which is which?

THE DIGITAL SLR ADVANTAGE

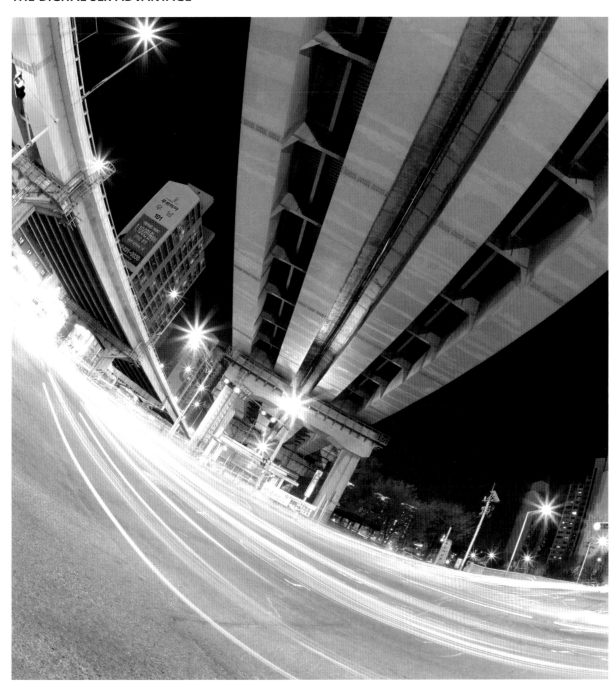

A digital SLR camera really comes into its own at nighttime (and in other low-light conditions), but you also have the benefit of being able to change lenses.

This night shot required a long exposure, which would most likely produce an image with a lot of noise using a compact digital camera. I also used a fisheye lens, and the very wide viewing angle and distortion that this type of lens produces is simply not available with compact digital cameras.

Camera settings

As noted, the real difference between a digital SLR (or SLR-style camera) and a point-and-shoot camera or phone is the level of control you have, and the settings you can change when taking photos. If you're a beginner, learning what all of the buttons and menus on your camera do can be a little daunting, but as an experienced photographer all of this information should be programmed into your mind.

Shooting modes

Most cameras have a range of preset shooting modes, but more advanced cameras will have manual settings as well. Being able to take control of your camera manually gives you a lot more flexibility, but you need to know what you're doing with these settings.

Tip

If you're new to photography it is useful to check the aperture and shutter speed settings when you use your camera's automatic modes—they will give you an idea of the settings you might want to use as a starting point when you experiment with the manual modes.

Automatic modes

When you set an automatic mode, the camera does all the thinking for you, so you just have to point and shoot. This is fine for snapshots, but if you really want to progress as a photographer you're going to want to stop using these settings quickly. If you've bought a digital SLR camera and only ever use the automatic modes, then it's fair to say that you've probably wasted your money and you would be better served by a good point-and-shoot compact digital camera that you can fit in your pocket.

Automatic: The camera chooses all of the settings, including exposure, white balance, and so on—all you do is frame the shot and push the shutter-release button. It is worth noting that while the camera's automatic setting can produce great results, it doesn't always get it right.

Portrait: The camera sets a fairly wide aperture so the background is blurred, but your subject stays sharp.

Landscape: The camera chooses a mid-range aperture so the depth of field will keep a lot of your scene in focus, from the foreground to the background.

Macro: Allows you to take extreme close-ups of objects. In the case of a digital SLR camera you will need a special lens to fully utilize this.

Sports: The camera chooses a fast shutter speed to help you freeze the action.

Sunset: Optimized so that the rich colors of sunset (or sunrise) are retained.

Night: The camera uses a high ISO setting to achieve a fast shutter speed to help avoid camera shake.

Flash off: Does exactly what it say—the camera's flash will not fire, regardless of the light levels.

Manual modes

When you switch your camera from automatic to manual, the fun and experimentation with photography begins. The different manual modes offer varying levels of control over the camera, and if you're a serious photographer this is where you should be.

Program: The camera chooses the aperture and shutter speed pairing. Many cameras allow you to adjust this paired setting, while keeping the same exposure overall.

Aperture Priority: This is a popular mode as you can change the aperture quickly, while the camera sets an appropriate shutter speed. This allows you to change your depth of field almost instantaneously and therefore you'll not miss the shot.

Shutter Priority: You decide the shutter speed while the camera sets the aperture. This mode can be useful for techniques such as panning or long exposures, or if you want to use a very fast shutter speed to freeze movement.

Manual: You have absolute control of all the settings on the camera. You can use Manual mode to control your depth of field; intentionally over- or underexpose your shot; and create myriad striking effects in-camera. If there is one drawback, it is that it takes slightly longer to set the camera.

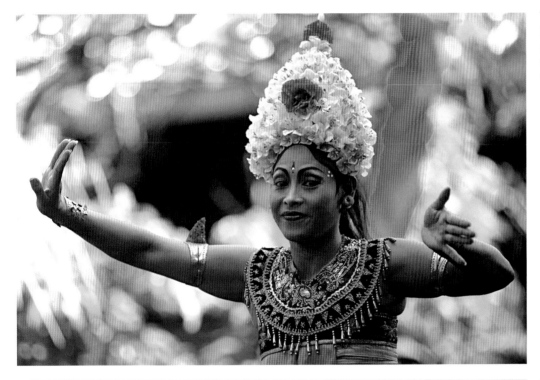

PORTRAITS

If you set your camera to its Portrait mode it will set a wide aperture. This means the background will appear out of focus, so the viewer's eye is drawn to the subject.

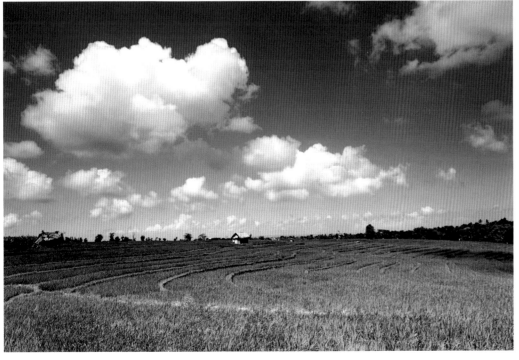

LANDSCAPES

Most landscape photographs will try to keep everything sharp by using a mid-range aperture setting for a larger depth of field. This is precisely what your camera's Landscape mode is programmed to do.

Exposure controls

There are three controls that are used primarily to determine the exposure of a photograph: the aperture, the shutter speed, and the ISO sensitivity. The three combine to produce what is known as an "exposure value" and photographers are always trying to balance these values to achieve the best result. If you are new to photography, then mastering this relationship is really one of the first things you need to be focusing on: these three values, together with the amount of available light, control the exposure of your photograph.

Self-timer

Many cameras have a self-timer feature, which can be useful if you want to take a self-portrait. It is also useful for triggering your camera without touching it—if you want to take a long exposure from a tripod pressing the shutter-release button could cause camera shake.

Aperture:

The aperture controls the amount of light coming into the camera by increasing or decreasing the diameter of a diaphragm inside the lens. It also controls the depth of field. The aperture is one of the most important settings on a camera, so it's necessary to have a good feel for what it does. The following will help you to understand the relationship between the f-numbers used to describe the aperture setting and their effect.

- **Wide aperture (f/1.2–f/4):** Used for shallow depth of field and creating "bokeh." A wide aperture setting is often used for portrait and still-life photography when you want a precise part of the scene to appear in focus.

- **Mid-range aperture (f/5.6–f/10):** The majority of lenses are at their sharpest at mid-range aperture settings and the depth of field is sufficient for most general subjects. These are the easiest settings for novice photographers to start exploring.

- **Small aperture (f/11–f/32):** At these settings you will have a large depth of field, so a lot of the scene will appear sharp, from foreground to background. These settings are generally used for landscape photographs, but it's worth noting that some lenses lose sharpness at their smallest apertures.

Shutter speed:

The shutter speed controls how long the light is allowed to reach the sensor in your camera for. You can vary this setting to either freeze motion or create motion blur.

- **Fast shutter speed (1/60–1/8000 sec):** Allows you to "freeze" movement. The faster your subject is moving, the faster the shutter speed that is needed.

- **Slow shutter speed (1/50–1/2 sec):** These shutter speeds can be used to create motion blur, perhaps through panning. A steady hand or a monopod is advised if you want to avoid camera shake.

- **Ultra-slow shutter speed (1 second+):** Very slow shutter speeds can be used to take photos of moving traffic, water, and other subjects where you want to enhance motion blur. Can also be used for star trails, but a tripod is essential for long exposures, regardless of the subject.

ISO:

The ISO essentially refers to how sensitive your sensor is to the light—the higher the ISO, the more sensitive it is. A digital camera allows you to set a different ISO each time you take a photograph, but note that high ISO settings can begin to introduce undesirable background "noise" into your images.

White balance

White balance is important primarily for making sure that the colors in your images are "correct"— the light that your flash produces is cooler than the light from the sun, for example. Most cameras feature a selection of preset options and manual controls. The presets are likely to include options for sun, shade, cloud, incandescent, fluorescent, and flash lighting, as well as an automatic white balance (AWB) setting that lets the camera decide the color balance. Advanced cameras will also allow you to choose a specific white balance based on the color temperature, measured in degrees Kelvin (K), and may allow you to set a custom white balance.

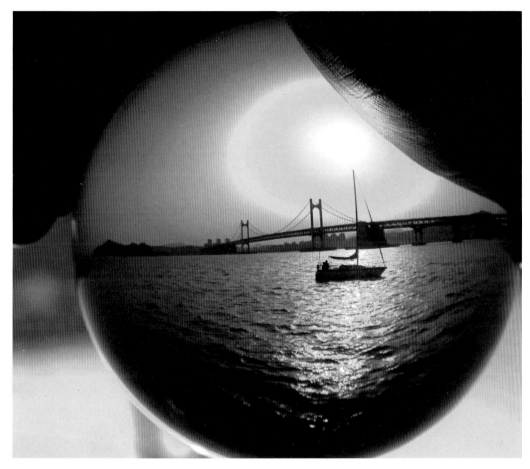

CUSTOM WHITE BALANCE

Getting the correct white balance is important if you want to avoid undesirable color casts, but white balance can also be used "artistically." In this photo, a custom white balance was set with an infrared filter over the lens. When the filter was removed, the white balance produced images with a deep blue color.

Focus

Most digital cameras will allow you to focus automatically or manually, and the majority offer multiple focus points to choose from. If the camera is set to fully automatic focusing it will choose which focus point is used, and therefore decide what to focus on. This might work some of the time, but it is far better to choose the focus point yourself to avoid back focus. Back focus occurs when the camera focuses on the background, and not the subject. Although you are selecting a focus point, the camera will still focus automatically, but you will know with certainty which focus point it will be using. Of course, manual focus is also an option if you really want to take control, although how easy this is will depend on the camera you are using.

FOCUS POINT

When taking a photo, make sure the focus is on your subject, and not on the background. When you (or your camera) focus on the background by accident, this is called "back focus."

Lenses

The lens you shoot with is going to make a big difference to the type of photo you take. It won't make or break your shot, but it is going to have an impact. Lenses can be divided broadly into two categories: prime lenses and zoom lenses. It is possible to buy zoom or prime lenses that cover focal lengths from super-wide to super-telephoto. Each type of lens has its advantages and disadvantages, so it often comes down to your photographic style when deciding which lens to get.

Prime lens

Primes lenses have a fixed focal length (see below) and are often used for taking portraits, street photos, and photographs in low-light situations because they typically have a large maximum aperture. A large aperture allows you to use a shallow depth of field, which means the area of your image that appears in focus is very narrow. In practical terms this means your subject can be in focus, but the background will be out of focus. This can isolate your subject and give your photo real impact.

The other great thing about a lens with a large aperture setting is that it lets in a lot of light, which can be invaluable when you're taking photos in low-light conditions.

Zoom lens

The other type of lens you will come across is a zoom lens. These lenses cover a range of focal lengths, so you can change your focal length very quickly—from wide-angle to telephoto, for example—which can be advantageous at times. A zoom lens is usually handy to have when you're photographing something that has a fast, dynamic edge and you simply wouldn't have time to change lenses without missing a shot. For this reason, a lot of wedding photographers use a zoom lens, as do sports and news photographers.

Focal length

Whether it's a prime lens or a zoom, lenses have a focal length that determines the angle of view. Focal lengths can be largely broken down as follows:

Ultra wide-angle
10–18mm (APS-C/cropped sensor)
16–24mm (Full-frame sensor)

Wide-angle
18–24mm (APS-C/cropped sensor)
24–35mm (Full-frame sensor)

Standard
24–40mm (APS-C/cropped sensor)
35–60mm (Full-frame sensor)

Short telephoto
40–90mm (APS-C/cropped sensor)
60–135mm (Full-frame sensor)

Telephoto
90–200mm (APS-C/cropped sensor)
35–300mm (Full-frame sensor)

Super-telephoto
200mm+ (APS-C/cropped sensor)
300mm+ (Full-frame sensor)

Ultra wide-angle and wide-angle: These lenses are often used for landscape photographs due to their wide angle of view. At extreme wide-angle focal lengths distortion can be an issue.

Standard: A focal length that has an angle of view that approximates what we see with our eyes. This is a common focal length that suits a wide range of subjects.

Short telephoto: Has a slightly narrower angle of view than a standard focal length, and is a popular choice for portraits.

Telephoto and super-telephoto: Telephoto lenses can appear to "compress" a scene and are also a good way to isolate a subject from a long distance. Mainly used for sports, wildlife, and performance type photography.

Alternative lenses

Certain lenses are available for specific niches, such as macro lenses, perspective control (tilt-shift) lenses, and fisheye lenses. In each case they perform best when used for specific subjects: a macro lens for close-up subjects such as flowers and insects; a tilt-shift lens for correcting perspective distortion in architectural photos (or creating an ultra-shallow depth of field); and a fisheye lens for creating dramatic distortion that can give very cool results. Another option is the Lensbaby, which is a form of tilt-shift lens (albeit less expensive) that allows you to selectively focus on one area of the photo.

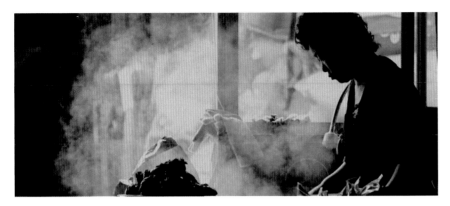

CAPTURING THE MOMENT

There are times when having the options to change focal length very quickly can be important. I would have missed this shot if I had to physically move closer to the woman or change lens, but because I had a zoom lens fitted I got the shot.

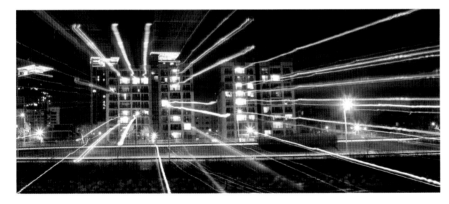

LOW LIGHT

In low-light conditions you need a "fast" lens, which means a lens with a large maximum aperture setting. This photo was taken at night with a 50mm $f/1.2$ lens—it would have been very difficult to get the same result with a "slower" lens that offered a maximum aperture of $f/4$, for example.

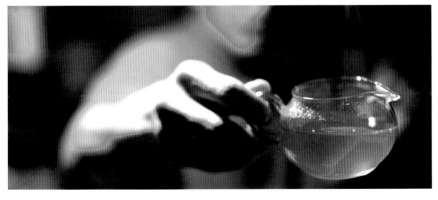

ZOOM BURST

A great technique that is only available with a zoom lens is the zoom burst. This technique is covered in greater detail on page 64.

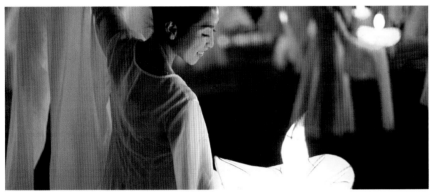

BOKEH

The out-of-focus part of a photo is often called "bokeh." In this shot the very shallow depth of field that isolates the subject to make it pop out is achieved by shooting at an aperture setting of $f/2$ with a prime lens. For more on bokeh see page 78.

Accessories

In addition to the camera and lenses, there is a plethora of other equipment that will help you with your photographic endeavors.

CAMERA BAG

You're not going to go very far without a bag to put your equipment in. Camera bags come in many shapes and sizes—some photographers prefer a backpack, while others prefer a shoulder bag or even pouches worn on a belt. It's really all about picking the right size and style of bag for you.

TRIPOD/MONOPOD

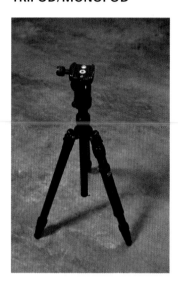

Every photographer should have a sturdy tripod, as it will open up a lot of different possibilities for photography. If you're interested in doing any form of long exposure work it is essential. Tripods can also be useful if you want to put yourself in that picture, you simply need to set the camera self-timer and pick the spot where you want to be in your image. A monopod is handy to have as well, as it isn't as bulky or heavy as a tripod, but it still allows the camera to be held more steadily in position.

EXTERNAL SHUTTER RELEASE

For long exposure photography an external shutter release will reduce the risk of camera shake. An alternative option is to use your camera's self-timer function—it will also allow you to trigger the shutter without touching the camera.

STROBES

A strobe is a great addition to your arsenal. Photography is all about the light, and sometimes you will need to introduce some of your own, which is when you'll need a strobe. You can use this on your camera, but you'll typically be bouncing the light off a surface such as the ceiling to light your subject. You can use a strobe off-camera as well, and this is where the real fun begins. Once you enter the world of off-camera flash you're going to want a host of other gear as well—light stands, umbrellas, snoots, gobos, radio transmitters, and soft boxes to name just a few!

FILTERS

Filters are a great way of enhancing your photos, and there are many types available. Filters worth considering are a circular polarizing filter and plain and graduated neutral density (ND) filters. As well as reducing haze in distant views, an ultraviolet (UV) filter can also offer good protection for your lenses—for this reason alone you should consider fitting a UV filter to every lens you own.

CLEANING KIT

Keeping your camera equipment clean will help you produce better photos, or perhaps prevent a great shot being ruined by dust particles. Your essential cleaning kit should include a blower brush to remove loose dust from the camera and lenses, as well as a quality lens cloth. Sensor cleaning kits are also useful if you find you have dust attached to your camera's sensor.

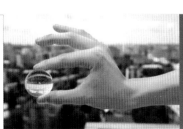

Other items

There are a few other noteworthy pieces of equipment to consider having in your camera bag: An angle-finder is great if you want to take a photo from a neck-breakingly low angle and there are props you might want to have with you for a specific photo. I often carry around a glass ball to take refraction photos with, for example.

The right equipment

"Which equipment should I take with me on this trip or shoot?" is perhaps the one question that fellow photographers have asked me more than any other and, to be honest, there is no right or wrong answer. The reason I say this is because every photographer will develop their own style, and that will play a significant part when it comes to selecting their equipment.

There are, of course, certain shoots that demand certain equipment. If I am going to take long exposure photographs at night, for example, I will be packing a tripod into my bag, and for sports photography I'll be taking a telephoto zoom lens with the largest available aperture. If you are going out to take a specific kind of photograph then it is possible to select exactly which equipment you should have with you, enabling you to take just what you need, rather than carrying an excessive amount of equipment.

It's harder to choose the right equipment if you're going on an extended trip, however, as you could well be doing many different kinds of photography. My home for the past five years has been South Korea, and there are times I will take a weekend trip to Seoul. The city is a great mix of modern and traditional culture, with all of the photographic opportunities that entails. I could photograph at a traditional market, in the temples or palaces, and take nighttime shots in the modern business district. Or I could turn my camera on people performing martial arts or the cherry blossom trees in the city park—the list goes on. Each of these scenarios requires slightly different equipment, so choosing the correct kit to take with me is always a dilemma. There are those that will say you should cover your focal lengths with wide-ranging zoom lenses, and there are those who will say that prime lenses are better. Some people will want to take additional equipment such as tripods and strobes, while others would prefer to travel light and shoot handheld using available light. All options are equally valid.

In my case, I usually have a camera body, a 17–40mm wide-angle zoom lens, a pair of fast prime lenses (50mm f/1.2 and 135mm f/2), a tripod, a selection of filters, an angle finder, cleaning equipment, and a external release cord. I carry all of this with me because I love to do long exposure photography, I like using wide-angle focal lengths to create dynamic photos with architecture, and I often want to use a wide aperture to create bokeh in my photos. This is not necessarily everything I will take with me, and I might also add a 70–300mm telephoto zoom, a fisheye lens, and strobes. Ultimately, it all depends on the style I anticipate shooting and my equipment is tailored to that.

ASSISTANTS

It can be easy to get bogged down with too much equipment, so make sure you only take what's required for the photographs you intend to shoot. If a lot of lighting equipment is needed, think about using a car or asking some friends for help.

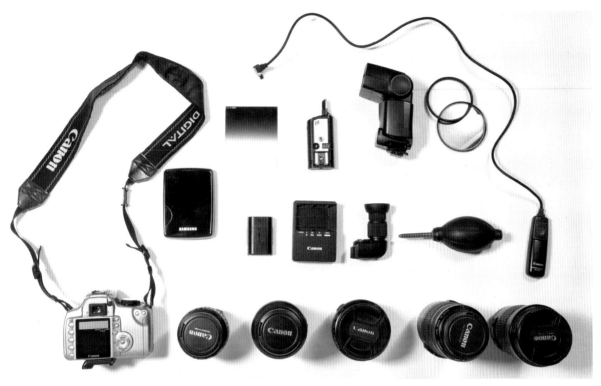

OPTIONS

There are many options when deciding what camera equipment to take on a shoot—here are just a few examples of what I might take with me. Here we've got a camera body, a selection of lenses, various filters, an angle finder, an extra battery and battery charger, cleaning equipment, and an external shutter release.

TRAVELING LIGHT

Choosing one lens to go out and shoot with not only allows you to travel light, but can also help you develop as a photographer by forcing you to think more about the way in which you shoot.

Computers

Once you've taken your images it's time to upload them onto a computer for storage and post-processing. The highlight of my day is viewing my images on a computer screen—nothing beats seeing them at a larger size.

These days there are many choices when it comes to the type of computer you use, and I find that size really does matter. I like my computer to be slick and slim for traveling, but a bit "meatier" for the things I do with my photos once I get home. For this reason, I have two computers—a MacBook Air in my case and a MacBook Pro at home. If you're not really a travel photographer, a desktop computer is an alternative.

This book isn't really intended to be about computers, so I'm not going to give advice on particular brands or operating systems—we all have our preferences and you'll probably already know what works best for you. I will offer one piece of advice though, and that is to get your monitor properly calibrated so that the colors you see on your monitor are true. If you're using a laptop it is a good idea to get an external monitor so you can do your post-processing work with confidence.

As I have already mentioned, computers are all about storage and display. In terms of storage you can use your computer's internal hard drive, but buying at least one external hard drive to back up your images is an absolute must. If you only have one copy of your photos you really don't have a copy at all—hard drives fail occasionally and if you haven't backed up your images, you're going to be one very unhappy photographer. An alternative option for backing up your work is to use one of the various Internet "Cloud" services that will store them for you. Flickr is also a great way to archive your photos, and doesn't cost a great deal each year.

While storing your images is important, I feel that showing your photos to the outside world is vital if you want to be a successful photographer. There are various ways to share photos on the internet, including web sites such as Facebook, Flickr, and Picasa, or you might want to create your own website. It's also a great idea to show your photos to the people you meet when you're out and about. Nothing beats face-to-face contact with people, and being able to show them your work in person isn't difficult—there are tablet devices, smartphones, and even netbooks, which are all very portable and equally capable of storing your digital portfolio.

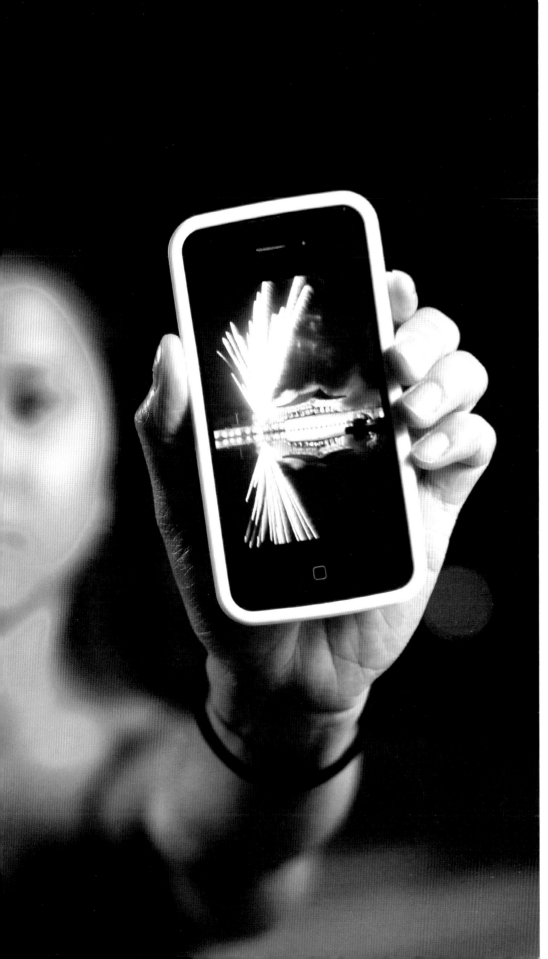

SMARTPHONE

A smartphone is a fantastic way of carrying a portfolio of photos around with you in your pocket—you can then show your work to anyone you meet!

COMPUTERS

The processing power of a computer is important in photography, and portability is also an issue if you're often traveling.

HARD DRIVES

It's possible to get external hard drives with very high capacities, but it's a good idea to have more than one so you can back up your work to several places.

Software

Computer software is important no matter what camera equipment you use—even if you're using a film camera there is a very good chance that your images will be scanned into a computer. The question then, is which software should you be using?

Everyone knows the behemoth of digital post-processing: Adobe Photoshop. This program is an immensely powerful piece of software that has truly revolutionized photography. I'm often asked if I've "Photoshopped" my images because some of the in-camera effects I produce are dramatic, but the truth is that most of my photos have minimal post-processing. Nevertheless, there is a lot that can be done in Photoshop to improve your photo, so getting to grips with the program—or an alternative such as Adobe Elements or Lightroom, Apple Aperture, or Corel PaintShop Pro—is a very good idea. You will probably have some photo-editing software that came with your camera, and this can often perform a lot of the functions you're going to need, especially when it comes to processing your camera's Raw files.

There are some types of photography where you might want, or need, to use more specialist software that works either as a plug-in for your editing program, to enhance its functionality, or operates as a standalone program. The most obvious examples are programs designed to produce HDR images, star-trail photographs, or panoramas such as Photomatix Pro, Startrails, or Calico. Of course, these are not the only options, and a search on the Internet will produce many more programs that perform these functions, as well as software that can expand your creativity in other ways.

SOFTWARE OPTIONS

There are many programs that can help you enhance or transform your photos once you get them on the computer.

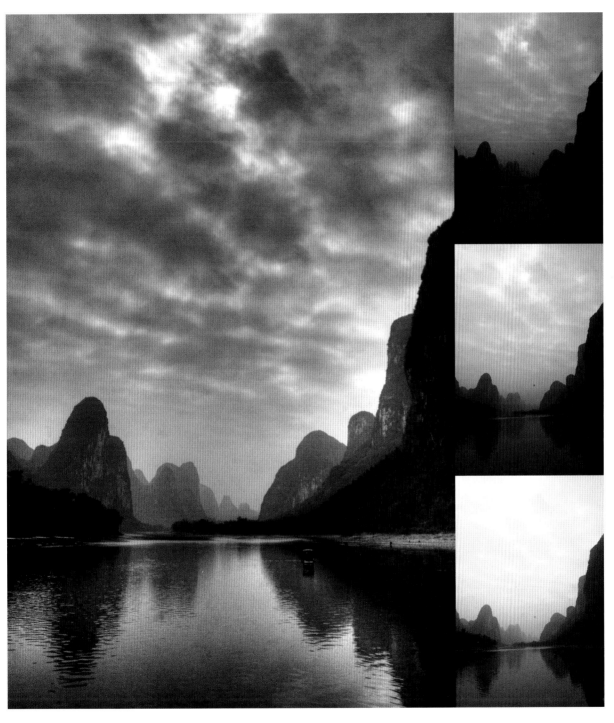

HDR IMAGING

There are numerous post-processing techniques that you can use to enhance your photographs, including HDR imaging, which is covered in more detail in Chapter 5.

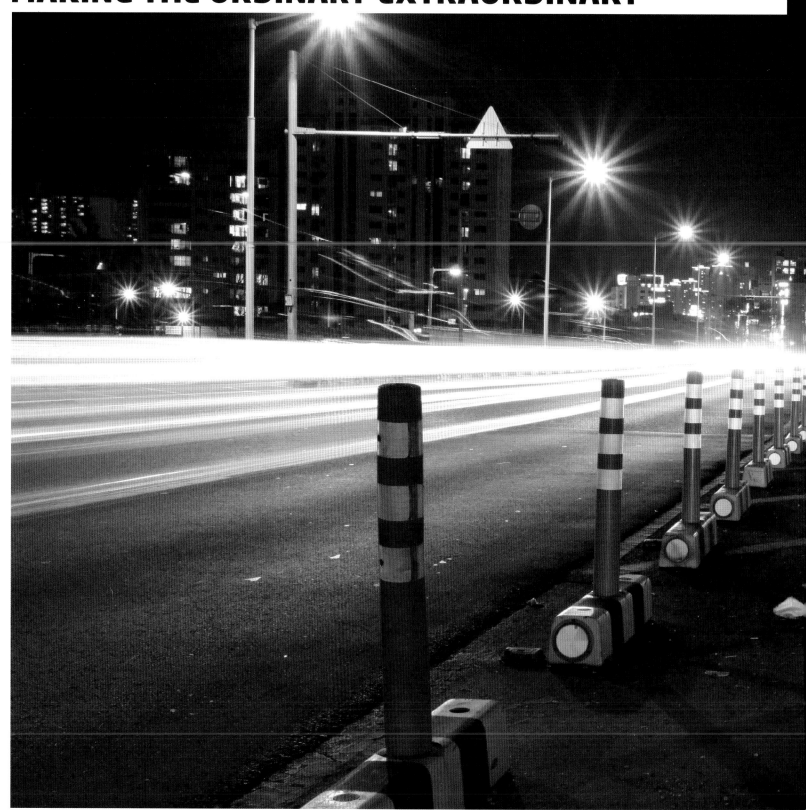

MAKING THE ORDINARY EXTRAORDINARY

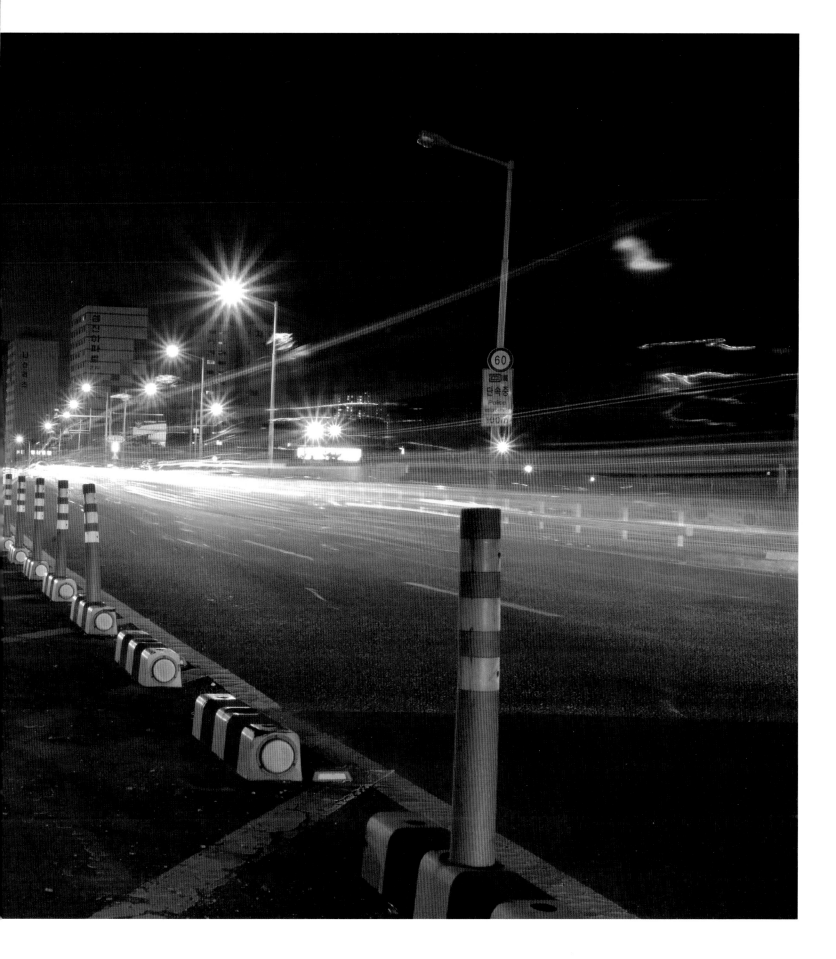

ORDINARY SCENE, EXTRAORDINARY PHOTOGRAPH

The question of what is ordinary is a complex one, not least because the answer is a double-edged sword—the word "ordinary" can simply be a polite way of saying "boring." However, when I think of things that are ordinary, I think of the simple things in life that I do every day. If you met someone who told you they had a 9–5 job and went to work five days a week, for example, you would probably think they had a pretty ordinary life. But if that person worked as a stunt man, you would probably think their life was exciting, or extraordinary: a slight change can make a dramatic difference to how interesting we think something is. It is the same with photography, in that a slight change of angle can often be all that it takes to transform an ordinary scene into an extraordinary picture.

There are many ways in which life can seem ordinary. The town you live in might have too many houses that look the same, or apartment buildings that all have the most basic design, but look again and you might see that those inanimate buildings have great repetition, lines, and texture that can be turned into photographic gold. Or how about a Buddhist monk? A monk's life has a lot of rigid repetitiveness to it, and to this humble religious man his life may well seem quite ordinary. But to a foreigner, the monk's lifestyle is exotic because it contrasts so markedly with their own—the ordinary again becomes extraordinary. Sometimes all you have to do is view your own neighborhood as a "foreigner" seeing it for the first time, and this can provide you with an interesting idea or angle for a photo as demonstrated on the following pages.

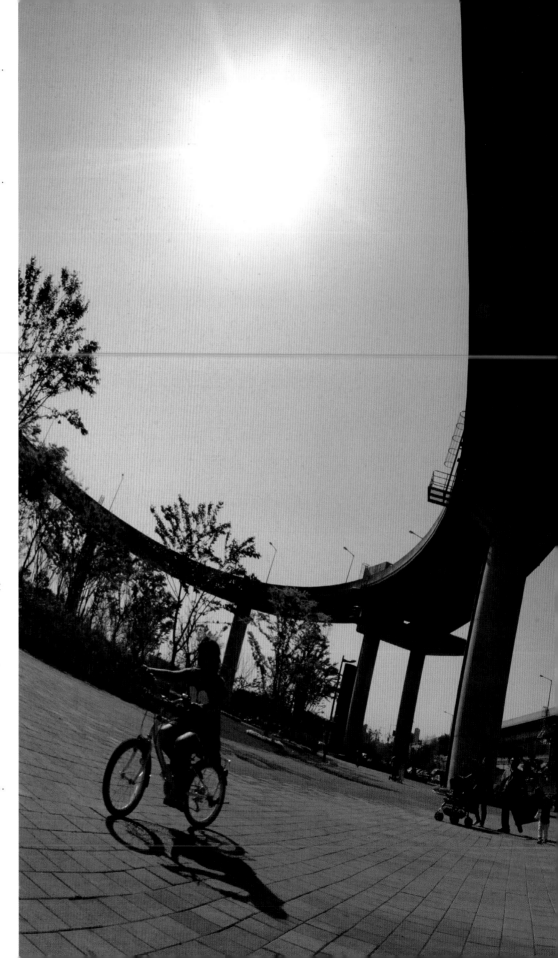

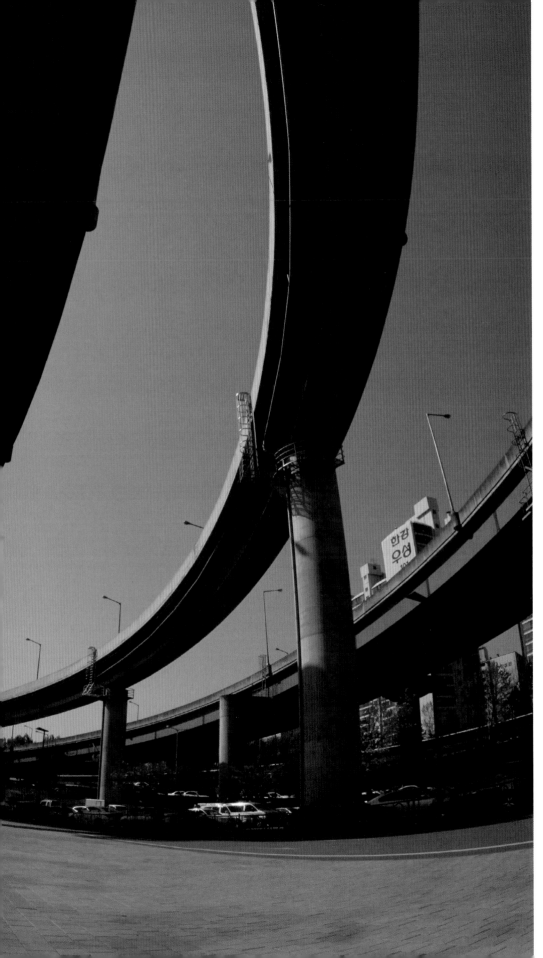

WHEELS WITHIN WHEELS

I've always found the road system fascinating, and the architecture you can find at an intersection can be amazing. For this photograph I used a fisheye lens to pull in the roads overhead. The cyclist in the picture gives a sense of scale, and adds a story to the shot.

A WORLD OF MOTION

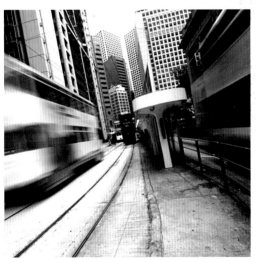

This shot was taken in Hong Kong and is all about contrasts. There is the contrast between the moving and static elements, and there is the contrast between color and urban grit. I tilted the camera slightly to add a dynamic edge to the image, and then it was just a case of waiting for the trams to roll past. A 1/2 sec exposure was slow enough to create the blur.

A PROBLEM SHARED IS A PROBLEM HALVED

In the picture my mother and girlfriend (now my wife) are busy making bunting for my sister's wedding. Lots of other people had jobs to do, but these two appeared alone, almost as if they were on stage. There is a great story of two people helping each other in this picture.

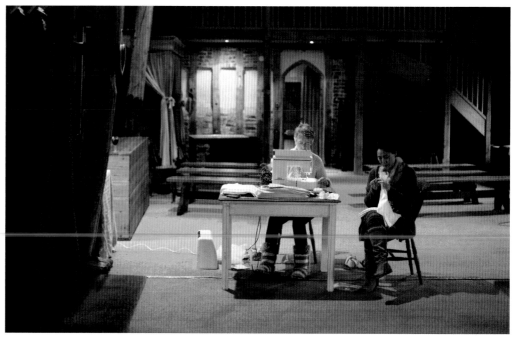

AN HONEST DAY'S WORK

This man may feel that his job is ordinary, but maybe he's involved in the construction of the world's tallest building—wouldn't that make his job extraordinary?

What makes this image stand out is the shallow depth of field, which blurs out the background. We can also see he is surrounded by metal, which contextualizes the image. The icing on the cake is the sparks, which give the image more . . . well, spark!

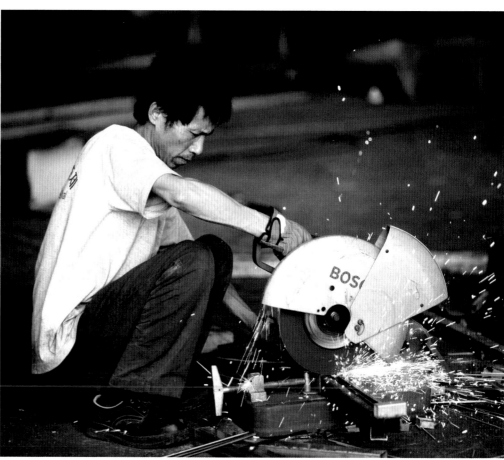

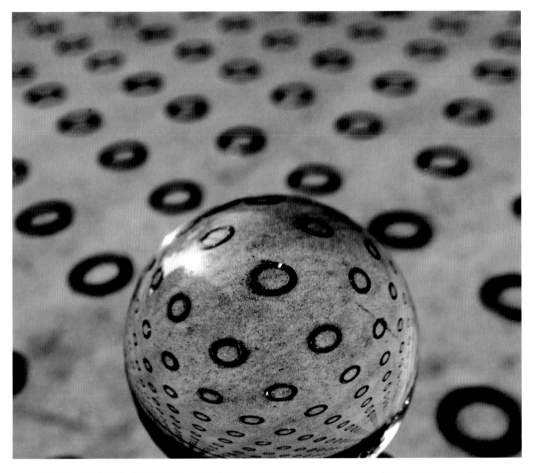

ARE WE ALL JUST REPEATS?

This is a photograph of the pavement close to a street crossing—a piece of concrete that hundreds of people walk on every day, but probably barely notice. However, it offers great lines and curves, not to mention repetition. The refraction in the glass ball adds an extra element, and introduces contrast between the in-focus ball and the out-of-focus scene outside the ball.

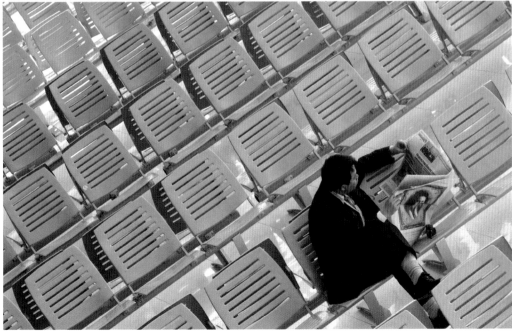

ABSORBING THE OUTSIDE WORLD

Airports often have a lot of modern architecture, which makes for good photographic opportunities. The lines of gray chairs might look uninspiring, but they offer great repetition. In this photo I've used the seats as a design element to draw the viewer to the main subject—the man reading the newspaper.

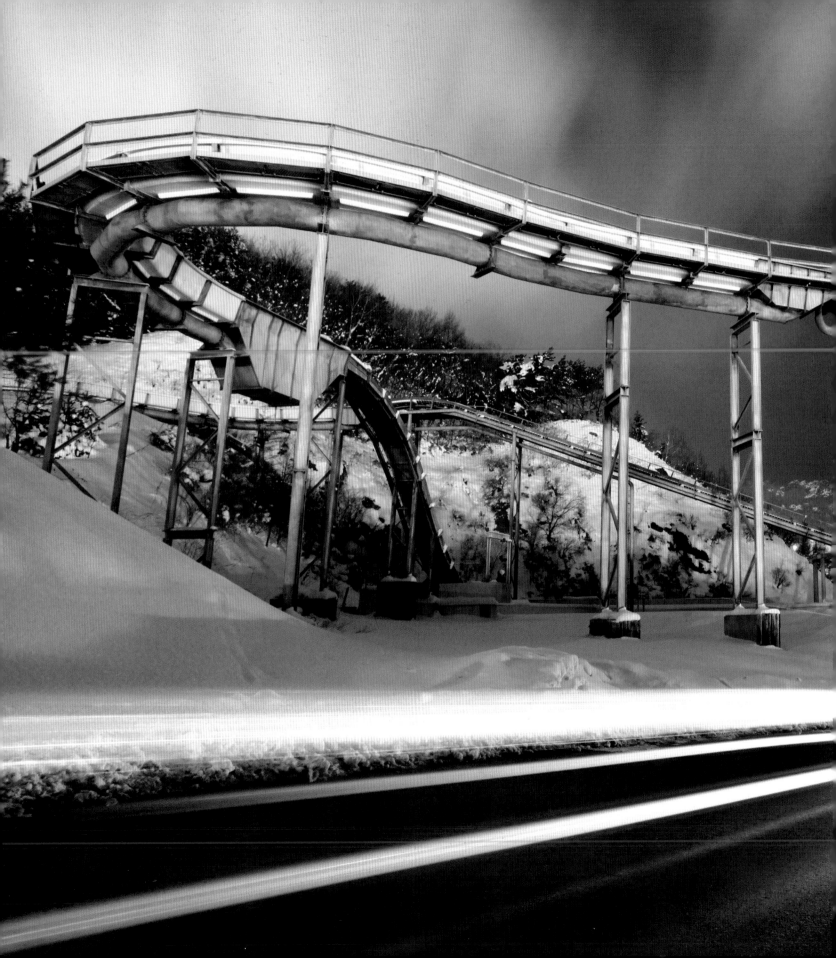

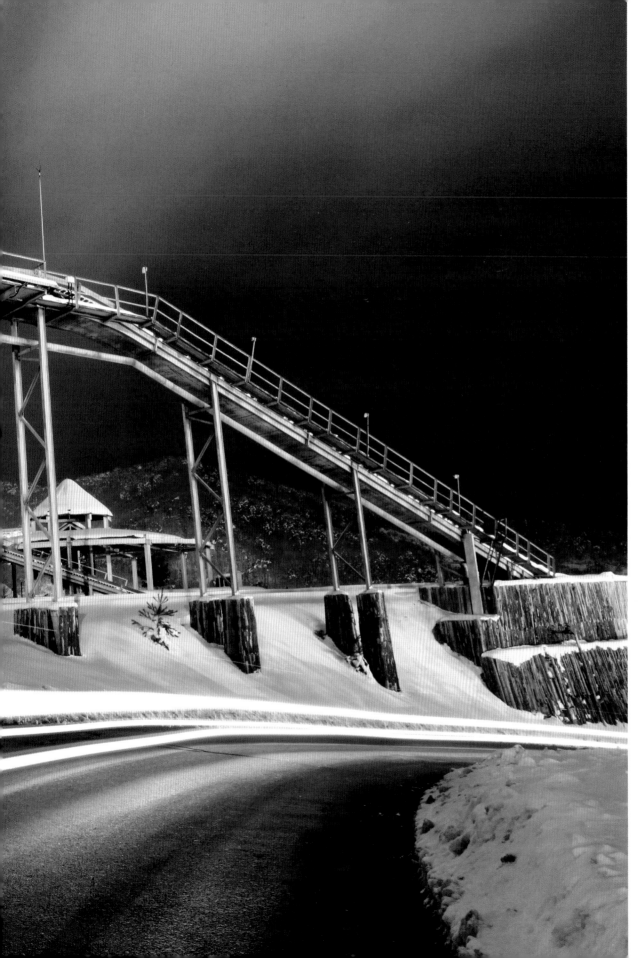

BLEAK CAN BE BEAUTIFUL

There is no doubt that when there's snow on the ground photographers head out in droves, but few would choose an industrial subject such as this aqueduct to create a striking shot. However, it provides a stark contrast to the surrounding nature.

The composition follows the rule of thirds, and to give it some more impact I used a long exposure. The cloud was blowing quickly across the sky, so a 25-second exposure created a dreamy, otherworldly feel.

ENERGY

Sunsets are always going to provide compelling subject matter for photos, but how about electricity wires and posts? In this photo they have created great lines that lead the eye through the picture and into the distance. We can also see a street light that will soon be powered by those electric cables, but the sun in the background is ultimately what provides this planet with energy.

The composition is simple but effective, thanks to the striking silhouettes produced by exposing for the sky.

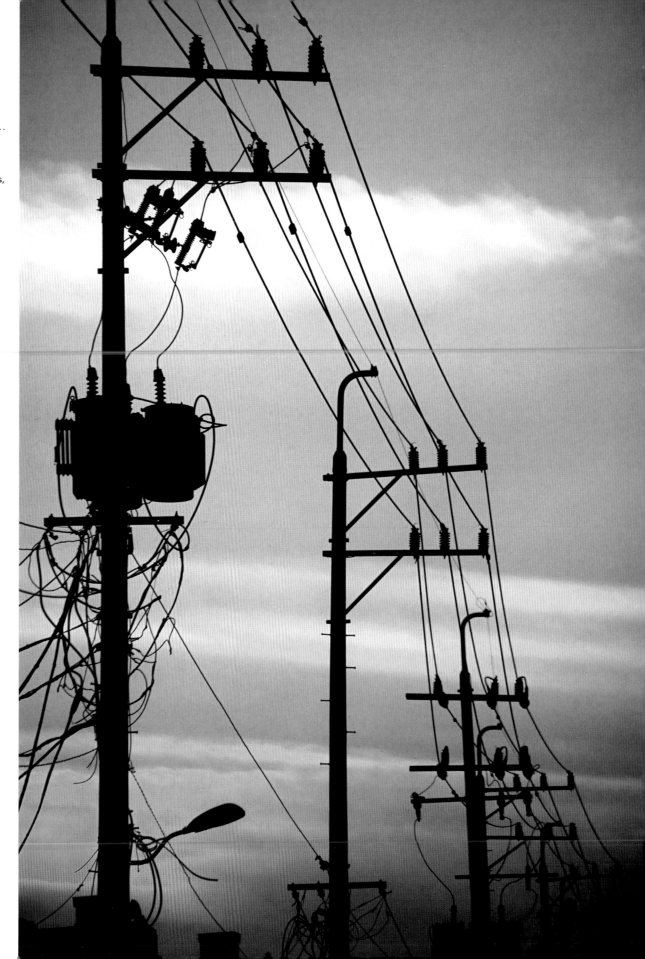

CONSUMER CHOICE

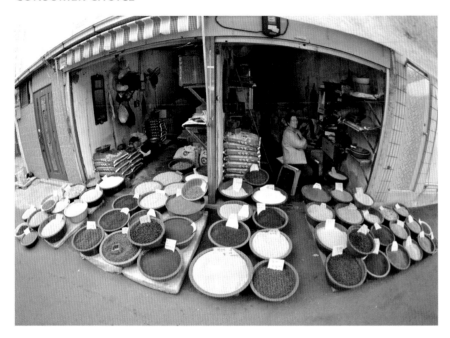

This is an everyday scene in the town where I live, and one that can be walked past without a second thought. However, the red bowls with food in them offer great color and repetition. In this photo I've used a fisheye to really tell the story of the scene in front of me. The lines and the two open storefronts hold the composition together.

LEAF

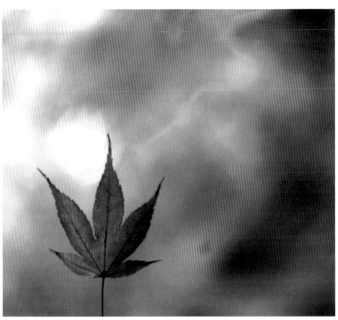

This is a simple photo that relies on the contrast of color and focus for its success. This was not chance, though—I was holding the leaf, which allowed me to select its background. The photo was taken using a 50mm prime lens with an aperture setting of f/1.2, which created a shallow depth of field and a colorful bokeh background.

URBAN LINES

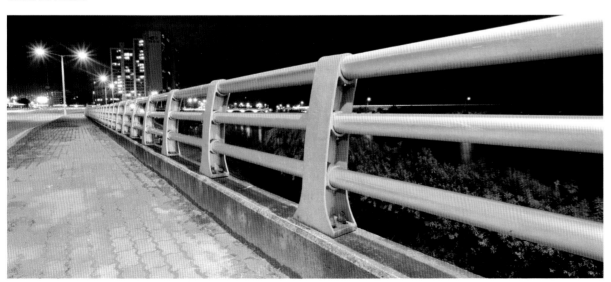

A nondescript street in the urban jungle, filled with concrete. It's not what most people think of as beautiful or picturesque, but nighttime can transform a scene. The barriers produce fantastic leading lines when viewed from a slightly lower point, and draw the eye to the apartment buildings in the distance, while the cloud has produced a slightly ominous sky. I applied the rule of thirds here, and used a wide-angle lens, which results in an interesting composition.

LIVING IN THE URBAN GOLDFISH BOWL

This is a typical cityscape, but by using refraction in a glass ball to really focus the eye on the scene, it gives it a far less conventional appearance. The blurred surround gives the cityscape an insular feel—where most cityscapes suggest an expanding scene, here it is confined by the orb.

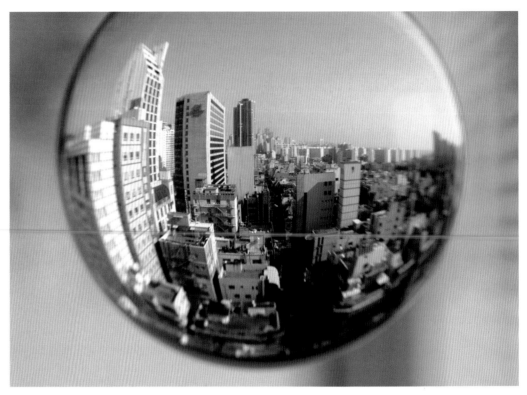

THIS TRAVELER

I might have mentioned previously that I love airports— I also love subway stations. I find the modern lines and sense of movement in a subway station very exciting. To make this self-portrait exceptional I decided to change the angle of attack a little. Using a tripod, I put on a 10-second self-timer and chose a 6-second exposure to create a blurred effect. I also chose to shoot low-down to record a different point of view, and tilted the photo to allow the lines to splay out in a striking way.

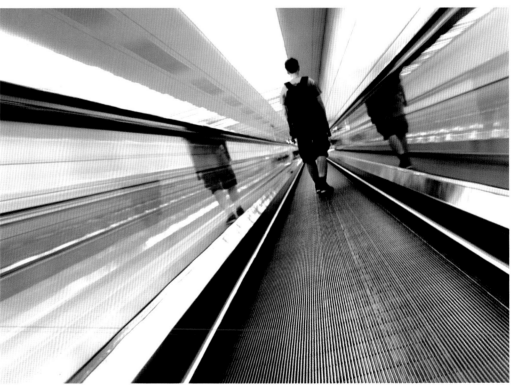

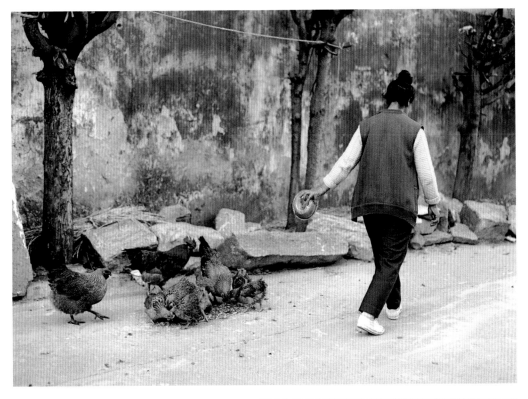

FEEDING TIME

The lady in this picture probably feeds these chickens several times a day. Her life is possibly quite hard, and as soon as she has fed these chickens she is off to do another task—this is an ordinary piece of street life, but also a decisive moment. The decaying wall in the background compliments the subject well.

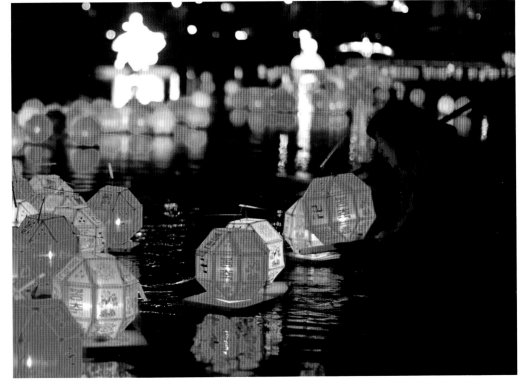

FLOATING THE LANTERNS

There are some days when you get a killer photo opportunity. This is very much what happened with this image, which was taken during the Buddha's birthday celebrations in the South Korean town of Suncheon. The river is usually no different to any other river, but on this one day of the year it came alive with the color of the floating lanterns.

I was able to get this photo of the lady floating a lantern during the festival. I used the light from the lantern to focus on her face, which made the shot very challenging, but also very rewarding.

RITUAL

This monk is performing a ritual that he has probably carried out many times before. However, while this may be an ordinary event for the monk, it is exotic and extraordinary to a tourist.

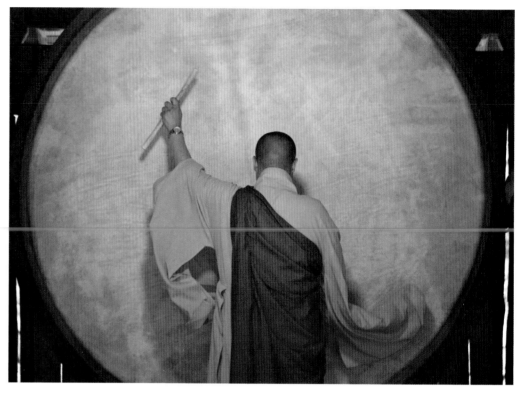

THE WARMTH OF GOOD FRIENDS

Nothing beats the company of good friends, especially if that involves sitting on the beach in front of a fire. This moment shows real warmth and happiness between these three people, with the subjects nicely isolated from the background by the light from the fire. The guitar adds to the relaxed mood.

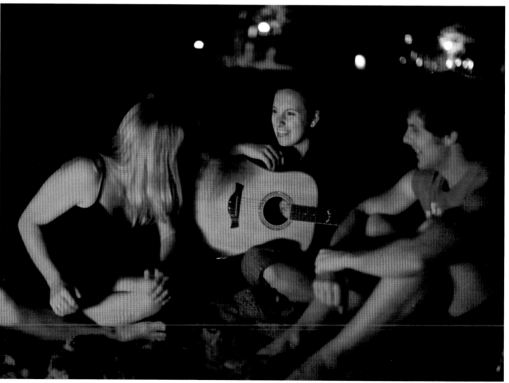

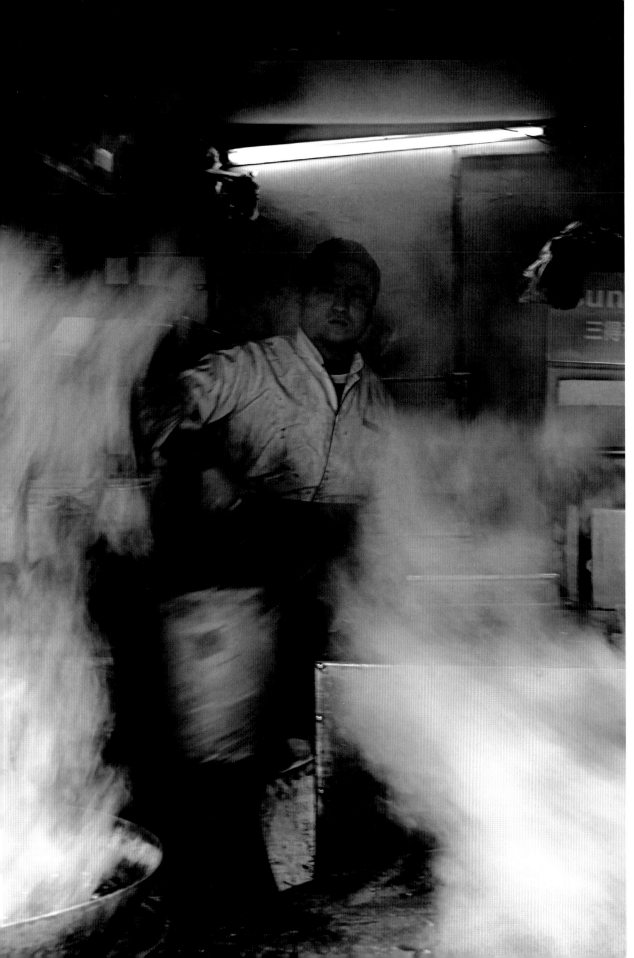

TOO HOT IN
THE KITCHEN?

This scene made me think of the
phrase "if you can't stand the heat,
get out of the kitchen." This man
works long and hard every day in
his kitchen, and this wide-angle
shot really captures the environment.
The slightly long exposure and very
ultra-wide focal length has created
a striking dynamic, with the steam
framing the figure perfectly.

The small picture

Although it might seem paradoxical at first, the best way to capture the atmosphere of a place is often not to capture it in its entirety. In any environment a quick glance around you will reveal a huge amount of detail and—if you're lucky—an overarching story that ties the elements together. Of course, the story might be in your head; you might have read a tourists' guide to the customs of the location you're visiting, or you might know the people and places involved yourself. In any case, the most important thing to do is forget everything you know and just look with your (photographic) eyes.

All good photographers begin framing shots as they survey a scene, even before they lift the camera to the eye or turn the zoom, and after a while this becomes instinct. However, reducing a place into a photogenic crop is one thing, but what about the atmosphere? Or the history? The answer is surprisingly simple—just take a few more photos. The point isn't to snap at everything, but to think about the narrative you're building in your head. It's rare that you'll ever see a magazine article about a landmark or an event that doesn't feature more than one image. With a digital camera, there's nothing to stop you shooting as many different angles as you like.

Moreover, much of that contextual understanding is provided by your knowledge of the subject, rather than the scene. On many occasions, the most interesting aspect of a subject might be its texture, or, as in the lanterns shown here, the attention to detail in their construction. Only a close shot will reveal that detail.

When you view your pictures later, you can arrange them so that a wide-angle survey shot appears first, just as a film editor would put an establishing shot at the beginning of a scene, before following with close-ups. When you come to choose a picture to hang on the wall, I'll bet you turn straight to the detail shots.

RITUAL

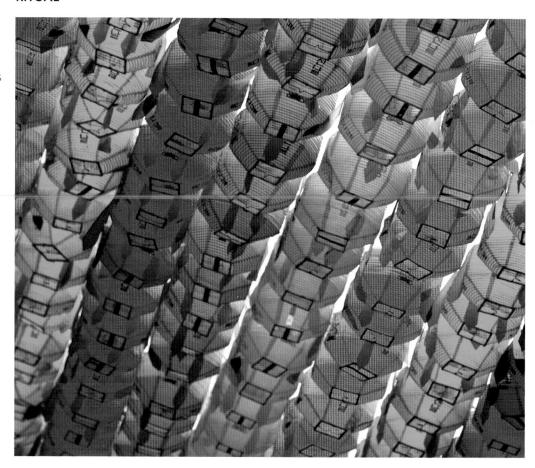

A close-up of these lanterns at a festival creates the illusion of endlessness because it doesn't show where the rows finish, and because it is shot diagonally. By using a telephoto focal length, the detail of each lantern is also revealed.

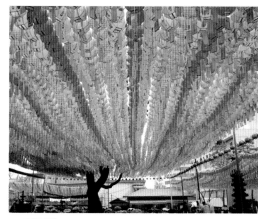

ORCHESTRAL PERFORMANCE

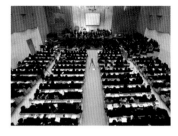

An orchestral performance is a classic example of the whole being greater than the sum of its parts, but the wide-angle view above reveals none of the passion or difficulty involved in playing the instruments.

Just as in the shot of the lanterns, a diagonal angle (right) is used to convey this player's place in a larger orchestra; the narrow depth of field emphasizes her unique input.

The intensity of this performer's expression (far right) is perfectly captured in the reflection on the grand piano. The final image has been rotated through 90°.

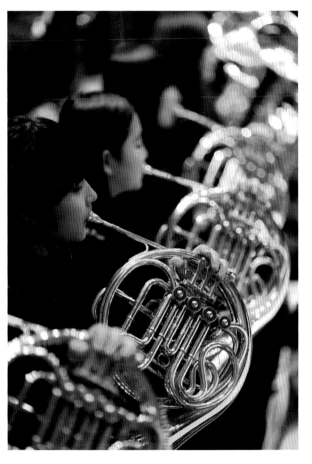

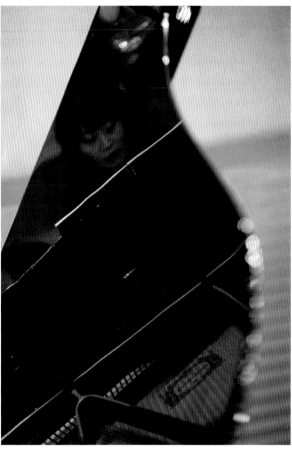

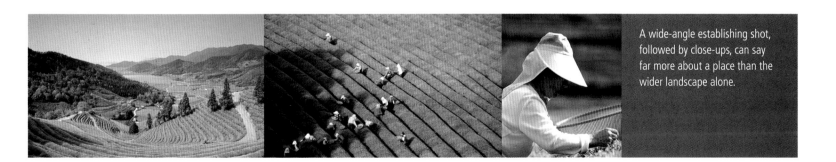

A wide-angle establishing shot, followed by close-ups, can say far more about a place than the wider landscape alone.

Case study: Building site

On the face of it, a building site is not the most photogenic of environments; certainly the appearance of the site isn't highest on the worker's list of priorities, and the colors of churned earth and concrete are rarely appealing either. But, like any other environment, there are details that you can use—in conjunction with the movement of the light—to turn an otherwise drab environment into a dynamic playground.

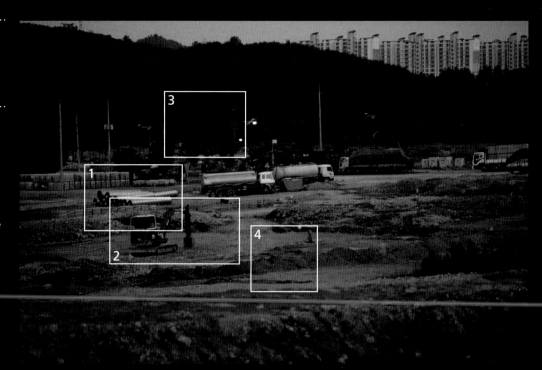

1. PIPES

The pipes offer a number of different possibilities, whether shooting down the center to the exclusion of everything else, or stepping back and zooming in on the pattern created by the packed lengths of pipe. Many other still-packed items on the site have appealing repeat patterns as well.

2. MACHINERY

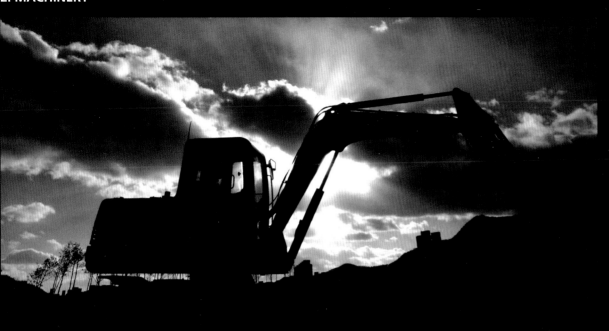

Creating a silhouette of the earth-moving machine emphasizes its strength and cold, mechanical form without the distraction of color or markings. Its apparent task—shown by the earth rising on each side—is exaggerated by shooting from a low angle.

3. TREES

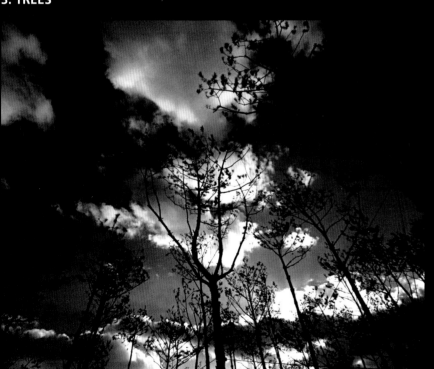

The spindly trees planted at the future entrance to the site are surrounded by debris and building materials, but by crouching down, shooting upward, and exposing for the sky, more interesting silhouettes are created. The final step is to post-process the image to give it a dark sepia tone.

4. GROUND

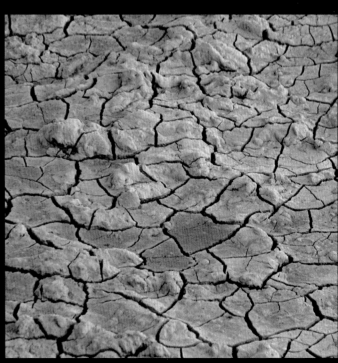

The dry, uncared-for earth has cracked to create this irresistible pattern, shot in the warm light at the end of the day. This was enhanced slightly in post-processing to reflect the golden tone of other processed shots in the series, such as the pipes and trees.

Case study: Urban neighborhood

Urban neighborhoods are absolutely stacked with good photographic potential. A lot of apartment buildings, footbridges, roads and the rest of the concrete jungle often don't appeal to many people's sense of what's beautiful but you need to look closer. Apartment buildings offer lots of strong lines, and usually have nice repetition as well. At nighttime the chance to use long exposure can really transform what appears a humdrum urban jungle into something space age! Then there is the human side to any neighborhood—where there are people there will always be good photo opportunities, and then it just takes the patience to capture the decisive moment. If you never thought to photograph your local neighborhood here are some examples of shots you might try.

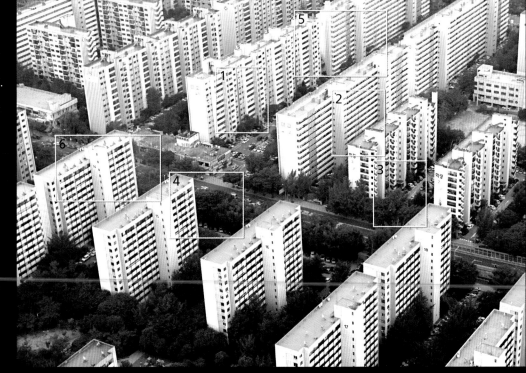

1. IN A WORLD OF HIS OWN

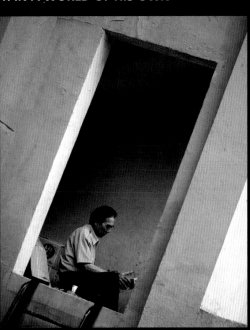

As a photographer you sometimes get a photographic gift, though you still have to take it. In this shot there are great lines, a nice frame, a little color contrast, and the man who really grounds the photo. This is an everyday scene, but all of the above elements combine to make this a powerful shot.

2/3. LINES AND REPETITION

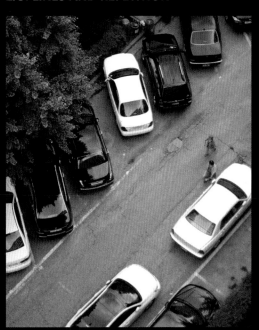 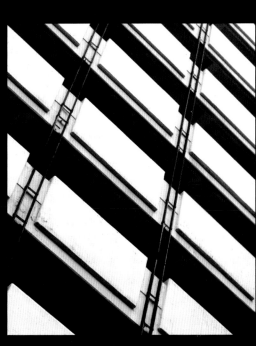

Here we have two great examples of the lines and repetition that can be found around apartment buildings. The use of point of view is important for both of these photos with one looking up, and the other looking down. In the photo on the left we can see the lines in the road, together with the intersecting lines of the parked cars, which give the image repetition. The photo showing the façade of the apartment is a typical example of strong lines and repetition found in buildings like this, a little angle with the photo framed this nicely.

4. LIGHT SPEED

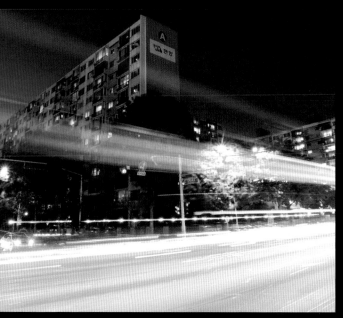

5. URBAN BUBBLE

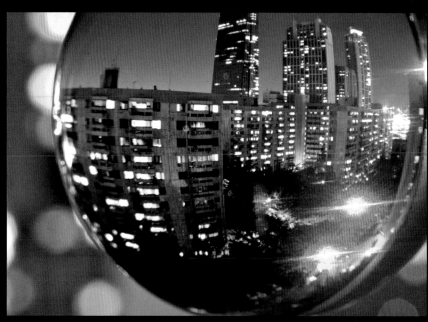

In this photo the traffic light trails from cars and buses are caught during a long exposure. This gives this image a much more futuristic feel, and adds dynamism to the scene.

Using a glass ball to refract the background is a great way to have an ultra-wide fisheye effect, but in the confines of a compressed scene. Taking this photo at night has meant the background bokeh adds a nice feel to the image, and we can clearly see the buildings inside the ball.

6. URBAN NEIGHBORHOOD

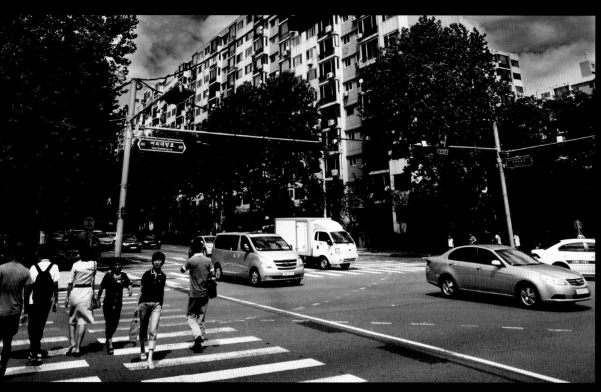

A well-composed photo with good use of the rule of thirds is always likely to pop. In this photo there are the contrasting textures with the sky and the pedestrian crossing on the street. A little patience here lends the image a human touch with people crossing the road.

Case study: Rural neighborhood

Sweeping landscape views, green grass and farmers in the field; it's all there in the rural neighborhood. There are many kinds of rural neighborhood of course, and increasingly agriculture has become more industrial. In this case study we're going to look at a farming area in South Korea that grows garlic and rice, among other things. This area will show you how to make a mixture of photos from portrait, landscape and still life and turn them into the story of this community. In this case the steep rice terraces have allowed for a great vantage point over the whole scene, before delving in and taking a closer look with some detail shots of things like tires and garlic.

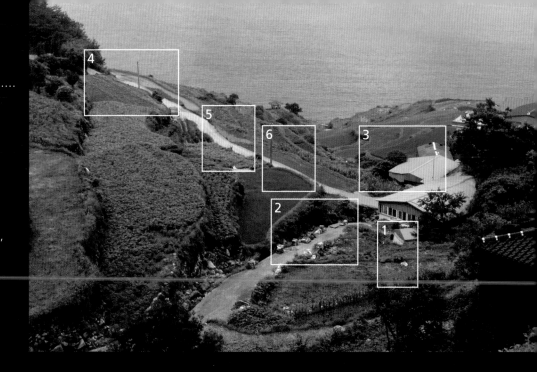

1/2/3. DETAILS

. Tire tracks: The tire track with the mud on it offers great texture and patterns, and the fact it's repeated on the ground is a nice added bonus. As the mud is there it gives the hint that this is not a concrete urban environment but something more rural.

. Garlic: A still-life image of the product being grown on this farm is a nice touch when telling the overall story. This photo is a simple, well-lit and well-balanced composition that has utilized the rule of thirds.

. Rice terraces: There are many different types of photos you can take of rice terraces. In this shot I've gone a little closer in to concentrate on the sweeping line that curves through the frame. Again, the composition is well-balanced and there is additional interest in the different shades of green that run through the shot.

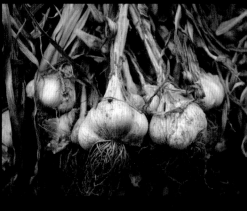

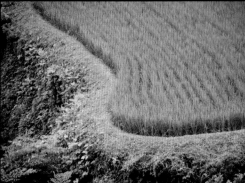

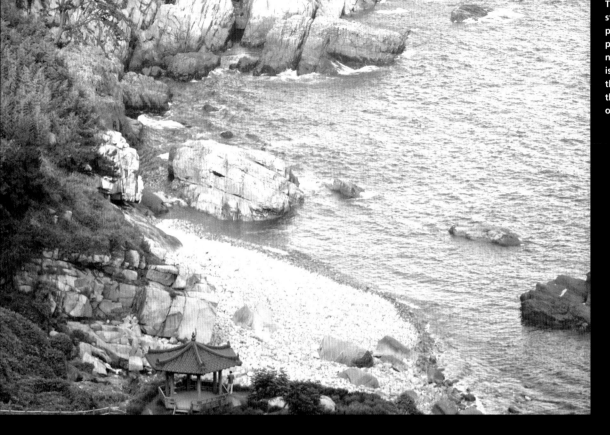

The rugged coastline along this stretch of South Korea is a good place for a landscape shot, and the pagoda in the foreground gives a nice point of interest. This pagoda is present in the landscape image of the overall scene, but here it proves the value of shooting the same object from a different angle.

5/6. ENVIRONMENTAL PORTRAITS

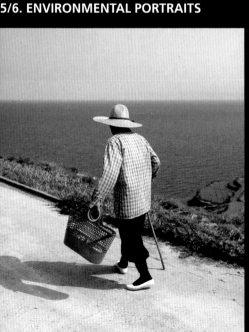

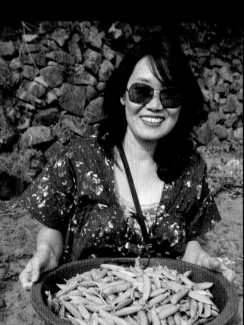

Environmental portraits are about shooting a person in their natural environment, and therefore contextualizing the scene. Here, we have two examples. The image on the right tells us that this is a farm, because the woman is holding a bowl of freshly picked peas. The portrait on the left provides us with more of the scene; again, we know that this is a farm from the rice terraces in the background.

Case study: Umbrellas

The umbrella really is a work of beauty, and I'm not talking about the fact it keeps you dry during a torrential downpour. The natural symmetry and lines it possesses are great for photography, and some of the umbrellas found in Asia are truly works of art. In terms of photography, umbrellas are often used in the studio to create nice lighting. An umbrella can also be used as a prop when shooting a model or as a still-life object. In this case study we're going to look at an umbrella in both scenarios and show how it is more than just an object to keep you dry on a wet day.

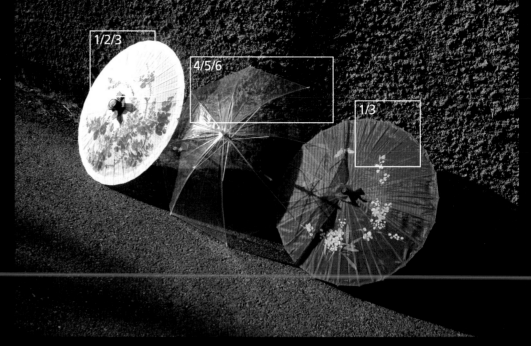

1/2/3. THE UMBRELLA AS PROP

Here we can see a sequence of photos all using the umbrella as a plot enhancer to tell a short story of the woman in the photos.

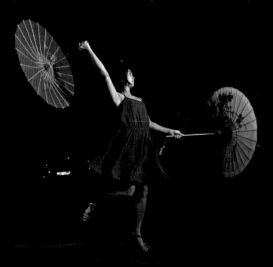

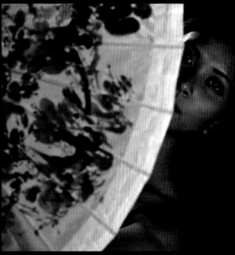

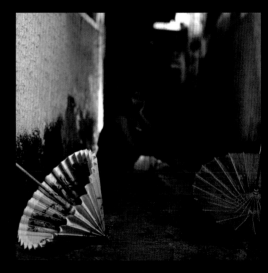

1. In this photo the umbrellas are used to add a sense of sweeping motion as they glide through the frame. The umbrellas are also great at increasing the area of the frame the model uses, allowing her to dominate the frame more. In addition to this the color scheme of red, white, and blue is instantly recognizable and draws the eye as well.

2. Here, the umbrella is used to compose and balance the photo. There is a strong black/white line and the model sits on the edge of this. We can also only see part of her face as the rest is hidden behind the umbrella, which adds a little mystery to the portrait.

3. In this photo the umbrellas can be considered both props and still-life objects. Everything is on the ground, we can see the woman in the background in soft focus.

4/5/6. THE UMBRELLA AS A STILL-LIFE OBJECT

Strictly speaking, this sequence of photos shows how an umbrella can frame a photo, though the spokes are still-life objects.

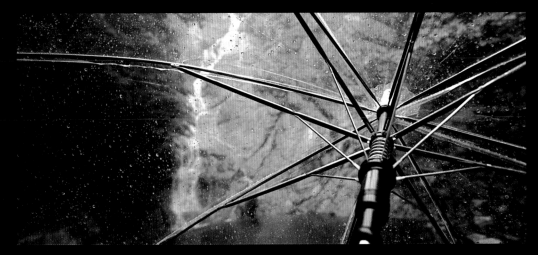

4. In this photo there is a river and waterfall that is in soft focus, giving this photo a dreamy feel while also adding a layer. The waterfall acts as a counterpoint to the spokes of the umbrella and there is a gentle gradation of green and brown through the frame. A nice touch here is the drops of water that are on the umbrella, adding a little texture to the shot.

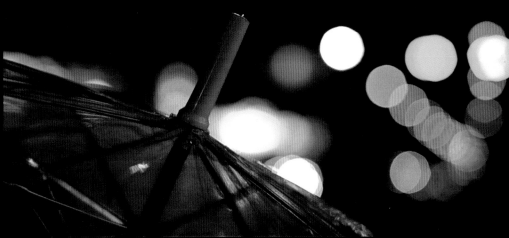

5. In this photo there are the lights from some background neon signs in the frame. Using a shallow depth of field given by a large aperture this light has been blurred across the frame. A nice counterpoint to this are the strong black lines that the silhouetted spokes of the umbrella provide.

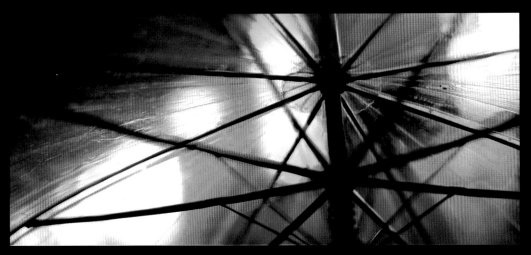

6. This photo has two main points of interest, which are the umbrella and the bokeh. The bokeh is of course achieved through a shallow depth of field and in this photo the bokeh is meant to represent the colorful dreams that are just out of reach.

Case study: Roadside

Everyone walks along the roadside, and just passes it by everyday probably without a second thought. Roads are such a functional thing that thinking about them in an artistic light isn't usually people's first thought. There is another way to think about them, of course, they're dynamic, contain lots of life, the arteries of modern living, and are linear, which is great for photography. There are many angles that can be used to take photos of roads, and there are few places that undergo such a great photographic transformation when going from day to night. In addition to this, places like road tunnels are always going to be photographic winners, just be careful out there as speeding traffic is dangerous!

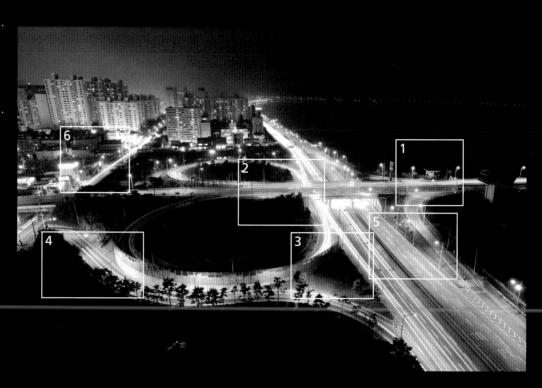

1. POINT OF VIEW

Getting low to the ground can be a great way of transforming something you see everyday into a completely different scene after all, who crawls on the ground on their way to work? It's easy to take too many long exposure photos at roadside, so to vary things this photo has been taken with a shallow depth of field to create smooth bokeh.

2. PANNING

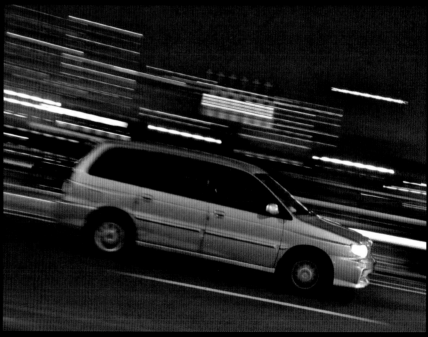

This is a rather obvious choice of subject matter for a case study about roads. The moving car is kept sharp, and a little tilt in the photo adds a touch of dynamism.

3. LONG EXPOSURE

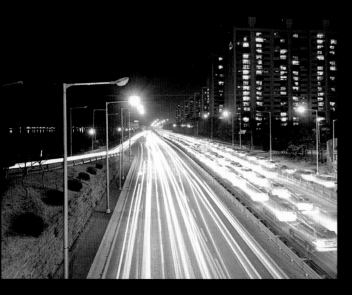

Long exposure of traffic taken from a bridge is always going to be a good shot, the only thing to watch for is keeping the frame nice and clean. In this photo the apartments in the distance add to the composition. The stationary traffic in the right-hand lane also tells a little story as well.

4. SILHOUETTE

As mentioned earlier tunnels are always going to be winners. Here, the tunnel frames the scene, and underexposing to silhouette the vehicle produces the shot.

5. MINIMALISM

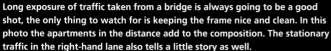

This shot, taken from a bridge, where it was possible to line up the lights together, is a good example of minimalism. It's important to make sure additional objects like apartment buildings or other lights are not in the frame when shooting for minimalism.

6. STREET PHOTOGRAPHY

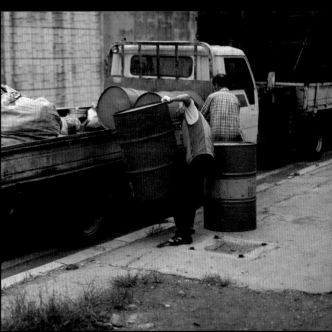

Street photography isn't given its name without good reason. It really shouldn't take anyone very long to find a scene of some everyday life occurring on the street. Once you have, all you need to do is compose well, and wait for the decisive moment to arrive.

Case study: City lights

The city has lots of lights, of course, streetlights, building lights and in South Korea there are lots and lots of neon lights! In this case study we're going to look at a street with many bars and karaoke rooms, that's norae-bangs for all those in South Korea. There are many ways to photograph lights, and here I'm going to use a few different techniques to more or less shoot the same scene. The reason for choosing neon lights for this as opposed to streetlights is because that may have stepped on the toes of the roadside case study. Let's look at all those bright red, green, and blue neon lights then in all their nighttime glory.

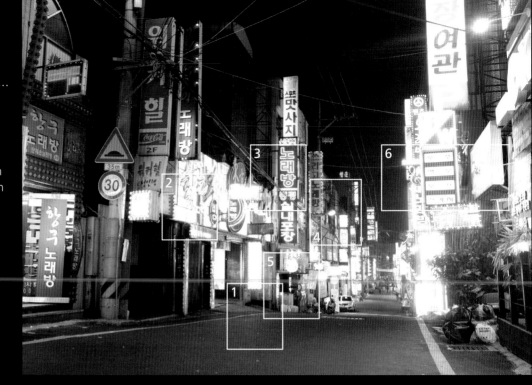

1. PORTRAIT

At night those lights can be used to make a lovely bokeh background. All that's needed is a nice prime lens with a large aperture. You'll have a portrait that pops out of the frame in front of those city lights.

2. ZOOM BURST

Here, a simple zoom burst has been used to give the photo a little more depth and dynamism. There is a nice glow to the lights as a result of this, and the shapes of the Korean script work well.

3. DRIFT

Neon lights can be turned into an abstract photo of drifting lines, as the colors blend into each other. This is a form of light painting, and is achieved by letting the camera move slowly from right to left on a tripod during a long exposure.

4. TILT

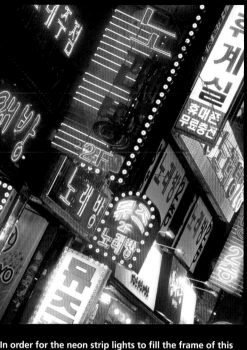

In order for the neon strip lights to fill the frame of this photo in the style of a modern patchwork pattern a little tilt has been used. The photograph of these taken with no tilt was a little flat, and had too much dead space, so tilt has been used here to solve this problem.

5. REFRACTION

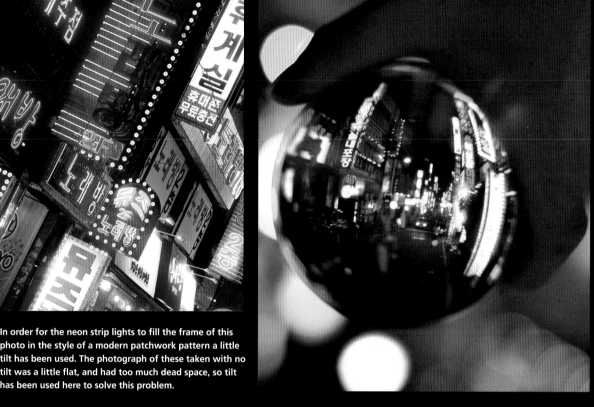

The overall scene of a street with neon lights is usually one that is a little brash. Here we see a car driving down the street with many businesses aiming to attract customers with their bright signs. All that neon is wonderful for bokeh of course!

6. BLACK AND WHITE

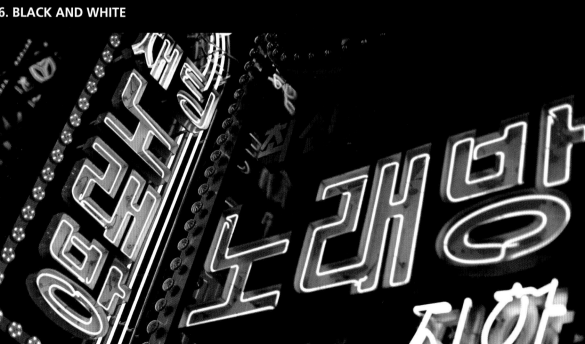

The high contrast, which the lights offer versus the background, makes this a candidate for black-and-white conversion, even with all those bright colors. Having a black-and-white image in this group also helps to break things up a bit and adds to the variety.

Case study: Macro

The world of macro is a strange and wonderful place, and there are many possible subjects, such as bugs, flowers, or extreme close-ups of bank notes. In this case study we're going to look at an artist's studio because it offers a number of objects than can be used for macro photography. It should be pointed out that it is possible to get even closer to a subject by using dedicated macro rings, but for this study a simple macro lens was used. The artist studio has good potential for macro with subjects such as paintbrushes and tubes, but we can also take macro photos of the artist.

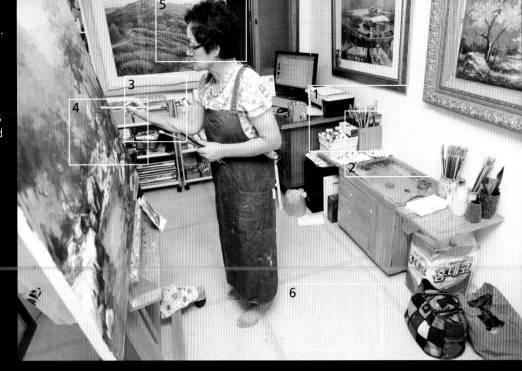

1/4. PAINTBRUSHES

Paintbrushes offer a number of possibilities when photographing them close-up. In the examples we have here one is more minimalist in nature while the other uses repetition and point of view.

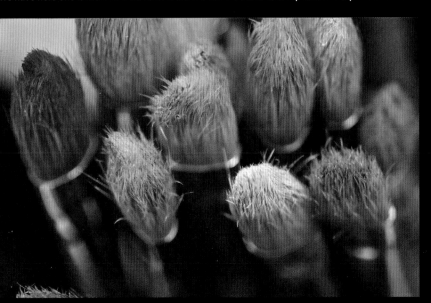

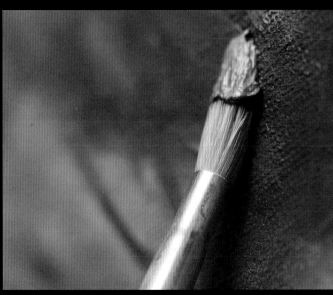

1. Lots of paintbrushes stored together can work well for repetition. This photo also uses a shallow depth of field to allow the brushes to melt into the background.

4. The focal point of this photo is the glistening green paint on the end of the brush. Here, we can see what the brush is used for.

These objects, when stored together, again offer a great opportunity for repetition in your photos. In this example I'm going to take some photos of the paint tubes as they are in the studio, and one shot where I used a light bokeh background.

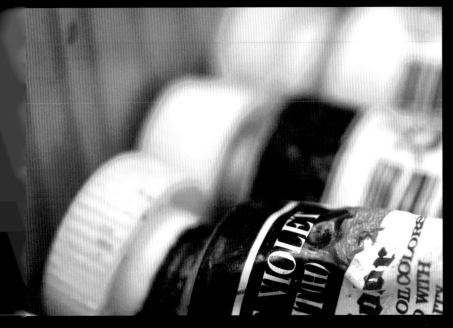

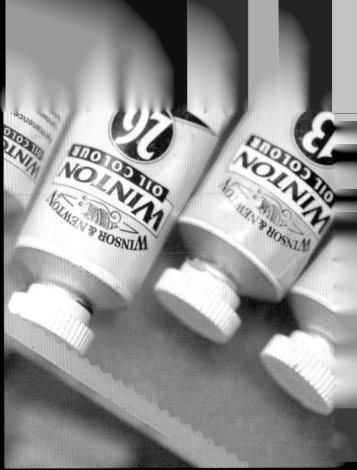

2. In this photo shallow depth of field has been used to isolate one of the tubes, sitting in a line of other tubes. There is a nice wood background, and the other tubes fade into a milky background.

3. Again point of view has been used, and there are also some nice diagonal lines that run throughout the image. The fact that all the tubes are of the same design also helps this shot.

5. THE ARTIST'S EYE

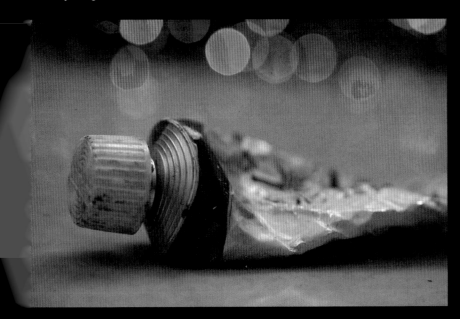

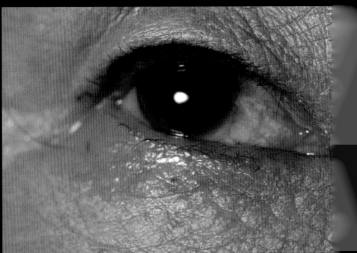

5. In this photo a paint tube has been lit using two off-camera flash units. The background is in fact some Christmas tree lights scrunched together, and the effect is achieved by using a shallow

It's not just inanimate objects that can be photographed using a macro lens, and in the artist's studio the eye of the artist offers a great subject for macro.

TECHNIQUES THAT TRANSFORM

Refraction

Every time you take a picture, you are manipulating refraction. This is the effect that occurs when light moves from one material to another at an angle. The shape of your camera's lens is designed carefully, usually in order to create a faithful impression of what you're looking at with your own eyes. Without going too deeply into the physics, at the boundary between one medium (for instance, the air) and another (glass of water), a light wave changes direction, and when you can see both mediums at once, light appears to "bend."

As a photographer, you can make use of this by looking out for objects that produce refraction in a sphere. On a rainy day, look at flowers, leaves, or tree branches, because you're bound to see water droplets. Look closely at these drops and you'll see the landscape refracted through them. You'll need a macro lens to take advantage of this, but you can then get quite a clear image of the scene. Perhaps you could position a flower behind the water droplet to produce a mysteriously refracted image?

Another possibility is a transparent object that you can put water into, such as a glass or vase. Positioning a wine glass filled with water in front of some rolling hills could produce an intriguing photo, and, of course, the connotations of the wine glass—a relaxing drink—are mixed with those of the subject behind. It's worth remembering that the camera is going to be focusing on an object that is very close to it, but the refracted image is likely to be some distance away. This can be used to your advantage, as you will see.

The next type of object we can use for refraction is a solid transparent spherical object, the most obvious being a crystal ball. However, the possibilities are endless: I've used the bobbles at the bottom of a drinking glass to produce great results, for example.

A final point to remember when using this technique is to make sure that the light coming through the refracting object is strong. If the light is weak, you may well see unwanted reflections from brighter lights nearby on the surface of the spherical object. Sometimes this reflection can add to the photo, but it is more likely that it will not. I've found the best time of the day to do refraction shots is sunset, and then just after sunset when streetlights and other illuminations are being turned on. Care should be taken when using a crystal ball in the midday sun; light will be focused through it, producing a hot beam, so be careful not to let it start an accidental fire!

REFRACTION

Refraction occurs when light is bent as it passes from one medium to another, as the change in angle and shape of the pen shows. When refraction occurs in a spherical object, the image becomes inverted.

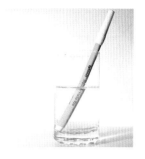

Here, we have refraction taking place in a wine glass, with the sunset in the background inverted by the glass. The bubbles were caused by water being dropped into the glass during the exposure.

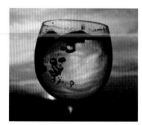

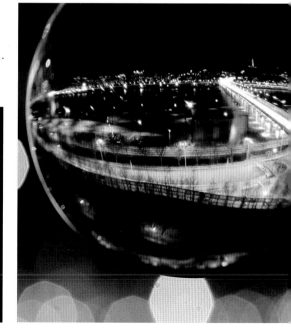

Equipment

- Point-and-shoot camera with a macro function.

OR . . .

- Digital SLR camera with a macro lens and/or a prime lens with a fast aperture.

- Flash when the ambient light level is low.

Props

- Crystal ball.

- Wine glass and water.

- Solid glass objects with curves.

THE INVERTED IMAGE

In this inverted image the "mackerel sky" is at the bottom of the image inside the ball, while the harbor is at the top of the refracted image in the ball.

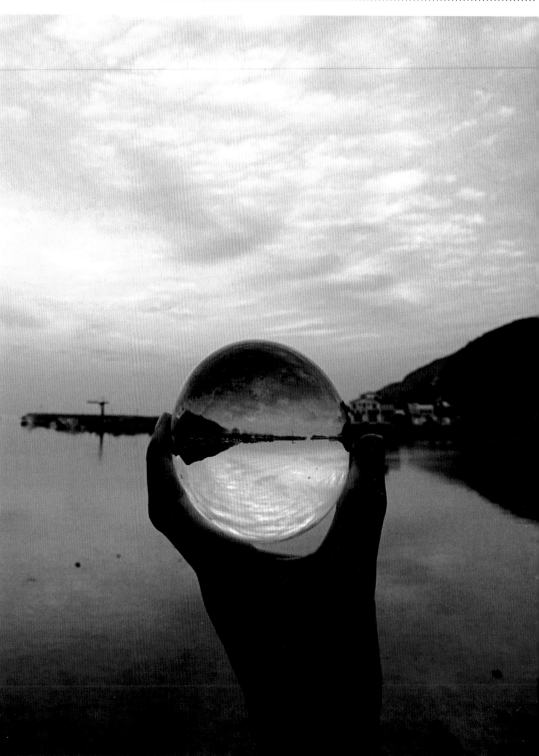

USING A CRYSTAL BALL

One of the best objects for refraction is a crystal ball. This image of a road junction has been flipped horizontally and vertically in post-processing so the junction appears the right way up, apparently hovering over the specular highlights of the out-of-focus streetlights.

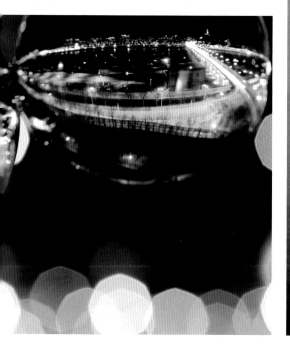

Zoom burst

A zoom burst is achieved by changing the focal length of the lens while the camera is exposing. This technique can give you stunning results when used well.

There are a few variables to consider when using this technique and these are as follows. The variables are zoom direction (in or out), location, flash, time of day, and the shutter speed to use. In order to be able to perform the zoom burst you're going to need to use slow shutter speeds—1/4 sec or slower is ideal—and therefore it's a good idea to use a sturdy tripod. If you're shooting during the day, an ND filter will allow you to open the shutter for longer without overexposing the picture.

Zooming out

Most people who use zoom bursts will tell you that you'll get sharper results by zooming in. This is true during the day, when the whole frame is flooded with various light levels, but at night the characteristics are different and you will likely have a scene scattered with points of light. If you press the shutter-release button and then begin to zoom out, the lights from buildings, streetlights, and other light sources appear to spread out and cover the frame.

A zoom burst is definitely a situation where you should use Shutter Priority or Manual mode, and when selecting your shutter speed you need to consider what kind of result you're looking for. With an exposure of 3 seconds, for example, you will produce an image dominated by the zoom effect, which is good for abstract photos of perhaps a zoomed neon light. A faster shutter speed is more likely to reveal some of the scene, while the other extreme—an exposure of 20 seconds or more—will allow you to zoom out for part of the exposure, and then expose for a normal long exposure for the remainder of the exposure, allowing you to show the "sharp" scene as well as the zoom burst. This can give something such as an apartment building a much more dynamic look.

Another important factor is your location and choice of subject. A building that is isolated from other buildings is usually a good choice, as this means only light from the subject gets spread across the frame, filling the empty space that appears around it as you zoom. If the background is a night sky, then light trails from lit areas of your subject will appear over the otherwise black sky.

Zooming in

Starting from the wide point and zooming in is the other way to produce a zoom burst effect. When using this you'll need to aim your camera directly at your subject, as everything around the subject will be blurred when you zoom. The subject will be focused better still with a little sunlight on it, or some flash. The aim is to zoom into the subject in a smooth motion and with minimal camera shake, so it's even more vital to use a monopod or tripod to reduce camera shake. A shutter speed of 1/4–1 sec often works well.

A good subject for this type of shot is a person's head, or perhaps a lone building, but you can be creative: I've used this technique to shoot directly down a subway carriage. The best shots will be those in which any trails from bright lights in your scene do not encroach on the central subject. Zooming in to the exact center guarantees that the highlights are pushed outward, but there are no hard and fast rules. Rather than try and plan your zoom bursts precisely, enjoy it and make good use of the instant playback on your camera to get the result you are after.

Resisting the zoom

You might want an object in the foreground not to be affected by the zoom. If there is strong backlight, and it's artistically acceptable to you, then you can expose your shot so that the subject appears as a silhouette. This can look great, but it's not your only option. If retaining detail is important, another choice is to use one or more

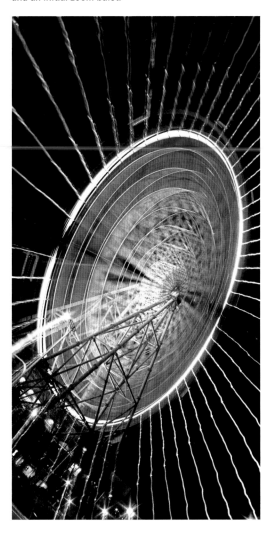

ZOOMING OUT ON A FERRIS WHEEL
A good object for a zoom burst is a circular-shaped object that has lights attached. This Ferris wheel in Osaka was taken with a 30-second exposure, and an initial zoom burst.

strobes to light the foreground. By default, cameras fire the flash at the start of the exposure (first-curtain sync), but many allow you to switch to the end of the exposure (rear- or second-curtain sync). The flash fires so briefly that it will freeze and light anything close to the camera, but not the background.

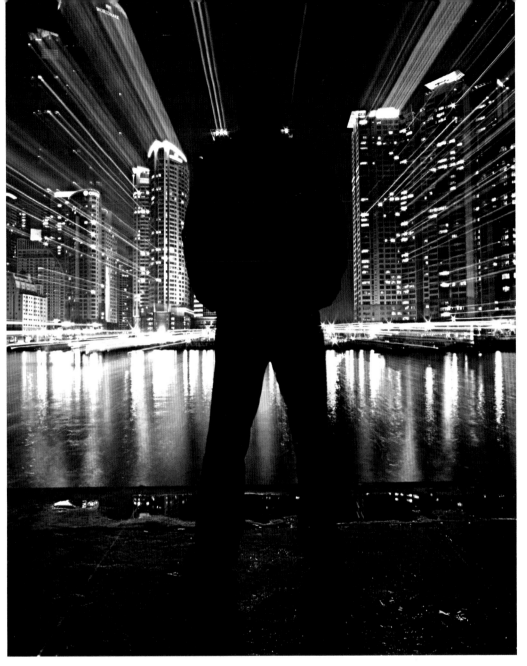

ZOOMING AND PRODUCING DEFINED OBJECTS

The focal point of this image is a friend of mine, whom I asked to stay still for the duration of the exposure. The lights from the apartments in the background focus the eye on the silhouette, and give the photo a dynamic feel. This exposure was 30 seconds long and I spent about 5 seconds zooming out. The remaining exposure was made with a fixed focal length.

ABSTRACT LIGHT PAINTINGS

Zooming can be used to create color abstract images. The trick is to choose the central point of the photo carefully, so the light spreads out as you want it to.

Equipment

• Camera lens with a manual zoom (such as those typically found on SLR lenses).

• While not essential, a tripod will reduce the risk of failure.

Note

• This technique is not possible on cameras with motorized zoom lenses, such as those found on digital compacts.

Silhouettes

A silhouette is a dark-shaped object within a frame that is produced when you shoot toward the light. Control of the exposure is important if you want to produce a silhouette: you need to take your exposure reading from the background, not the subject, and you may also want to set the exposure level about 1 stop darker than the meter reading.

The next consideration is your point of view. Most often (although not always), you will want to get below the subject so you are shooting upward. This will prevent the horizon line cutting across the silhouette in an awkward place. When the ground is producing strong backlight through some form of reflection, you can shoot downward and create a silhouette—water or a wet street will both reflect a lot of sunlight.

The subject of a silhouette can really be anything, but silhouettes work best when the subject can be readily identified by their outline. Silhouettes of people usually work well, but it's often the case that you will only want one strong silhouette, rather than multiple in an image: a single silhouette is often much clearer. In addition, don't discount elements such as tree branches, which can frame a silhouette or provide a textured background.

The time of day is important for this type of photography, with the best time usually around sunset/dusk when the sun is low in the sky. At sunset you can also work with strong oranges and reds, although you will be able to use the blue sky as a background if you shoot during the day. Another option for creating silhouettes is to use a strobe behind your subject, although you will need to think carefully about how you will hide the strobe and trigger it.

The final consideration is the location. In general, you want to have a clear, uncluttered background, and a beach, the brow of a hill, or a riverbank, where there is sunlight reflecting off the water are all examples of good locations.

SUNSET SILHOUETTES

Taking photos of silhouettes at sunset can create striking images.

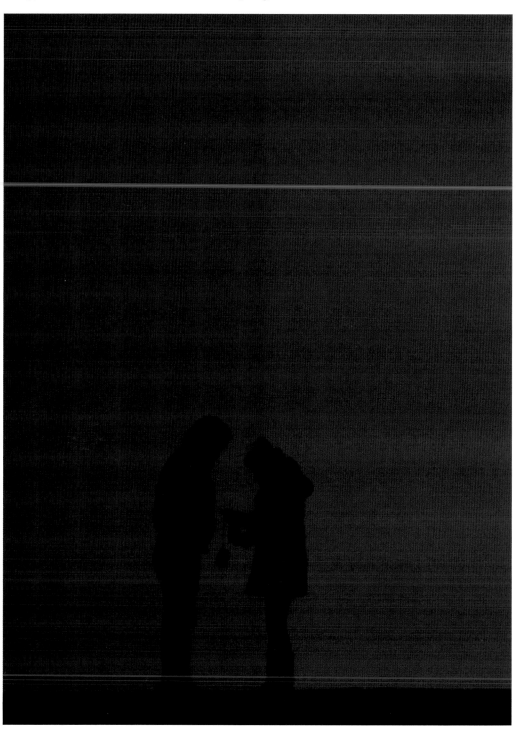

SILHOUETTE USING THE REFLECTING LIGHT

AIMING SKYWARDS

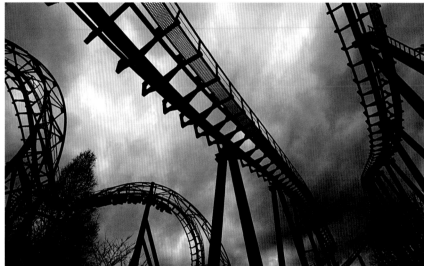

Shooting up at the sky with this rollercoaster ride overhead was an obvious opportunity to capture a silhouette. The sky had an ominous feel so I exposed for the clouds, silhouetting the rollercoaster easily.

LAYERED SILHOUETTES OF MOUNTAINS

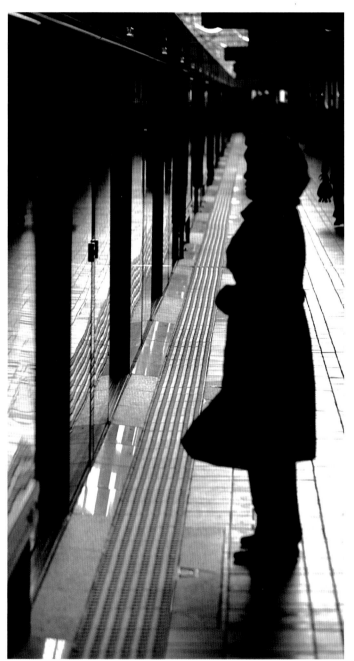

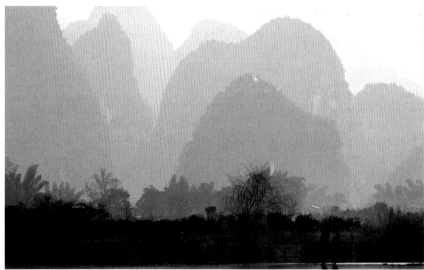

In this image, the light reflecting on the platform at a station was creating strong silhouettes, but I needed to shoot from a high angle—this photograph was taken standing on tiptoes!

On occasions when the light is right, hills and mountains can create a layered silhouette effect. In this shot the people are silhouetted also, as the background is lighter than they are.

Long exposures

A long exposure is when you keep the shutter open for an extended period of time, usually somewhere in the range of 1/2 sec or more—perhaps even several minutes. Long exposures can be a lot of fun and can produce some stunning results, as the images you record are very different to the scene you see with your eyes.

At the faster end of the long exposure range (1/2–1 sec), the aim is often to introduce slight blur to the subject, but still retain some detail. However, with longer exposure times you're going to be completely blurring anything that is not stationary, and producing "light streams" with objects that have light shining on them.

It goes without saying that for photos involving long exposure times you are going to need to keep the camera steady, either by placing it on a flat surface such as a wall or the ground, or by using a tripod. A tripod is preferable as you can position the camera more accurately.

Another consideration is the amount of light in your scene. At night this is not going to be much of a problem (low light levels naturally result in long exposure times), but during the day it is likely to result in overexposure, unless you use neutral density (ND) filters to reduce the amount of light coming through the lens.

A final suggestion is to use an external shutter release or your camera's self-timer to trigger the shutter—simply pressing the shutter-release button with your finger could cause slight camera shake. In addition, if you're using a digital SLR, use its mirror lock-up feature (if it has it) to stop the camera shaking when the mirror flips out of the way of the sensor.

DYNAMIC VERSUS STATIONARY

I noticed cars would wait at this junction, so I aimed to make a long exposure with one stationary car. The resulting contrast between the dynamic movement and the static vehicle is what makes this shot.

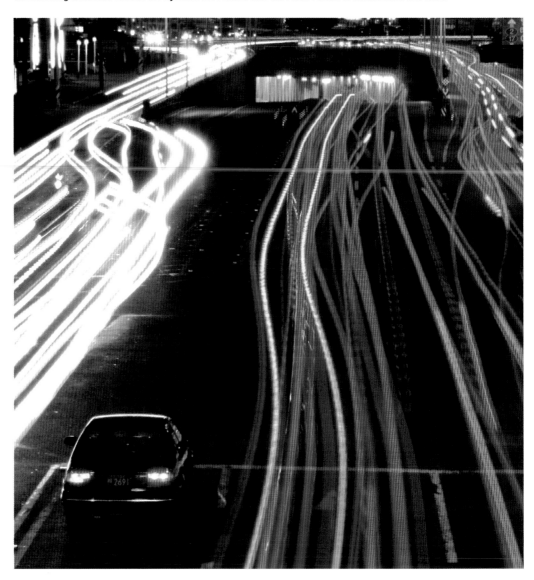

Equipment required

• Camera with shutter speed control.

• Tripod.

• External shutter release.

STAR TRAILS

This star-trail photograph was taken on a beach in Indonesia with a 17-minute exposure!

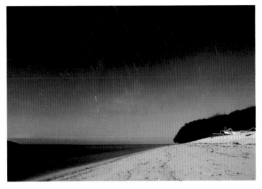

DAYTIME TRAFFIC

Cherry blossom is always picturesque, but with this shot a 1.6-second exposure has captured the movement of the cars.

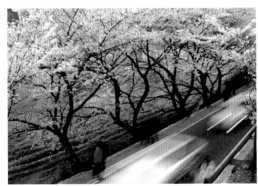

CAPTURING THE MOVEMENT OF A CROWD

This busy market street in Taiwan was a conveyor belt of people. A long exposure was used to capture this movement.

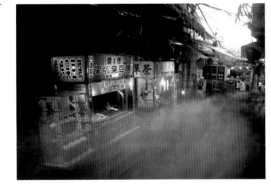

TURN WATER INTO SILK

Daytime long exposures will likely require an ND filter to achieve a slow shutter speed. Here, a long exposure of moving water has given it a silky appearance.

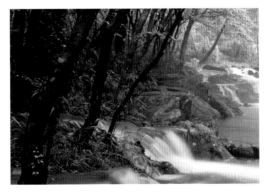

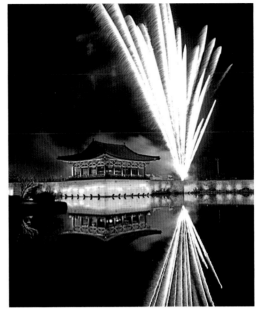

FIREWORK LIGHT TRAILS

This photo was all about knowing where the fireworks would be set off from, and then anticipating when they would fire. The exposure was 3.2 seconds at ƒ/9.

Types of long exposure

Motion blur: This type of exposure uses a shutter speed of 1/2–1 second. The aim is to capture movement in your subject, but without it becoming unrecognizable. This type of shot can work well with moving people, or perhaps moving cars.

Daytime long exposures: The first time most people try long exposures is at night, but if you get a strong ND filter then you can try daytime long exposures as well. To get interesting results, photograph subjects that include moving elements, such as flowing water or clouds.

Fireworks: Firework photography is a lot of fun, and it isn't difficult. The trick is choosing the right location, and anticipating when the fireworks will be launched. Focus your camera on an object in the distance, and then set it to manual focus to "lock" the focus. An exposure in the region of 1–2 seconds with an aperture of ƒ/8 is a good starting point.

Light streams: This is usually a long exposure of car light trails, although another example is a fairground ride. Exposure times of 5 seconds or more are typical when taking this type of shot.

Star trails: There are two ways of recording star trails. The first is to make one very long exposure of 20 minutes or more, or you can take lots of 30-second exposures and merge them in post-processing.

Point of view

Your viewpoint when you take a photograph can often transform an everyday scene into something altogether more eye-catching. The three key things that can affect the point of view are: the focal length of your lens, the angle you take the shot from, and your height in relation to your subject.

Focal length

Photographers can dramatically change the type of picture they produce by changing the focal length of the lens. This change is also called changing the field of view. A telephoto lens of 100mm or longer will appear to compress your shots, while using a wide-angle lens will reveal a lot more of the scene. This is an important consideration when choosing the point of view of your photographs, as a different field of view may restrict the number of angles you can shoot from.

Angle

It goes without saying that you can take photos from any number of angles, whether it's looking down at your feet or craning your neck and looking straight up. However, the angle can be divided into three broad sections: looking down, looking ahead, and looking up.

Photographs that are taken when you're looking down are most likely going to be shot from a high vantage point such as a tall building, a hill, or perhaps even an airplane. You don't have to be really high to use this "top down" perspective—just so long as you're higher than your subject.

The most common angle you will shoot at is straight ahead, which is the way we normally see the world. What might make this angle more dramatic is your height in relation to your subject.

Looking up is the final angle, and the one that you're most likely to miss if you're not properly exploring an area. The reason I say this is because, while we often look ahead and down, it is less common for people to look straight up. There are times where this angle can be very effective though, such as when using a wide-angle lens between tall buildings, or getting down on the ground to shoot a flower.

Height

As well as the angle you're shooting at, the height of your camera is also going to have a bearing on your point of view. It can sometimes be good to take photos from a very low position, and while you might lose a bit of dignity crawling around on all fours, you could get a great shot. If you're going to be taking photos at ground level, having an angle-finder on your camera is a good idea, as it will enable you to use the viewfinder. A low height is often needed when taking photos of reflections, as the closer you get to the reflecting surface the better your reflection is going to be.

Conversely, you may well find that getting high up will give you a much better vantage point for a shot. If it's possible, going to the top of a tall building in a city, especially at night, can get you some great results. If you're a hiker, then climbing mountains may also be a way of taking photos from a higher vantage point.

THE OVERHEAD VIEW

This is not an angle commonly seen at a wedding, which makes this shot all the more striking.

GETTING LOW TO THE GROUND

The camera was positioned low to the ground for this tropical beach scene.

GETTING UNDERNEATH YOUR SUBJECT

Looking straight up at these lanterns gave strong lines to the image. Introducing refraction provided an extra twist.

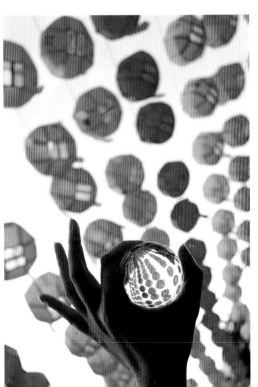

SPIRAL STAIRCASE

Shooting straight up (or straight down) at a spiral staircase is a tried and trusted technique.

THE FISHEYE POINT OF VIEW

Using a fisheye lens can produce dramatic results, but care must be taken as it will distort objects at the edge of the image. This photo was taken looking straight up, using the wall to frame the statue.

COMPRESSION OF THE SUBJECT

This photo was taken looking straight ahead. A 220mm focal length appears to compress the cars.

Lines

Lines are an important design element in photography that cannot be dismissed. Lines have the potential to ground your photo with a solid composition, but they can also be used to give your image a dynamic edge. There are several ways in which lines can appear in a photo, and there are some rules that you should apply to the position of those lines.

Leading lines

Leading lines will typically run through your photo and lead the eye to the main subject, hence their name. It goes without saying that leading lines will give an image much more impact. Leading lines can be any one of a number of things, such as tree lines, a fence, or roads. If you're taking a portrait, it can sometimes be a good idea to position your subject so that the lines lead directly to them.

The rule of thirds

This is one of photography's golden rules, which of course means that you should learn it and then break it! Good application of this rule can produce naturally balanced images, so it is worth learning. The rule is that you should divide your frame into three (imaginary) sections, both horizontally and vertically. The lines are great for positioning elements of a shot, such as the horizon in a landscape, or the side of a building, for example, while the point at which any of the lines intersect is the perfect position for a key subject or detail.

Infinity points

These are points that lead off into the distance of a scene, seemingly forever. The relationship between leading lines and infinity points is often a very strong one, and this can be used to great effect. A place to find an infinity point might be a subway tunnel or a tree-lined path in a forest. It is usually a good idea to position your subject at the apex of the infinity point to add to the effect.

Lines as design elements

Lines can also form strong design elements in a photograph and, as I will discuss on the following pages, they can make nice patterns. Lines can be straight, curved, or circular—all of which will form nice shapes in your image. A good example of where you might see graphic lines is a street crossing or the lines of crops in a field.

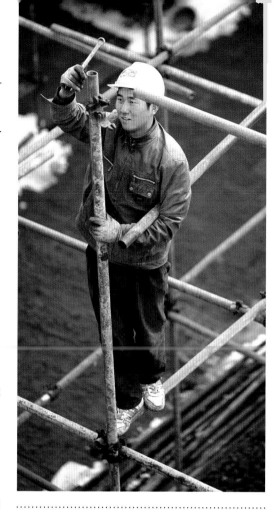

SCAFFOLDING LINES
The lines in the scaffolding surround the laborer, and they all point toward him as well. This gives the photograph a graphic quality.

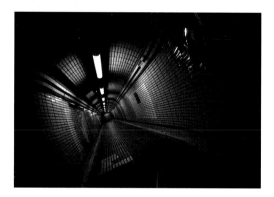

TUNNEL
Tunnels and photography are a marriage made in heaven. Here the lines all lead off into "infinity."

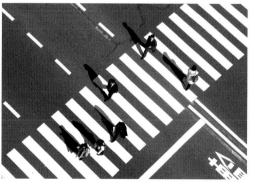

PEDESTRIAN CROSSING
The lines along the road and the lines the people are walking on give this shot a very graphic feel.

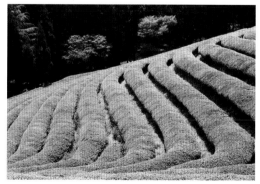

A TEA FIELD
The lines provided by the bushes in this tea field are a great design element.

THE RULE OF THIRDS

This is an example of using the rule of thirds to compose a shot. In addition to the trees, beach, and sea, there are numerous other lines running through the picture as well.

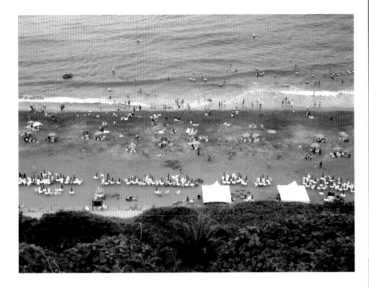

RICE PADDY FIELDS

LINES THAT LEAD THE EYE

All of the lines in this image take us toward the man walking off in the distance—they're not called leading lines for nothing!

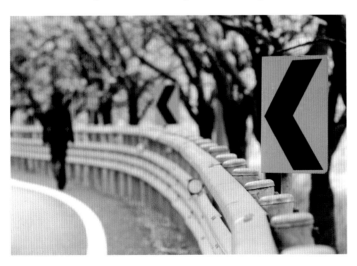

The lines in this rice paddy field lead up to the houses in the distance.

Patterns

Patterns can form an important part of the design of a photograph, and in some cases they can become the subject in their own right. There are patterns all around us in the world, both natural and man-made. These patterns could be in the form of lines, circles, textures, or anything else that has a repeating pattern.

The first thing a pattern can be used for is to make a textured photograph that can be used as a background for something else. This type of image is literally everywhere you look: brick walls, pipes, shells, seeds, pebbles, or even the pavement containing a repeating pattern. Repeat patterns can make a great backdrop for a portrait, allowing you to contrast your subject with the pattern so that they stand out. Something as simple as a brick wall or a leaf background is all you need.

Another way of utilizing a pattern is to break it in some way. For example, having a single square within lots of circles will draw the eye to the square and give it real impact. This type of pattern breaking could be through color contrast (see page 86), as well as shape.

You can also use pattern to create a stronger contrast, where there is a clear divide in a photograph between one type of pattern and another: the divide between a wall and the pavement, for example.

A FOCAL POINT IN THE PATTERN
Lines in the sand can produce great patterns. In this case the pattern is broken by a single piece of vegetation.

PEBBLES MAKE GREAT TEXTURE

The pebbles on a beach can form an interesting texture. Although they are not all the same, the overall effect is a type of pattern.

MAN-MADE PATTERNS

In this photo a circular pattern has been formed by a chain. The eye is drawn to the center of the image.

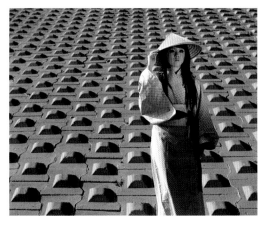

FEEDING THE MASSES

This pattern was produced by concrete blocks that run underneath a bridge. It provides a strong backdrop for this portrait.

LINES OF LETTERBOXES

The letterboxes in this photo provide a uniform pattern, which is interrupted by the one that is open slightly.

CONTRASTING PATTERNS

This image has two distinct patterns: the roof at the lower left and the lanterns at the upper right. This produces a contrast in patterns.

Cropping

Some people say that cropping is essential if you want to turn a good photo into a great one, while others insist that if you need to crop an image then you have failed as a photographer. These are both extremes when discussing the merits of cropping and are, in a way, correct: there are times when cropping is the only way to get the image you want, and there are also times it should be avoided.

Cropping is a post-processing technique, so it is something you will usually do once you get home and your images are on your computer. There are times when cropping a picture can be very handy, and in the publishing world the ability to crop an image to suit a layout is essential. It's for this reason that photojournalists will deliberately leave space around their subject frame to allow an editor to crop their photo as they might see fit.

Personally, I believe that you should get the shot right in-camera as often as possible. However, I will not hesitate to crop an image if my maximum focal length doesn't reach as far as I would like—in this case I'll simply crop the image in post-processing to "zoom in" a bit closer. I will also crop when I want to create a specific shape, such as a panoramic or square image. A lot of people like the feel of these classic formats, and while there are cameras that specifically allow you to take these types of image, if yours does not, you will need to crop.

Finally, there are times when you might make a little mistake, such as including a distracting element at the edge of the frame, or perhaps someone walked into your frame as you fired the shutter. If this happens, and the rest of the shot is good, then cropping is a great solution. There may also be times when you see a "photo within a photo." If this is the case, you have to question why you didn't perhaps take that photo at the time, but cropping can still be used to extract that image from your original shot.

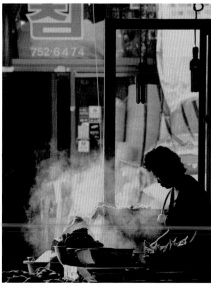

THE AJUMA

This street photo of a South Korean lady (or ajuma), works better when it is cropped square. The square crop allows the subject to dominate the scene a little more, and removes distracting elements from the top and bottom of the image.

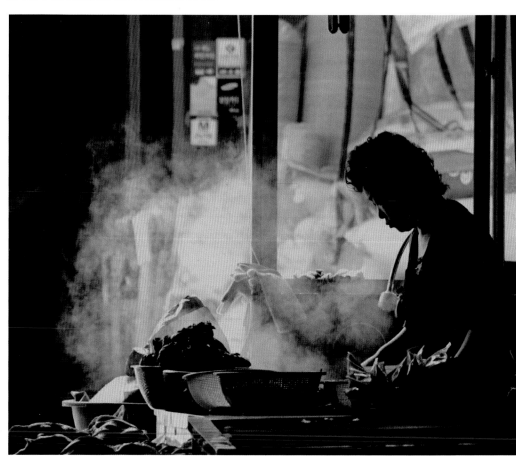

THE FISHING PORT

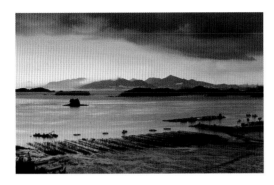

This photo was taken on a trip to Namhae Island in South Korea, but it works better as a panoramic landscape. Cropping it in this way has removed a few distracting trees at the bottom.

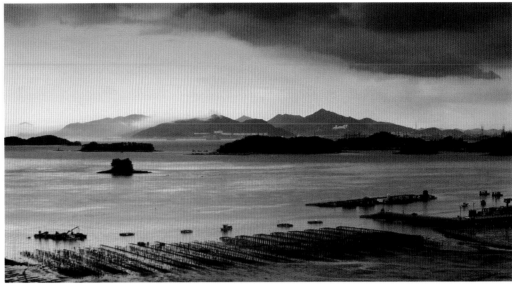

INFRARED TREES

The long shadows from the morning sunshine were impossible to avoid when I took this shot, which meant cropping in post-processing.

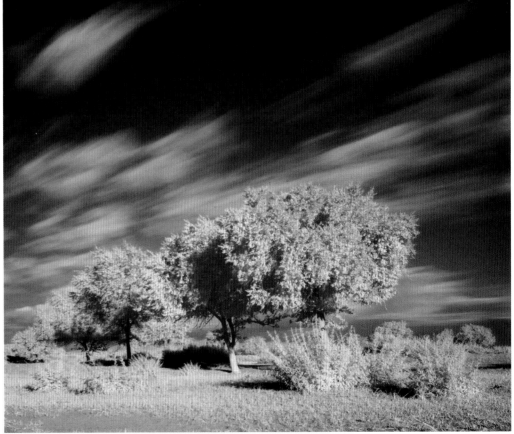

Bokeh

Bokeh is a Japanese word that refers to the out-of-focus areas of a photograph, and it's something that can be used in an artistic fashion. Unlike some of the previous techniques, such as lines and patterns, bokeh is produced by using the correct camera settings, so let's take a look at how it's done and when you might want to use it.

Bokeh is produced when you use a lens with a wide aperture to produce a shallow depth of field, so the background (and sometimes the foreground) is thrown out of focus. When you are looking to incorporate bokeh in an image you will need to be shooting at an aperture of at least f/4 (and ideally wider) to produce the required shallow depth of field—the wider the aperture, the more pronounced the bokeh effect. It is also usually important to get close to your subject, and to have a reasonable subject-to-background distance as well.

The most beautiful bokeh can be achieved when shooting toward a light source such as streetlighting or neon lights (but not the sun!), or light reflecting off a surface such as wet leaves or water. When the light is out-of-focus it can make attractive bokeh, and this can often be used as a background to a photograph.

Once you have a feel for making bokeh, you might want to consider trying shaped bokeh, which can be a lot of fun, and is simple to do. The first step is to make a "lens hood" out of black card, and then decide what shape you'd like the bokeh to be. Cut this shape out of a circle of card and mount this in your lens hood—your bokeh will take on the appearance of your cut-out shape.

BUDDHA BOKEH

To produce this image a macro lens has been used to photograph a glass ball. The background has been blurred, and due to the curvature of the glass, parts of the image inside the ball are also in bokeh. This effect isolates the line of Buddha statues in the photo.

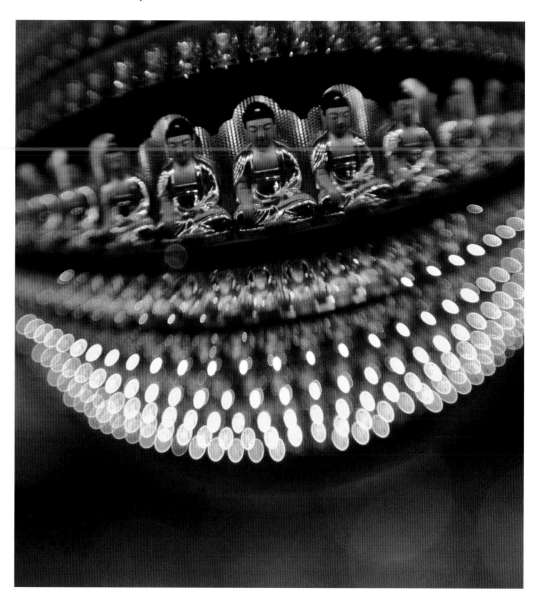

MEANING IN THE MIST

This is a more abstract use of bokeh, as the background is blurred completely.

MAKING SHAPES WITH BOKEH

If you want to be really creative you can use shaped bokeh. In this photo the bokeh has been made into a heart by cutting the intended bokeh shape out of a disc of card that is fitted to a hood in front of the lens.

Minimalism

Some people say that photography is based on the art of subtraction; the careful selection and arrangement of elements in a scene so the viewer can concentrate on the message the photographer wishes to communicate. If this is really the case, then minimalism is photography in its purest form, and if you can crack minimalism as a technique you won't go far wrong as a photographer!

Minimalism is all about creating a simple photograph, often with a subject that is surrounded by lots of "negative space." There are certain places that lend themselves naturally to minimalism—a desert, for example, is already a very sparse environment—but if you're living in a claustrophobic city you may find that minimalist images are a challenge at first. However, it's easier than you might imagine, and there are several techniques that you can use to help you.

Depth of field

Using a shallow depth of field is a great way of creating a minimal image, as it will allow you to throw the background out of focus. Simply position your subject at a distance from the background and use a wide aperture setting on your lens—depth of field will do the rest and

conceal a whole host of potentially distracting background details.

Focal length

You can use any focal length to create a minimal photograph, but the way in which you use it will vary. If you're going to use a wide focal length, for example, then the chances are you'll need to use something expansive, such as a wall or the sky, as the negative space around your subject. However, if you're in a more crowded environment, you may find it is hard to avoid distracting elements in the scene. In this case, you may find that using a longer focal length helps.

Light

If you get a situation where your subject is lit by sunlight (or flash), but both the foreground and background are dark, you can use this to create a minimalist composition. In the case of sunlight you'll be looking for a strip of light filtering between buildings or through a window or door, while you can use a snoot on a flash to direct the light in a similar way. If you expose for your subject, everything else should be black, providing you with a minimalist, high-contrast photograph.

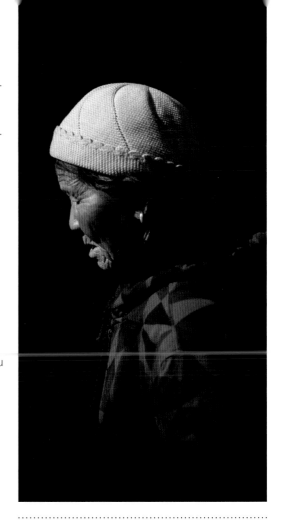

NATURAL LIGHT

In this photo a shaft of light has been used to illuminate the woman. The rest of the photo is underexposed by 2 stops, turning the background black and giving this environmental portrait a minimalist edge.

A SNOOTED STROBE

A snoot is something you put over a strobe (flash) to direct the light onto a specific area of the scene. In effect, it creates a shard of light. This can be used to light things in a minimalist way, as is the case with this photograph of smoke from an incense stick.

WIDE-ANGLE MINIMALISM

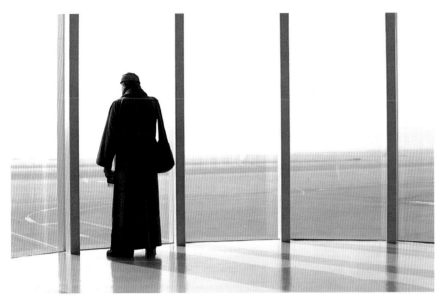

Modern buildings such as airports often have clean lines that lend themselves well to minimalism. Here a monk looks through the window at the airport, prior to boarding a plane.

BOKEH BACKGROUND

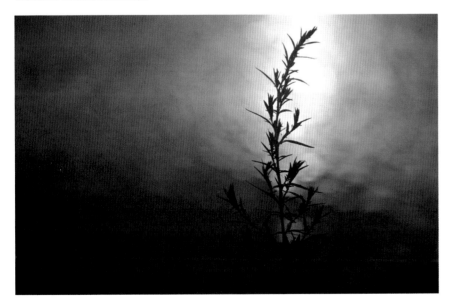

Here a shallow depth of field has been used to isolate the subject from the background. The subject has also been silhouetted against the light to draw the eye even more to its edge.

HORIZON LINE

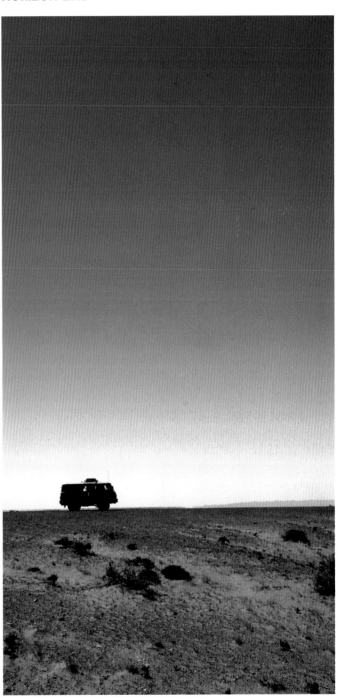

A clear blue sky and desert location provide the minimalist feel for this shot.

Reflections

Reflection photographs can be real winners, but they don't have to be a double image—they can sometimes fill the whole frame to produce an abstract image. There are also photos that use a smaller reflection which perhaps tell a story in the image. Any reflective surface can be used to take reflection photos. Perhaps the most obvious surface is a mirror, although shiny metal, flat water, sunglasses, or glass can also work well.

Angle of Incidence Angle of Reflection

Equals

Incident Ray Reflected Ray

Plane Mirror

Point of view

When you're taking reflection photos your viewpoint is going to be very important, and will differ depending on the reflective surface you are using—when you're taking photographs of reflections on water, for example, you will often need to get low to the ground, unless you want to take a reflection of the sky. This is due to the angle of the incident light rays hitting the reflective surface, which is going to be at a low angle if you want to take a photo of a building or a mountain reflected in water. As you'll be low to the ground, an angle-finder can be a real benefit for this type of shot. The other thing that can help is a polarizing filter, which will really enhance the reflection.

When you are taking photographs using other reflective surfaces, the incident light is likely to be more direct, so you will not need to have quite such a low angle to take your shots. This type of reflection could be from a surface such as a window or a car bonnet, for example, but because the angle of incidence is more direct, you need to be careful that you're not reflected in the photo as well—unless, of course, you're taking a self-portrait!

Light

The time of day is important when taking reflection photos. Typically, you'll want to be shooting when the sun is fairly low in the sky, but taking photos at night can also produce stunning results, as the lights from buildings and streetlights will reflect strongly in metal and glass. You need to consider whether you want to have the light behind you or in front of you—both situations have benefits. If the light is behind you, then your subject is going to be well lit, and the reflected image may even appear as strong as the scene itself. When the light is behind you though, your reflected subject may well appear in silhouette when it is reflected.

WHAT CAUSES YOU TO REFLECT?

The clear plastic safety barrier at the edge of the subway track made this reflection. In order to get the best reflected image I needed to get as close to the barrier as possible.

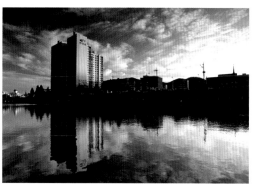

GET CLOSE TO THE ANGLE OF REFLECTION

To capture this reflection it was necessary for me to get close to the riverbank, and then close to the surface of the water. The evening light lit the apartment building on the opposite side of the river perfectly.

RIPPLES CAN PRODUCE ABSTRACT REFLECTION

In this shot there is no "real" image, just the reflection. A stone was thrown into the water to produce the ripples and add to the abstract feel.

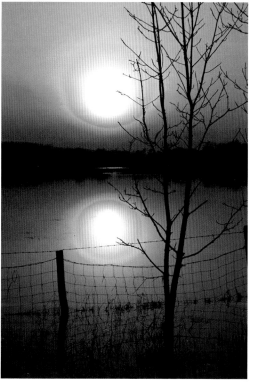

SUNSET REFLECTION

A reflection of the sunset on water is a common shot, and for good reason—it always looks good. The silhouettes of the tree and fence add to the composition.

Infrared

Infrared (IR) photography has been around for a long time. With film, it was simply a case of buying film designed specifically for infrared photography and using a special filter over the lens, but a few things have changed with digital capture. The first thing to understand is that the human eye can't actually see infrared light, which begins at a wavelength of 700nm and continues to 900nm, and the same applies to digital cameras. In fact, digital cameras have a filter fitted in front of the sensor to reduce the amount of infrared light that is recorded by the sensor. This means you'll either have to adapt the camera for infrared use by having this filter removed and an IR filter added, or you'll need to use an IR filter over the lens, although this may not be very effective. It should be noted that an infrared effect can also be applied in post-processing, but here we will concentrate on in-camera infrared techniques.

Adapting the camera

There are a number of specialists who can adapt your digital SLR camera for infrared photography, but it is very important to realize that the process is costly and the camera will only be suited to infrared photography—the manufacturers fit the IR blocking filter for a reason! The advantage of adapting your camera is that you will not need to use long exposures to take IR photos and lenses that produce a hotspot when using a filter will

not do so with an adapted camera. The ability to take long exposures is also still possible, of course, and you'll need to use an ND filter to achieve this kind of effect.

Filters for infrared photography

There are a selection of filters for IR photography, and they will filter light of a specific wavelength: Hoya's R72 filter is designed to filter light at 720nm, for example. Most IR filters will appear opaque to the eye, blocking visible light, but they transmit the IR light that we cannot see. As the camera sensor will only see a small amount of light due to the filter, this means exposures can often last for minutes, so you'll need to use a tripod. You'll also need to compose your photo first, then add the filter, and finally you have to switch to manual focus or the camera will lose the focus point.

The final result

After all of the effort involved in making an IR exposure, you will most likely end up with a red/brown picture that will look very different to the IR photos you may have seen on the Internet or elsewhere. This is fixed by converting the image to black and white in post-processing, and then possibly toning the image. There are numerous ways in which this can be done, and we will look at black-and-white conversion in Chapter 5.

THE OLD TOWN OF JAKARTA

This photo, taken in the old town of Jakarta, uses infrared to add a nostalgic feel to the image.

Tip

Because IR light is filtered out—in part, or in its entirety—by most cameras, the results you will get from simply fitting an IR filter will vary considerably: some cameras will record IR light, but others will not. It's a good idea to do some online research before you invest in an IR filter, just to be sure that your camera will work.

THE OBSERVATORY IN GYEONGJU

This observatory was one of the first to be used in Asia. The infrared treatment, combined with a long exposure, give this photograph an otherworldly look.

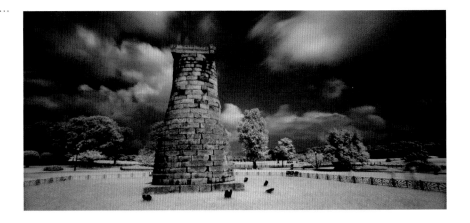

TEMPLE

These three images show the same scene shot in color; in infrared before processing; and the final, processed image.

Color contrast

Color harmony and color contrast are as important in photography as they are in design, or any other creative area that uses color. Just as black and white contrast with each other, so too do certain colors—common examples are yellow and purple, red and green, and red and blue. Used well, these color combinations can really make an image pop.

The impact of color contrast on your photos can be affected by several factors—it will be diminished if there are other colors in the shot, for example. You will also find that color contrast has less impact when the amount of the contrasting colors is roughly equal and the colors are spread throughout the image: a small amount of one of the contrasting colors will have its contrast enhanced next to a larger area of the other color. Images that have a clear dividing line between the contrasting colors also appear stronger.

Finding color contrast

Color contrast can be found in many places, both natural and artificial. Sometimes you might even need to make your own. If you are looking for blues and greens, then they are not hard to find at all—the sky, water, green grass, and leaves are all found quite readily. To contrast with this you need to find warmer colors: yellows, oranges, and reds. Flowers are a great option here, and yellow flowers contrasting against the blue sky always look good, especially when they're combined with a low, "worm's-eye" viewpoint.

BLUE BUTTERFLY

This blue butterfly has been isolated against a yellow background. A shallow depth of field has been used to further focus the eye on the butterfly.

COLOR CONTRASTS

Just as monotone has contrast between black and white, there are also contrasts between colors. This wheel shows how the warmer colors of yellow, orange, and red contrast with the colder colors of blue, green, and purple.

INDONESIAN STREET

The strong contrast between the blue food stall and the red wall grabs the eye in this shot. On closer inspection you can see that the stools the men are sitting on are also red and blue.

LOTUS FLOWER BUD

FILM

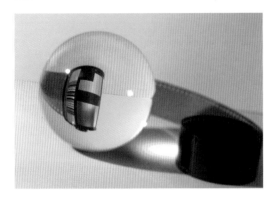

The blue/yellow color contrast in this shot has been created artificially by using some blue and yellow card. Including the glass ball to refract these colors gives the image a nice twist.

EGG PLANTS

This photograph demonstrates the use of green/purple color contrast. A strong diagonal line has been used to divide the image, and a few vegetables of the opposing color are on the opposite side of the divide.

The blue/pink color contrast is enhanced by the minimalist feel, and the gradation of blue from top to bottom.

Street photography

Street photography is many people's favorite form of photography, and when it's done well it can produce fantastic results. For some people, street photography is photography at its purest, because the best images are invariably about a precise moment in time that captures a mood and tells a story, with no second chance if you get it wrong.

Telephoto versus wide-angle

In photography there is a mantra that if a photograph isn't good enough, you were not close enough—a quote credited to Robert Capa. There are two ways you can get closer to your subject: use your legs to move physically closer (as Capa was intimating) or use a longer focal length to bring your subject nearer.

Using a telephoto lens has several appealing traits: you won't be intruding on your subject, and therefore you'll have a better chance of getting a "natural" shot, and you'll also compress the scene through the use of a telephoto lens, which could help cut out distracting elements in the background.

With a wider lens you'll need to be much closer to your subject, but because your field of view is wider, you will find that it is easier to tell the story and gain a greater context in terms of the subject's surroundings. The downside is that with so many elements in the frame it can be harder to compose a good photograph and the chances are that your subject will know you are taking their picture. However, in some ways this is a more "honest" way of working, as it allows your subject to say no if they would prefer not to be photographed.

Ultimately, though, it is the result—and not the equipment you use—that really matters.

Asking permission

If you're taking photos of people, then asking for their permission is often a good idea. Building up a rapport—no matter how slight—will go a long way, as a person who is relaxed will look better in your photograph. On the flip side of the coin the decisive moment is precisely that—a moment—and asking permission can mean that you lose any spontaneity. So this is really going to come down to your own judgment and what it is you are hoping to achieve: getting your subject's permission will help if you want your shots to be posed, or at least a little more "controlled."

Isolating your subject

One of the tricks with street photography is finding a balance between establishing the context, and creating an image that is not overly cluttered. A lot of the other techniques discussed previously can be used to get the correct balance. A shallow depth of field will help isolate your subject from its background, for example, or you could use light to help the subject stand out from a darker background. You could also make use of leading lines to draw the viewer to the subject, and this is another reason why people think of street photography as photography at it's purest—you have to combine multiple techniques simultaneously, while relying on a single shot to capture a decisive moment.

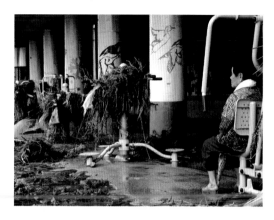

BETTER DAYS

This photo was taken during the rainy season in South Korea, and this is the aftermath of the river bursting its banks. In this case the photo was taken without the women knowing—I wanted to capture the mood of the scene without having an unnatural posed smile.

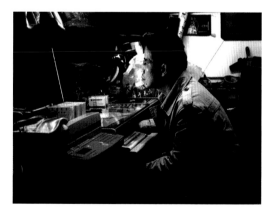

HARD AT WORK

In this photo the available light from a computer screen is lighting the face of the man in the photo. The rest of the lighting in the image is moody, with various objects bringing context to the scene.

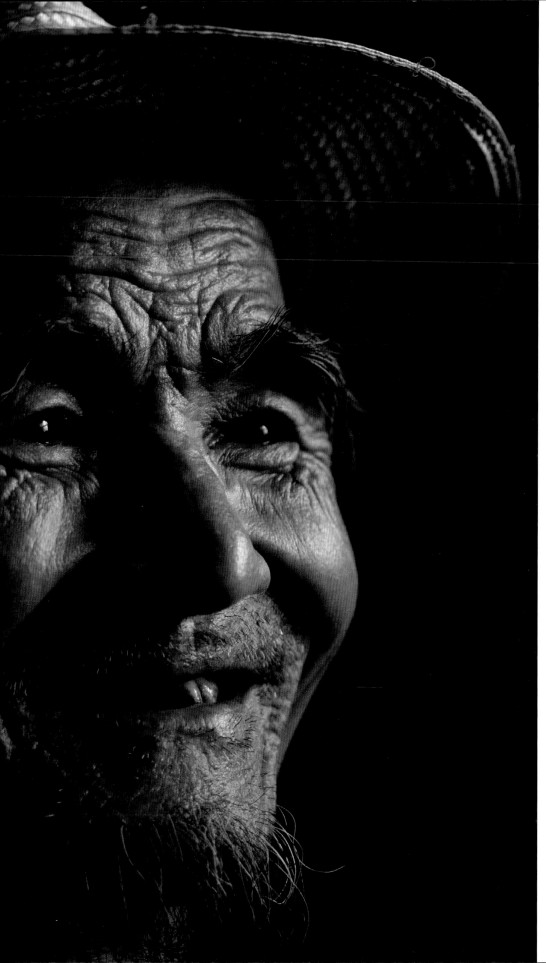

SMILE AND THE WORLD SMILES WITH YOU

For this photograph I needed to get permission from the man to take his picture. Although we couldn't speak each other's language, gestures and nods sufficed, and I used more gestures to direct him to look away from the camera and toward the window light that I wanted to use. Without his permission, this shot would not have happened.

THE GUARD

As can be seen from the eye contact, the subject of this photograph knows his picture is being taken. In this case, the man wanted a little compensation to have his photo taken, although he is far from being a professional model!

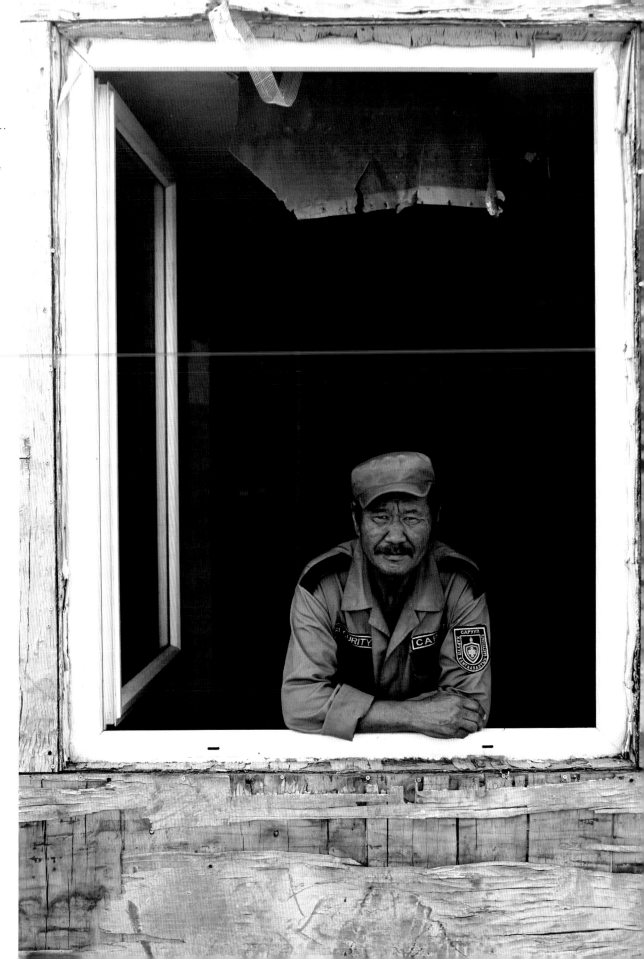

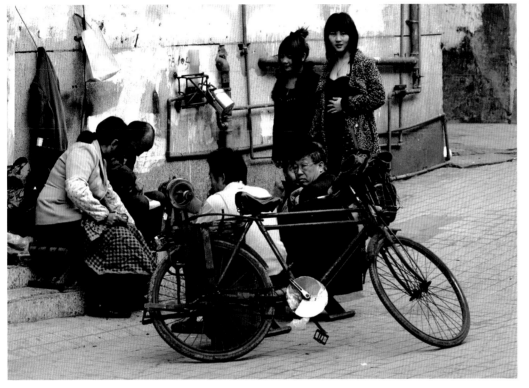

STREET COMMUNITY

Context and storytelling are important elements of good street photography. In this image, the group of people interact with each other, apparently shielded from the world by the bicycle in front of them.

THE APPLE CART

The use of a wide-angle lens or focal length is great for providing context, but care must be taken that the photograph is well-composed and not too busy. Here, the woman pushing her apple cart gives the viewer a clear focal point, bringing the frame together.

HDR imaging

Have you ever admired a beautiful sunset, only to photograph it and have the colors in the sky bleach out and the foreground appear so underexposed that it's almost black? In this situation, and similar high-contrast scenes, trying to adjust the exposure for one area will only make the other worse: you can either retain detail in your highlights, but have blocked-up shadows, or allow the brightest areas to turn white in order to keep definition in the darker tones. The reason for this is the difference in brightness between the lightest and darkest areas (the dynamic range) of the scene exceeds the dynamic range of your camera's sensor. In short, the camera cannot capture the full brightness range with a single exposure.

However, there is a way in which this can be resolved: HDR imaging. HDR, or "high dynamic range," imaging relies on several exposures being made of the same scene using different exposure values, so you have one shot that has detail in the brightest areas and another that reveals detail in the deepest shadows, with one or more exposures in between. These are then combined using HDR software and processed to create a single image that reveals the scene's full dynamic range, regardless of how extreme it was.

Shooting for HDR

In order to make an HDR image you will need to shoot a sequence of photos of the same scene. Some photographers will shoot only three frames, while others will shoot five, seven, or even more. The actual number is less important than making sure that the sequence records the full tonal range of the scene, so you will need to have a variety of shots that are underexposed, correctly exposed, and overexposed. The easiest way to achieve this is through automatic exposure

bracketing—your camera's instruction manual will give you details on how to use this. It is also a good idea to select continuous shooting, so the sequence is made in as short a time as possible. This will help avoid any problems with parts of the scene that move between exposures, such as clouds or trees blowing in the wind.

Your camera should be set up on a tripod (to keep all of your shots aligned) and an external shutter release used to minimize camera shake. Once you have composed your scene, take your sequence of exposures with the camera set to Aperture Priority or Manual mode. It is important that the aperture stays the same between shots, as if it is changed the depth of field will change also, again leading to mismatched images. Once you have your sequence, you are ready for the post-processing stage, which is discussed later in this book.

When to use HDR

In many ways there is no right or wrong when it comes to HDR, only personal preference. The sunset scene described above, for example, could be shot for HDR, so detail is seen in both the shadows and the sky, but you might equally prefer the silhouettes that a sunset provides. Typically, you would shoot HDR when you want to balance the light across the frame, so you don't lose detail in a photograph because it has been blown out or silhouetted. You might also shoot HDR if you're photographing into the light, either at the sun or with the sun behind some clouds, or perhaps if you are indoors and the light from a window is blowing out part of the image. In fact, HDR can be an incredibly useful technique for interior photography.

GURYE: THE HEAVENS

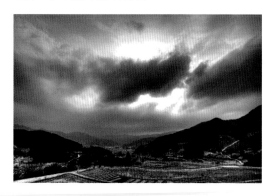

HDR can be very effective when you are shooting toward the sun. The differing levels of light in the sky are brought out well with HDR processing.

Pitfalls of HDR

HDR is not a magic wand that will cure all your lighting woes. Aside from the considerations that need to be made when you shoot your sequence of images, there is the very real risk of halos and unusual colors appearing during the post-processing stage if care is not taken.

XIAN WALL

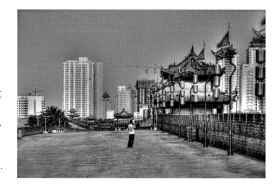

There are times when HDR images can look more like computer graphics or illustrations than photographs. There is a lot of detail in this shot, and the red flags pop against the blue sky, but noticeable halos have been introduced during processing.

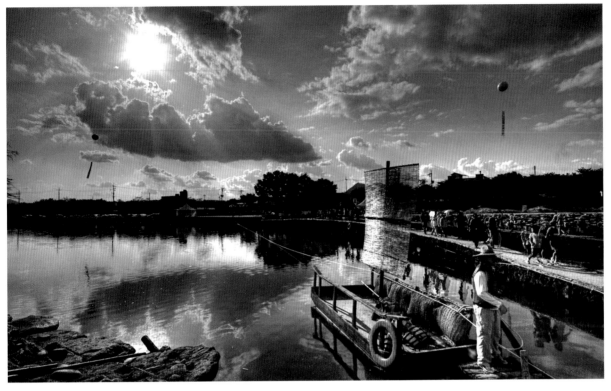

NAMWON: RIVERBOAT CROSSING

With the sun behind the people and the boat, they would have been silhouetted in a single exposure, or the sky burnt out. However, HDR has balanced the light levels across the frame.

PAVILION

The glow of the sun as it begins to set gives this HDR a warm glow, and the pavilion to the right gives it an exotic mood.

Panning

Anything that shows dynamism in photography is great, and panning is a fantastic technique that will help you achieve precisely that. This is also a fun technique to learn, and although it takes some practice, it's relatively easy to get started. There is a nice element of minimalism in a panned photograph, as you'll be looking to keep your subject sharp while at the same time blurring the background.

The first thing you're going to have to do is to choose a subject, and, of course, your subject has to be moving. If you're new to this technique I'd recommend starting with bicycles, as these tend to be relatively easy to get good results from while you practice. Alternatively, you could pan with running people, cars, or boats.

Once you've chosen your subject, set the camera to Shutter Priority and set the shutter speed between 1/10 sec–1/60 sec. There is no single "right" shutter speed—it all depends on how fast your subject is moving and how much blur you want in the shot, which you will only be able to determine through trial and error.

Your position relative to the subject is also important—you want to be somewhere that allows the subject to move parallel to your position, and that gives you a clear line of sight as it approaches. The final thing to think about is the background: it will be blurred, but there is still the potential for distracting shapes and colors, although I find that a completely plain background does not tend to show the movement quite as well.

Now that you've got your camera set up, it's time to take the shot. As your subject approaches, focus on them and start tracking with your camera until you feel confident that you are moving in sync with the subject. Make sure that you have the subject in focus by pressing the shutter button halfway down, and—still moving the camera—take the shot as smoothly as you can. You may find that your first few attempts produce an overly blurred subject because your movement was out of sync with the subject. This is where practice comes in! If you're looking to get additional sharpness, using a strobe while panning can help to freeze your subject momentarily.

Practice panning

A park can be a great place to practice your panning; you'll find joggers, people on rollerblades (and rollerskates), as well as cyclists. You will probably be able to find a nice tree to use as your background as well. Once you're a little more confident, consider photographing racing cars or motorbikes, although getting a photo of these will take some serious practice—you'll probably be using a long telephoto lens, so camera shake can also become an issue.

Tip

If your camera won't focus automatically on a moving subject, try focusing manually at the point you anticipate the subject being when you're going to take the photo. Then, when the subject comes into shot, it will move into focus.

BIKES

Bicycles are one of the easiest objects to start practicing panning with—they don't have a lot of moving parts, and tend to travel at a smooth pace, which is not too fast to follow.

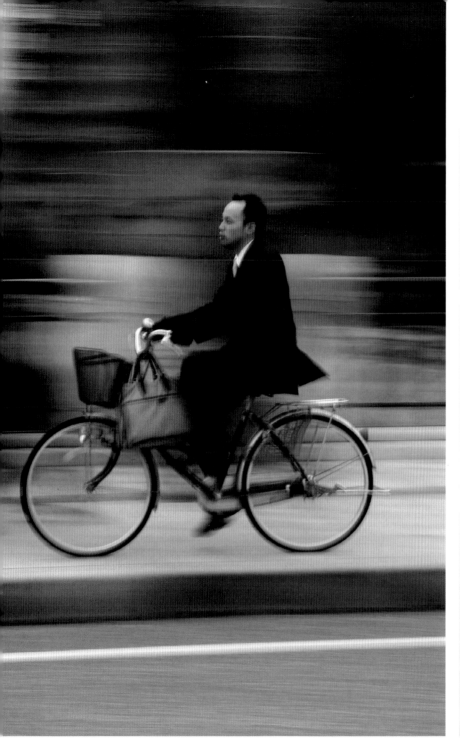

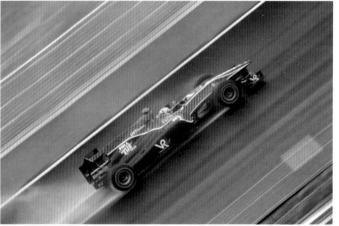

GOING TO THE RACES

Places where you can watch a race are great to try out panning. In each case the principal is the same: smoothly follow the action while taking the photo. Of course, following a racing car poses different challenges to a three-legged race or a horse race, so it will take some practice to get it right. However, as many races involve a number of laps, you can check your shots on the camera's screen as you prepare for your subject to come round again!

Light painting

Photography is all about the light, regardless of whether you are using the light from the sun or strobes to get great shots. There is also another way of lighting your shots creatively though: light painting. This general term covers multiple light painting methods, as outlined below.

Light painting with your camera

This is relatively easy to do, and there are several different ways of achieving great effects. A zoom burst (as described on page 64) is one way in which you can paint with light, or you can combine a long exposure with a moving light source such as car lights or fireworks (see page 68).

Alternatively, you can combine these two techniques and physically move the camera during a long exposure. Any light sources in the frame will be blurred, creating abstract patterns in your image. Your movement with the camera can be as random or as considered as you like, depending on the result you are after. Another approach is to use a strobe and an exposure of around 1 second. The flash will freeze the subject, while the long exposure will give you time to light paint by moving the camera.

Light painting behind the camera

This is a way of lighting specific parts of your subject by combining a long exposure with a flashlight or similar portable light source. For this type of photograph you are definitely going to need to use a tripod, as you will be working at night and the exposure times are going to be very long. Once you have set up and composed your shot, set your camera to its Manual mode and set a shutter speed of around 20 seconds at an aperture of $f/8$. While the exposure is being made, use your flashlight to "paint" light onto the subject. Review your shot to see which areas need more or less light, and whether you need to adjust the exposure settings.

Light painting in front of the camera

As well as directing light onto your subject from behind the camera, you can also move into the scene to paint with light, using anything from a flashlight or strobe, to a glowstick or sparkler—anything that will create light in the darkness. As before, you will need to use a tripod, as exposure times can vary from several seconds to minutes. Once you have got the composition set, activate your camera's 10-second self-timer (so you can get into position) and trigger the shutter.

When the shutter opens it's time to start making shapes and patterns in front of the camera with your light, which will hopefully complement the scene you are taking a photo of. If you don't want to be seen in the shot it is a good idea to wear dark clothes, and to use a very long exposure so that the light patterns are visible, but you don't register as you move around in the dark.

LIGHT PAINTING

This ger, a Mongolian home in the desert, was "painted" with a torch during a long exposure. The land in front of it was also painted in.

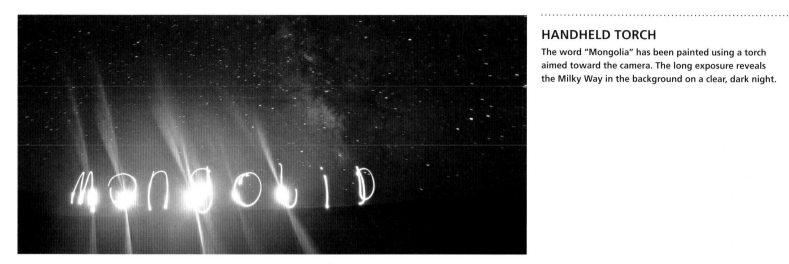

HANDHELD TORCH

The word "Mongolia" has been painted using a torch aimed toward the camera. The long exposure reveals the Milky Way in the background on a clear, dark night.

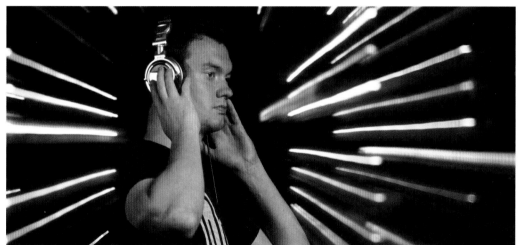

FLASH AND BLUR

In this photo a strobe was used to "freeze" the DJ, with a zoom burst also applied during the 2-second exposure to "paint" with the background lights.

TORCH ON A STRING

For this abstract image a torch was suspended on a string, directly above the camera. In total darkness the torch was turned on and gently swung until it was producing even loops. Once the torch was swinging smoothly, I made a 20-second exposure that recorded just the movement of the light.

Shadows

Without light there are no shadows, and shadows can be used in photography to make some interesting effects. Shadows can be formed by natural light or artificial light, and you can also move objects in front of a light source to create your own shadows.

Natural light means the sun, which can produce very strong shadows. However, as you can't change the position of the sun, you'll have to change the time of day you choose to take your photographs, and maybe even the time of year if there is something specific you are setting out to achieve. Often, the best time for photographing shadows with natural light is at the beginning and end of the day, when the sun is low and produces long, atmospheric shadows.

There are lots of things that form shadows—any object that gets in the way of sunlight, in fact. But that does not mean that all objects form nice shapes, so you need to look carefully for appealing shadow subjects. People are an obvious choice, and getting a high viewpoint is often a good idea if you want to see the shadows clearly. Objects such as trees and staircases on the outside of buildings can cast great shadows.

Light sources such as torches, streetlights, or strobes can be used to cast shadows, and with torches and strobes you have the added advantage of being able to change the direction and intensity of the light. You can introduce shadows into your shots by blocking the light in front of a strobe, either by using a dedicated photographic "gobo" to add texture, cutting out card shapes, or even simply by making shapes with your hands in front of the light.

A popular wedding photograph that utilizes artificial light to create a shadow is a ring placed in the center of a book, with a strobe fired behind it. If this is set up correctly, the ring will create a heart-shaped shadow across the book—the perfect shot for a wedding ring in an album.

THE LOVE SHADOW

In this wedding-style shot a strobe was used to create the shadow from a ring. The technique relies on a heart-shaped shadow being made by the book's gutter.

SHAPES IN THE SAND

As the sun gets low in the sky it produces strong shadows. In this shot of a desert, these shadows give the sand dunes shape and form.

SELF SHADOW

A slight twist on the idea of a self-portrait is this "self shadow," which makes this scene more interesting.

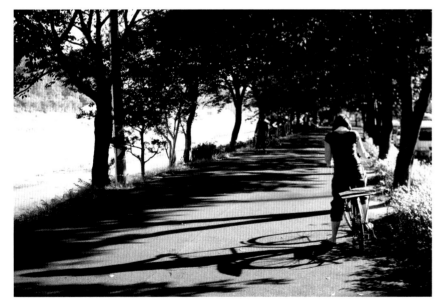

THE SHADOW CYCLIST

The shadow in this scene is coming across the frame, with the sun slightly in front of the camera. The shadows from the trees both frame the shadow of the cyclist, and prevent flare from the sun.

COLOR SHADOWS

You can create shadows with your hands, but if you introduce a semi-transparent, colored object you can get some really interesting results.

Location scouting

A good photographer always has their camera with them, so why do we need to scout for photos? The first answer is simple: you may well have your camera by your side when you happen across a great location, but the people or conditions that you want to shoot might not be available at that moment in time.

Location scouting can also be useful if you are ever asked to shoot some portraits for friends, or perhaps a local band approaches you wanting some promotional photos. If you've got time before the shoot, take the opportunity to explore the area, looking for potential spots that would suit the scenario you wish to portray. Let's say you've been asked to photograph a couple, for example, and they want to be photographed outdoors in a nonurban environment. You'll want to find tree lines, flowers, or paths that can be used to produce leading lines, and perhaps aim to shoot when the lighting conditions will allow you to create bokeh from light coming off the leaves. The same principal could also be applied to a band, although here you will need to look for a scene that compliments their music: you might want to use natural backdrops for a folk band, but something more urban or industrial for a band whose sound is grungier.

It is also a good idea to scout out a location when you are photographing a parade or fireworks show. In both of these instances, identifying a good vantage point before the event can make or break your shoot. In this case, a little prior research is needed to determine the parade route or the position the fireworks will be set off from. Once the location/route has been established, it is a good idea to walk around the area looking for buildings that you might be able to photograph from, or make plans to arrive early to reserve your spot before other people get there.

If you are keen to experiment with night photography, you may also need to scout out possible locations during the day, although you will you need to be able to "see" nighttime photos during the day. A lot of the time, a vantage point over a busy traffic junction will make for a good night photo, but finding that vantage point is something best done during the day.

Tip

A smartphone can be a great tool for recording location shots. The photos taken on smart phones are often geotagged, so all you have to do to find the location of the photo is look at the map function on your phone.

Tip

If you like taking cityscapes, use Google Maps, or a similar service, to scout out locations before you leave home. The satellite map will allow you to see potential spots, such as apartment buildings, where you might get a good vantage point.

THE RUNNING TRACK

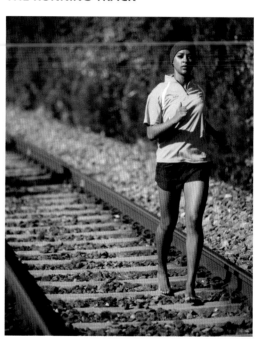

This is a place I pass on my way back from work every day and I planned to return to the spot at a later date to take some photographs. Note that this track was not in use!

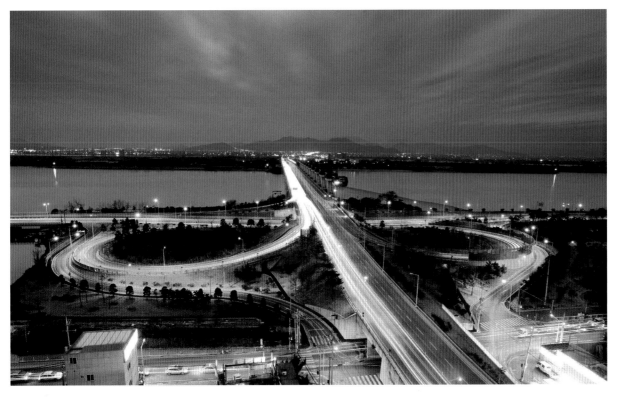

FINDING A VANTAGE POINT

To find this vantage point I used Google Maps to look for big intersections, and for apartment buildings that overlooked them. I then set off on the subway to the junction, found the apartment, and took this shot from the top floor.

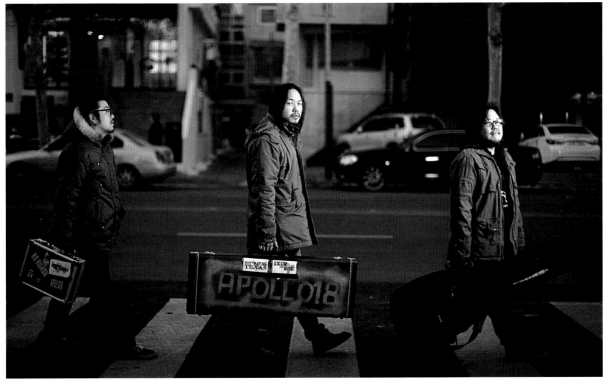

KIMCHI STREET

This photo was inspired by the famous Abbey Road photograph of the Beatles. I wanted an urban grungy edge, hence the inclusion of buildings in the background. I had scouted for locations the day before I shot this Korean band, and used my iPhone to record places I wanted to return to the following day.

Seeing photographs

Whenever you're out and about with your camera, perhaps scouting for locations to shoot at a later date, you should be looking for things with photographic potential. Although some people have an ability to "see" good images, it doesn't come naturally to most. To start with, it is probably wise to practice one style of photography at a time, such as landscapes or portraits, until you get to the point where seeing that particular type of photograph becomes second nature. The aim is to reach a point where, instead of it being a conscious decision to take a photo, it becomes an unconscious reaction to a scene or situation.

Once your experience in photography has progressed, you'll have likely mastered several techniques, and each technique will activate a certain part of the brain; this is called activating a schema. This means that when you are walking around looking for photo opportunities you are often as not looking for places that activate

certain schemas—and this will usually provide you with the situation for a good photo. It is also true that if you stop using a technique entirely, over time you will lose the ability to see the best situations to apply that technique in the future. This is a compelling reason to get out and take photos as often as you can, and to explore multiple techniques so you can give a photograph a particular style or look, and take ownership of the image.

Practice one technique at a time until you have mastered it, and then move onto something else that interests you. It might be that you buy a wide-angle lens, or perhaps a filter, as new equipment can change the types of picture you take, and allow you to see even more photo opportunities. At this stage, it can be a good idea to revisit places where you have previously taken photos, as you will see them with slightly different eyes, due to the new filter or lens you now have, as discussed on the following pages.

BOW AND ARROWS

This was shot during a festival in Mongolia, when the archers were taking a break. The first shot tells the wider story and shows the archers relaxing. As I walked through the tent I noticed the bows and arrows, which create strong lines, so I lined up the diagonals and took a closer shot.

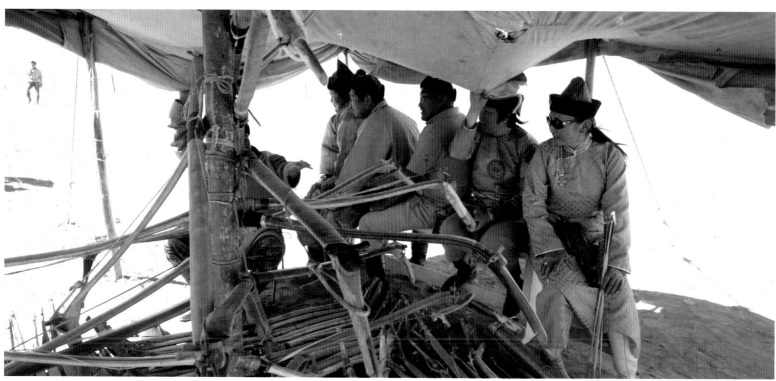

THE DESERT IN A GLASS BALL

I have been taking photographs using glass balls for quite some time, so my eye has become sensitive to places where this technique will work: it is usually the case that the ball needs to be in an elevated position, with good backlight. As I was walking in the Gobi desert I knew that placing the ball at the top of a ridge would likely give me a good shot. I came to a high ridge along the dunes, and set up with the ball. In this sequence you can see the scene without the ball; with the ball; and the final image, which was flipped so the refracted image in the ball appears the right way up.

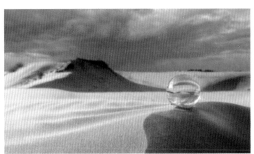

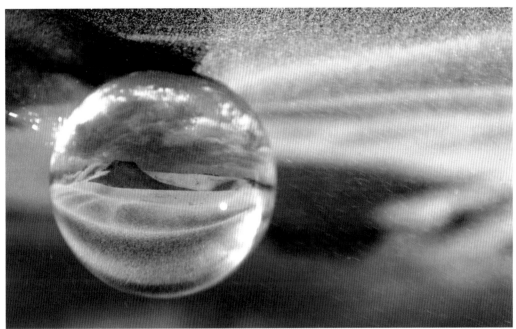

THE LONE TREE

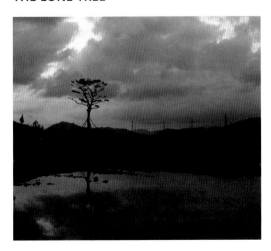

This was a photo I took while writing about minimalism for this book, so it could be said that my schema for this type of photo was very much active. I'd decided to go on a photo walk that day, not to take any specific kind of shot, but just to see what I could find.

I walked through a new part of town and saw this tree on its own. The way the branches appeared against the background clouds was what first interested me, and I initially shot the tree as a reflection. I then decided to get a little closer, and as I did, I saw I could position the tree against a bright part of the sky to increase the contrast and create a minimalist silhouette.

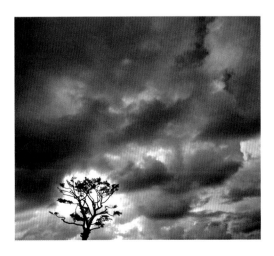

Return visits

It's great to revisit something you've seen before, just like catching up with an old friend. In photography, you should always visit places you've been before, and there are lots of good reasons for this.

New equipment

If you've bought something new for your photography, such as a lens, filter, or tripod, then revisiting a favorite location will allow you to get to grips with the equipment in familiar surroundings. As you will already have looked for a variety of angles during previous visits, these can be revisited with your new equipment, allowing you to concentrate on getting the best from your lens or filter, rather than spending time searching for the best vantage point.

New techniques

A place you are familiar with is great for experimenting with new techniques, as you will again have the benefit of knowing what to expect before you arrive. As well as using it as a practice ground, you can also bring a new technique to an old location with a view to improving on your past images—there may be a place you have visited before that would work well at night with long exposures, for example.

Check the conditions

Sometimes, all it takes is a change in weather or season to transform a location. It makes a lot of sense to visit a location that has changed because of the seasons; it's almost like having a blank canvas to work with. The last time you visited a place might have been in Summer, for example, but return in fall and the leaves may have changed color, while winter could bring snow. With each visit, the same location could look fundamentally different.

When photographing a new season, you'll often find that a series of photos will best tell the story of that season: close-up photographs of single leaves in fall could be combined with broader landscape views across a valley of trees with different stages of leaf color. A classic way of showing seasonal change is to take a shot of a single tree, returning in each season to take a photograph using the same composition.

As well as seasonal changes, weather and conditions can also transform a location. If you're planning some sunset photography, for example, check out the weather forecast before going out to shoot—the sun setting behind broken cloud will produce very different images to those seen when the sky is clear. Similarly, check the times of the tides if you plan on shooting coastal photographs, as the tidal state could have a big effect on what your photograph will look like.

The same conditions

Sometimes you will come across a location that you absolutely love, perhaps revisiting it only a few days later. There's nothing wrong with this, as even when the weather conditions are the same, people never are, so capturing the human side of a location is an option, especially if you concentrated on landscapes on your previous visit. Another thing that could have drawn you back is a performance or festival. In Korea, for example, some towns have martial arts performances that happen daily throughout the warmer months of the year. The thing about performances is that there are so many potential moments of capture that going back and taking photographs again will almost always result in more good photos.

Previous experience

Having been to a place before, you really should be one step ahead of the game in terms of planning what to take photos of, and everything from the previous trip should be recalled and used on subsequent visits. It is a good idea to start the process by having a look at the photos you took previously. Study them with a critical eye to decide how you can improve on them, perhaps by changing the viewpoint slightly or using a different technique to add a new dynamic. Of course, you may find that some images cannot be improved upon, in which case you will know not to waste time reshooting them.

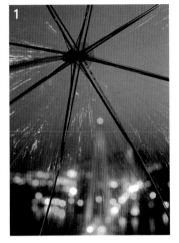

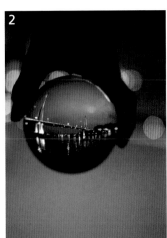

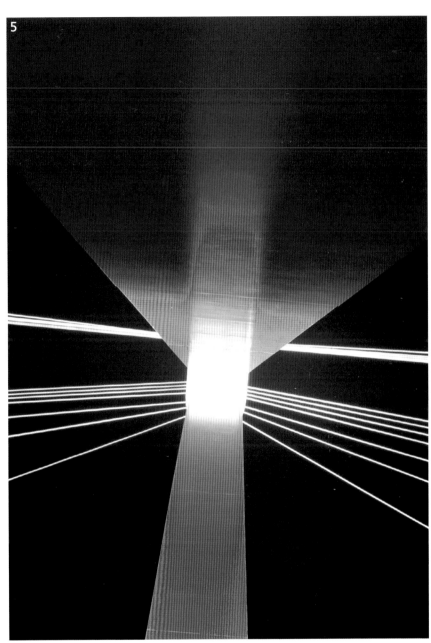

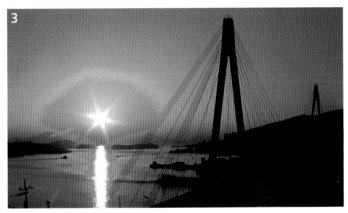

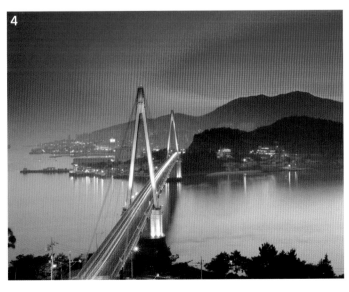

THE DOLSAN BRIDGE, YEOSU

Yeosu is a port on the south coast of South Korea. The Dolsan Bridge is the port's most dominant architectural feature, and one that I have photographed on numerous occasions. As can be seen here, I've used many different techniques to transform the subject, including an umbrella (1) and glass balls (2) to change the style of image, a sunset silhouette (3), a graduated filter (4), and finally an abstract photo of the suspension wires of the bridge (5).

PERFORMANCE PHOTOGRAPHY

Any event that involves a performance is worth photographing on multiple occasions: there could well be new decisive moments that were missed on a previous shoot, and performance routines often change.

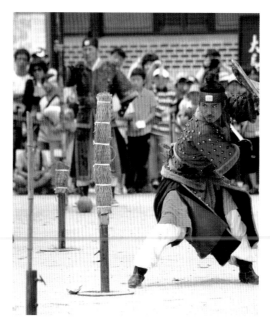

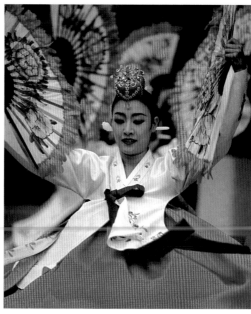

THE CHANGING SEASONS

As the seasons change, certain places become more attractive, such as this road during cherry blossom season.

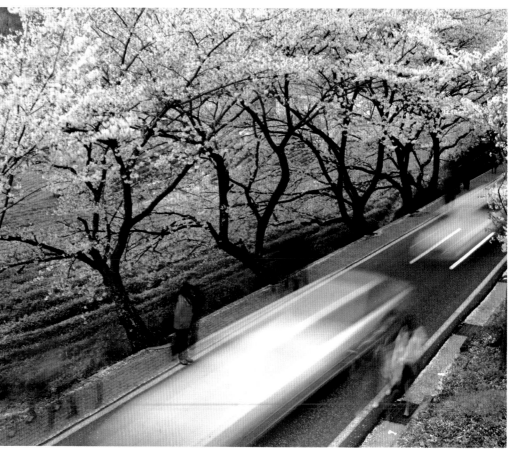

BEFORE AND AFTER THE SNOW

Some places are naturally photogenic, regardless of
the time of year. This temple set inside a narrow gorge
is a great example, although a return visit to see it
in the snow produced a slightly better image.

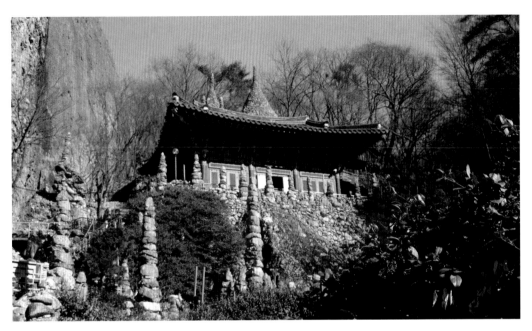

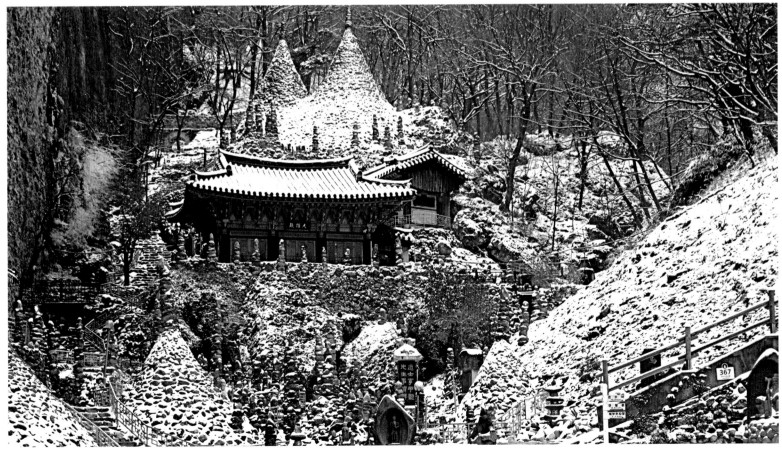

Models

Some photographs do not actually benefit from having a person in them, while others will look equally good with or without a model. However, there are also scenes that are positively enhanced by including a model. In adding a person to a scene the hope is you'll be aspiring for something more than a photograph of your best friend grinning inanely in front of a tourist attraction, although this is perfectly OK for a vacation album!

When to include a model

Adding a model to a scene is really a judgment call: the key thing to understand is that a model will give your photograph a clear focal point. The most obvious places to include a model are when a scene has a strong leading line, or a natural frame. You may also find somewhere that offers the chance of a pretty bokeh background, or a derelict building, a beach with some rocks, or somewhere else entirely that allows the model to contrast with their background.

Finding a model

There are numerous places where you can find a model, starting with yourself: there's no reason at all why you cannot set the camera up on a tripod and then use the camera's self-timer or a remote shutter release to take self-portraits. Alternatively, a lot of your friends (or family) will likely be happy to pose in front of the camera for you, and this can be a great way to spend some real quality time with them. It's usually a lot of fun as well.

If you want to find someone with a little experience in modeling, there are numerous websites that put photographers and aspiring models in touch with each other, such as Model Mayhem, for example. Through these websites it is easy to find people who are keen to build a modeling portfolio, and will therefore give their time for free. As you become more experienced, you should consider charging for your time, but be aware that the same applies to models— some experienced models won't work for free.

Equipment

When it comes to the equipment you need to photograph a model, there is no single answer. If it's a sunny day you might consider taking a reflector to fill-in any shadows on your model's face, or you may prefer to use flash instead. If you opt for strobes, then umbrellas, softboxes, and other lighting modifiers could help you achieve a better picture, but it is up to you how much (or how little) you take with you. What you will find, however, is that the more you take, the more useful it can be to have a friend with you. Not only will an extra person be helpful when it comes to carrying all your kit, they can also help with simple things such as holding light stands that might blow over on a windy day.

IVY LEAVES

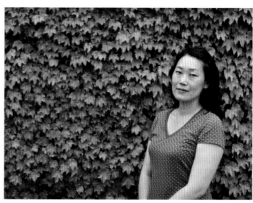

Natural backgrounds are often great when including a model, and these ivy leaves form a rich green texture. My model was wearing a red top, and the color contrast this provided made the image pop.

Tip

After a shoot, it's always advisable to get your model to sign a model release. This will allow you to use the photographs you've taken for commercial purposes, such as publication in magazines or submitting them to an image library.

ON TOUR

I was asked by a magazine to take some photos of a Korean band, Apollo 18, while they were on tour in the U.S. As the band were touring, it made me think of a bus stop that I'd taken some long exposure photos of earlier that month. I realized I could use a long exposure and make the band members sharp if I used some strobes, so the day before the shoot I visited the location with a friend to determine the flash and exposure settings. That way I could be as quick and professional with the band as possible.

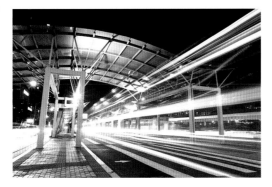

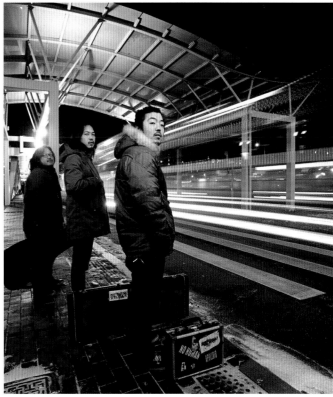

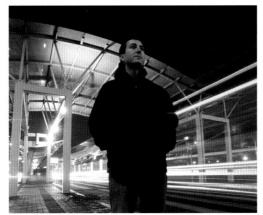

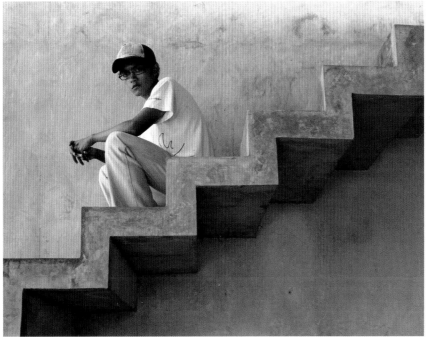

STEPS

I liked the way these steps intersected the wall, but felt the photograph needed a model. I asked a friend if he'd mind being in the shot.

Dusk & night

Going from day to night will have a dramatic impact on the way that something looks, and by extension the way that it is going to be photographed. Once you understand what you're doing when you are taking photos at dusk and at night, this may well become one of your favorite times to take pictures. However, a certain amount of previsualization may be required with some subjects: you will need to imagine how a road might appear at night when there are light trails from cars, for example. The same is true of structures such as buildings or bridges. These could be lit up at night, and the artificial light sources may change the way you want to photograph them.

Types of photograph

In many ways, photography doesn't change when day becomes night. You still need to compose your shot, look for leading lines, and all the other elements we have already discussed, but there are a few popular subjects that are transformed at night:

Landscapes: A gray, urban cityscape can be transformed from ugly to chic just by shooting it at night when artificial lighting and light trails from cars add color. In rural locations, taking photographs of star trails is another option worth exploring.

People: When it's dark you actually have more control over the way your subject is lit. If you're taking street photos, the available light may help focus the eye on the person you're photographing, while their surroundings are plunged into darkness, or you can use strobes to turn the outdoors into a virtual studio.

Abstract: At night you can use a wide aperture to produce strong bokeh from street and building lights. You could also experiment with different forms of light painting, as mentioned previously.

Equipment

Night photography requires a little more equipment than just your camera body and a lens, which makes it slightly more specialized. As it's dark, the following equipment could prove useful:

Tripod: Every photographer should have a sturdy tripod, especially in low-light conditions where you are likely to be using long exposure times. A tripod—ideally coupled with an external shutter release—will help keep your photographs sharp.

Strobes: When the light is low, you can always introduce your own light. Strobes are most useful when taking photos of people, but they can also be used to light the foreground in a landscape picture, or to "paint" an entire scene using light-painting techniques.

A fast lens: A lens with a wide maximum aperture—such as f/1.2 or f/1.8—will allow you to use relatively fast shutter speeds in low-light conditions. This type of lens might be used for street photography at night, where the available light from shop windows or street lighting is used as the light source.

HONG KONG, THE CITY OF LIGHT

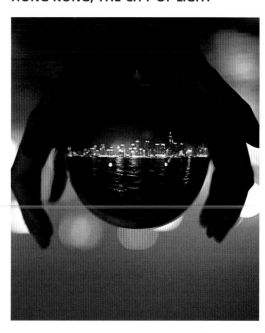

Hong Kong's brightly lit waterfront is an obvious choice for a nighttime photograph with strong bokeh. The city's skyline can also be seen inside the orb.

Tip

It is a good idea to spend a little time during the day looking for potential locations that you can take photos from when it gets dark.

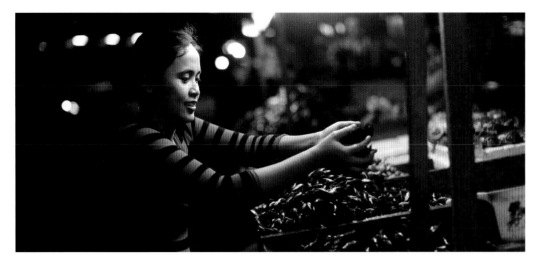

THE NIGHT MARKET

A market can provide good low-light opportunities and is worth visiting at night with a fast lens.

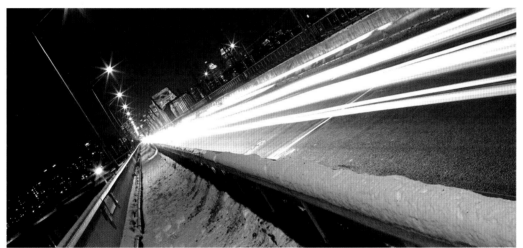

NIGHTTIME CAR TRAILS

There are times when you'll walk past an area and realize its great potential for nighttime photography. The white light trails from the passing cars and the snow compliment each other well in this street scene.

PHOTOGRAPHING A MODEL WITH STROBES

The way the railings are lit enhances this photo, and the strong contrast works better in black and white.

Alternative plans

No matter how meticulously you plan a shot there is always the chance that something will go wrong, so you should have a "plan B" ready. There are numerous reasons why you might need to change your plans—bad weather, a model canceling at the last minute, a delayed flight, or myriad other possibilities. Of course, one option is to reschedule the shoot, but even if that's possible there's no reason why you shouldn't try something different to save wasting the time you've set aside.

Bad weather

Most of the time, photographers want "nice" weather if they're shooting outdoors, which means no rain. However, rain opens up the possibility of other kinds of photography. A few years ago, I was traveling through China and staying in Yangshuo, which is home to some of the most stunning Karst mountains in the world. Apart from the day I arrived there was torrential rain, so all of the sunset landscapes I had anticipated taking along the river were clearly going to have to wait for another trip, and with poor visibility, even general landscape photography during the day was out. Instead, I took some portraits of my girlfriend, using the various rooms of the converted farmhouse we were staying in as the backdrop. I also did some interior photography, and took some abstract images using water droplets.

Model canceled

Nobody enjoys being stood up, but there's every possibility you can reschedule the shoot you had planned, and take your shots another day. In the meantime, why not practice your skills? If you hired a studio, for example, and you've got a friend with you who was going to be your assistant, take it in turns to be the model, and dedicate some time to practicing a new lighting technique or style. You can do the same on location as well, and that way you will have done something productive with your time, and you'll have a new skill for the next time you shoot with a model.

Travel delays

Delays to travel plans sometimes happen, and if you have a limited amount of time in a certain location then any time you lose could really count. The ideal situation is to plan your trip with a few days extra, so you have a "buffer" to cover any unforeseen circumstances. However, if this isn't possible (whether it's due to time or cost), then prioritize which photographic goals are most important to you—is there a location you can live with not photographing, for example, or one that definitely needs to be included in your shooting itinerary?

RAIN STORM IN CHINA
The elements sometimes conspire against you: rain is one thing, but a torrential downpour is quite another. Here, the Karst mountains had to wait.

A ZOOM BURST
A zoom bust, using a doorway as a frame, has meant that the weather was less important in this shot.

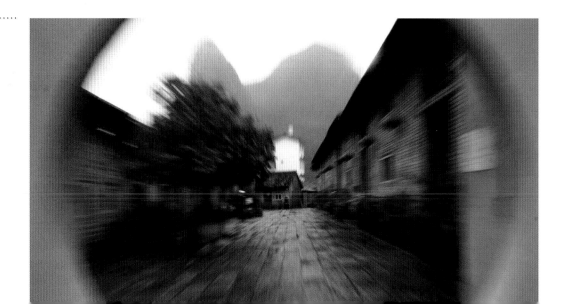

WINDOW LIGHT FOR PORTRAITS

Interior photography on a rainy day can be very enjoyable. The light almost demanded a model in the photo, and my girlfriend was kind enough to pose for me.

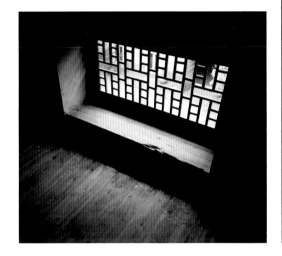

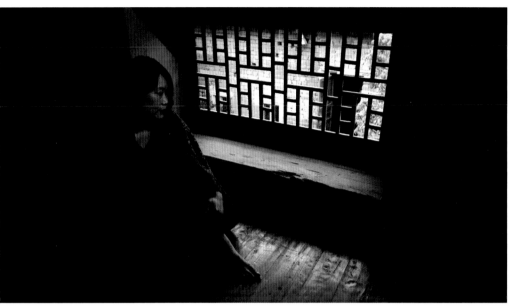

DOOR FRAME

The doorway in this old Chinese farmhouse made an excellent frame for this portrait; it may have been raining outside, but this didn't stop me experimenting with strobe lighting indoors.

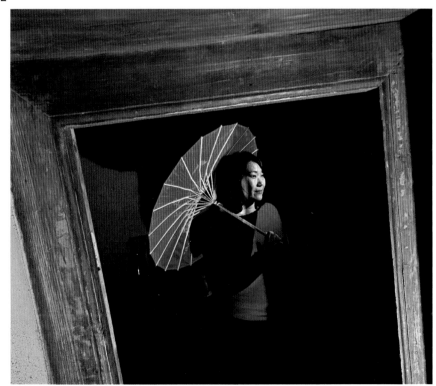

MAKING THE MOST OF THE RAIN

Photographs of water droplets can produce interesting results. If you use a macro lens, a refracted image can be seen inside a water drop. Flipping the resulting shot allows the refracted image to appear the right way up.

Black & white

There is a lot more to creating great black-and-white images than simply changing a color image to grayscale, and it starts with the subject of your photograph—some subjects work much better in black and white than others. The first thing to realize when you're aiming for a black-and-white result is that you want to be shooting in color. Although your camera might have a black-and-white mode, converting your shots to black-and-white during the post-processing stage will provide you with much greater control. However, this does mean that you're going to have to imagine how the photo will look in black and white.

Tones are the new colors

When shooting in color, you can use color contrast to make certain elements within an image stand out, but this is usually not going to give you the quite the same results in a black-and-white image of the same scene. An example of this is a strong red/green color contrast. When converted to black and white, primary red and green tones will produce shades of gray that are very similar to each other, so while they contrast strongly in a color photograph, they will merge into a single tone

in black and white. It's important to consider this when taking photographs that you intend to convert to black and white, although shooting in color will enable you to adjust the individual tones during post-processing.

Texture

Without the distraction of color, black-and-white photos can often emphasize textures in a photograph, especially a contrast in textures. When shooting for black and white this is something you'll need to look out for, whether it's the texture of a wall, or perhaps the texture given to the sky by different cloud formations.

Shape

Shape is important in color photography, but a strong shape in a photograph can become even more graphic when it is seen in black and white. This could be some amazing city architecture such as the dome of a cathedral, or the shapes on a person's face that are brought out by light and shadow. When conveying shape in a photograph, light and shadow is vitally important, but this is even more paramount in black and white.

A MONGOLIAN WOMAN MAKES DINNER
The lighting in this photograph lends itself well to a black-and-white conversion, thanks to the backlight. The image also feels more intimate in black and white.

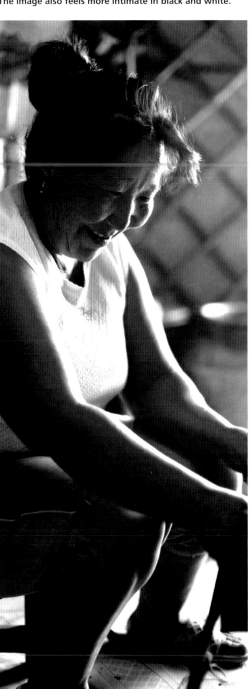

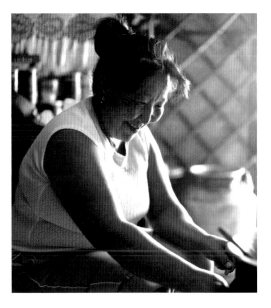

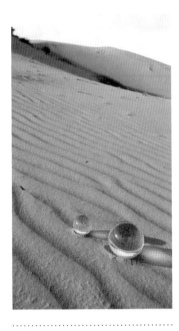

LINES AND CURVES

The lines in the sand produce excellent texture, especially as the long shadows from the evening sun are formed. This makes images like this a good choice for a black-and-white treatment.

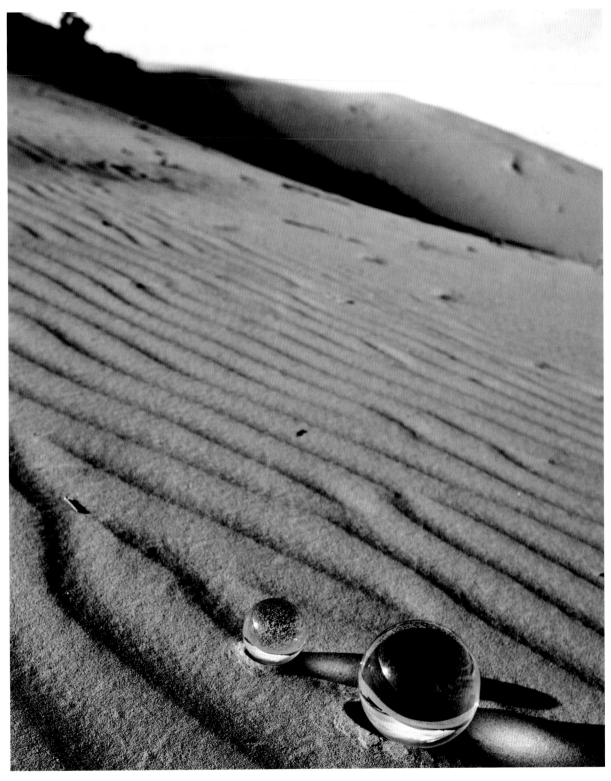

Limited light

The way that a photographer uses light often defines the photo, so having a good appreciation of this is important. You need to develop a feel for when a scene needs to be exposed for the subject, or exposed for the background or other area in the frame: light can be used to highlight a subject, silhouette a subject, or perhaps to produce shadows across the frame.

Silhouettes

The opportunity to create photographic silhouettes is all around us, but you want to be looking for defined shapes and scenes that are not too busy. A good place to start looking for silhouettes is at the beach, with light reflecting strongly off the sea, or you might try the light at the end of a tunnel—both of these will often produce great silhouettes.

Shadows

Shadows are a key element in photography, as they create a three-dimensional sense in a picture, so while soft, even lighting is great if you want a record of your subject, hard, direct light is often more exciting. If you're in a situation where most of the light is blocked out, but there's a thin beam coming through a window or doorway, then use this as a "spotlight" on your subject. Streetlights or shop windows will have the same effect at night, especially when the background is dark. It is also possible to create a beam of light using an off-camera strobe, perhaps adding a snoot to direct the light. In each case, care should be taken to expose correctly for the subject, and not to allow a dark background to fool the camera's lightmeter.

DREAMING OF A GOOD YEAR

The light from a flame can often look great when it's used to light a person. There were countless opportunities to take this type of shot as people lit lanterns during the Chinese New Year celebrations.

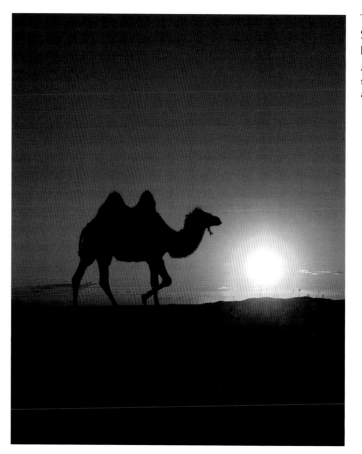

SILHOUETTES AT THE END OF THE DAY

A camel in a desert makes a great subject for a silhouette, especially around sunset.

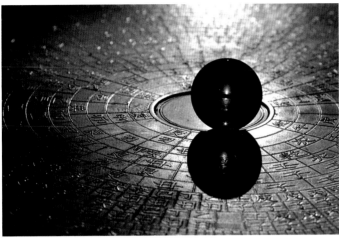

PREDICTING GOOD LIGHT

The light reflecting off this Chinese horoscope allows the Chinese characters to be picked out clearly. The ball provides a focal point for the image.

IN THE SPOTLIGHT

Stage lighting often uses strong, directional light that will highlight a performer's face and plunge the background into darkness.

NIGHT MARKET AVAILABLE LIGHT

The light filtering into this dimly lit market creates a natural "spotlight" on this girl, who already stands out thanks to her red jacket.

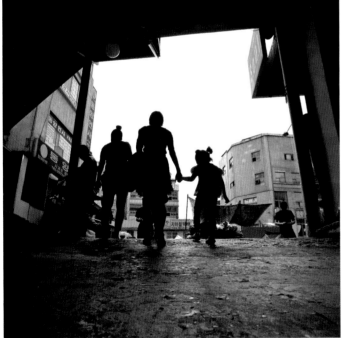

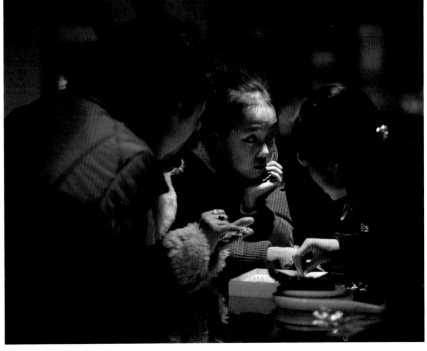

INDOORS CAN OFTEN BE LIMITED FOR LIGHT

This market area opens out into the daylight, which makes it an ideal place to capture silhouettes against the bright sky.

Focal point

While some photos don't need an especially strong focal point, the majority will benefit from having something that acts as a point of focus. A focal point is usually what grabs the attention of the person looking at the photograph, and it can also give the picture a reason. With experience, you may find that identifying and using lines, patterns, and curves becomes second nature, as does composing a good shot. However, adding a focal point to that composition will elevate your images.

A lot of scenes have a natural focal point, and it's likely that this point in the scene is what encouraged you to take the photograph in the first place. But there will be times when you are out with your camera and you take a well-composed shot that lacks impact. There might not be anything technically wrong with the picture, other than that it lacks a focal point.

In this case, you may want to consider introducing a person (or object) into the scene to provide a focal point. How you go about this is up to you—in some instances it might be beneficial to return at a later date with a friend or prop to include in the shot, or you may just need to be patient and wait for a passer-by to enter the frame. Waiting for the "decisive moment" is usually the recipe for a good street photo!

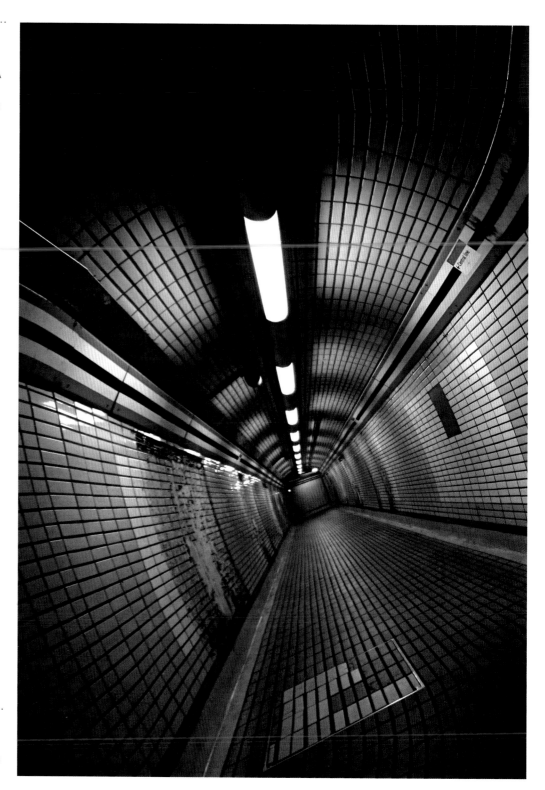

TUNNEL VISION

A good example of strong leading lines and composition, but you could argue that this shot lacks a focal point. The addition of a person in the tunnel would resolve that.

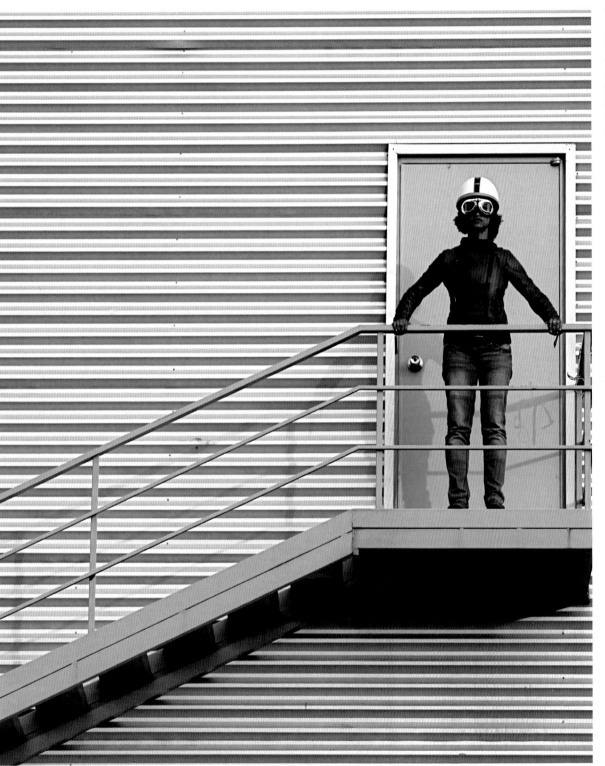

A MODEL ALWAYS MAKES A GREAT FOCUS

This wall has great lines running through it, and the door was the ideal position for a model. In this instance, I returned to the location with a friend and took the photo— the addition of the figure creates a strong focal point.

TOGETHER AGAINST THE ODDS

In this scene, the silhouetted people add a focal point and provide a sense of scale.

121

Telling a story

The classic saying is that "a picture tells a thousand words." In many cases this statement couldn't be more true, and you'll find that the most powerful images often have a story to tell. We've already talked about creating a balanced photograph with a focal point, but to tell the story you also need to provide context within the image. To do this you need to show your subject interacting with the environment around them, so if you're photographing a portrait it needs to be something more than just a simple record of what a particular person looks like. However, this is easier said than done.

How to tell a story

Using a long telephoto lens is an easy way of taking a candid portrait of a person without them knowing, so they'll appear more natural. However, because telephoto lenses have a narrow angle of view you will lose some of the context in the shot. The solution is to use a lens with a wider angle of view, so that both your subject and his or her surroundings can be recorded: a 50mm lens is a good focal length on a full-frame digital SLR (or around 35mm on an APS-C format sensor). If you're using a wider lens, good composition becomes even more important, as recording more of the subject's surroundings means it is easy to create a shot that is too "busy."

The other thing to look for is the elusive "decisive moment," which is a phrase credited to French photographer Henri Cartier-Bresson. This is the precise moment when the scene in front of you is "perfect," but you have to be both patient and very quick to capture it. A little anticipation will go a long way here—for example, you might need to wait in front of a market stall to capture the interaction between a customer and the market stall owner. You also need to have your camera ready, so be sure to check the exposure and white balance at the earliest opportunity, so you don't have to fiddle with your camera.

Where to tell the story

The whole world is your playground here, but there are a few favorites for photographers, such as street markets. However, moving away from the tried and trusted locations will get you a more unique shot, whether that means wandering down to a port to get "slice of life" photos of fishermen, heading to subway stations, or simply taking photos of people in a park—a couple walking along a path or kids playing in a fountain, for example. The whole world is out there waiting to be photographed—you just need to get out and do it!

CAPTURING THE MOMENT

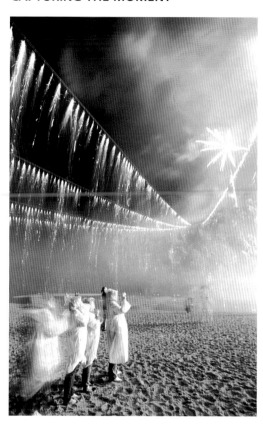

These traditional fireworks dripped sparks for over one hour onto the shores of a Korean river. The group of people taking photos of this event add a nice story to the shot.

WHAT ARE WE ALL DESTINED FOR?

In this subway shot a zoom burst has been used to add a sense of motion, and therefore enhance the story of people commuting.

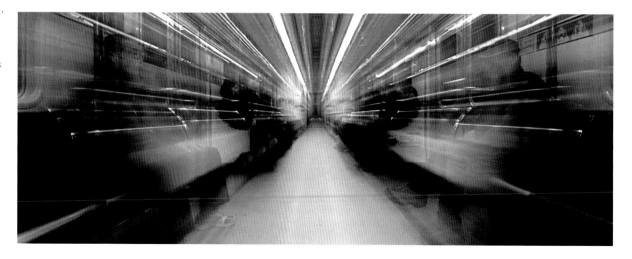

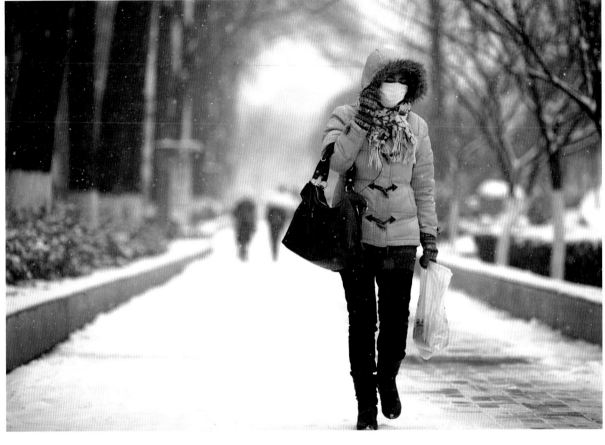

TRYING TO STAY WARM IN THE WINTER

The clear focal point of this photograph is the woman in her yellow coat, which almost jumps out of the scene. There is a lot of context here, with the snow surrounding her, but her general "concealed" appearance adds a sense of mystery.

WHEN WE'RE YOUNG IT'S ALL PLAY

In this scene there are some children playing football outside their apartment block. I watched them play for a while and waited for a good moment to capture this story of everyday life.

LIFE AT THE FOOD MARKET

Markets are a great place to take photographs with a story: in this scene you can see the market traders and their produce.

123

At home

So far, everything seems to suggest that to create successful photographs you need to be outdoors in front of sweeping landscapes, making long exposures at night, or shooting in the street or on the subway. However, you can also produce stunning shots without leaving your house. There are quite a few styles of photography that are possible indoors, including interior photography, food photography, family portraits, close-ups of household objects, and many more. You could even make yourself a lightbox and produce studio-style product shots.

Interior photography

Regardless of their personal taste, most people will aim to make the interior of their house or apartment look "attractive," no matter if they are the home-owner or are renting (although renting can place certain restrictions on how "creative" your interior decoration can be). Interior photography is not easy though, and it is worth making some effort to tidy or organize the room you want to photograph, before you begin—interior shots do not benefit from looking "messy."

With interior shots, it can be difficult to get the correct white balance when there is a mix of domestic tungsten lighting and daylight from windows, so setting a custom white balance could well be the answer. This usually involves photographing a white or gray card and setting the camera to use that as its "neutral" point, although you would have to consult your camera's manual for the precise instructions, as they differ between cameras.

Contrast can also be hard to control, unless you are lighting the entire interior yourself, with areas of the room closest to a window appearing much brighter than those at a distance. This is even more obvious when the window itself appears in shot, so you could try shooting an HDR sequence.

Still-life photography

Product and food photography share a lot of the same principles, and generally fall into one of two categories: photos where you want to include the background to provide context, or those that have a plain color background to create a cleaner, more minimal image. For the latter, a homemade lightbox can be a great asset, or you could take close-up shots of household objects in their natural position, using a shallow depth of field to avoid background distractions. The key is to look around to see what there is that has photographic potential—you will not have to look far.

Portrait photography

Assuming you don't live alone, portrait photography is always an option, whether that means candid photographs of people going about their daily life—cooking, for example—or slightly more formal, posed shots. If your house has a room with a white wall this could be used as a background for some simple studio-style portrait shots, and if you're ambitious you could combine this with off-camera lighting. Perhaps you could even turn one room in your house into a semipermanent portrait studio?

THE FAMILY

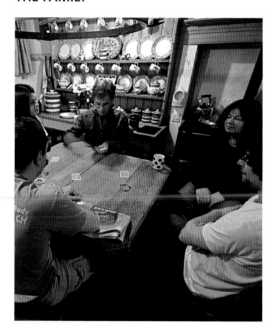

The people you share your home with give a place its warmth and life, which can provide you with countless photographic opportunities.

STILL-LIFE PHOTOS OF THE KITCHEN

HOUSEHOLD UTILITIES CAN MAKE INTERESTING PHOTOS

Details of "found" still-life objects in the kitchen often make good photos.

Careful selection of your subject matter, and the angle you take the photo from, may mean that you can get great shots with minimal tidying required. These photographs were taken as part of a "utilities" project.

Your neighborhood

Your local neighborhood offers endless potential for photography, but because it is so familiar to you it is easy to pass things by every day without noticing their potential. Look more closely and you might find something special.

Street photography

Unless you live in a particularly remote area, there is likely to be lots of street life outside your door, and you won't have to go far to find it. This could be a person posting a letter, a jogger running along the street, or people waiting at the bus stop. If you live in a city there is more potential for photos that need a decisive moment to provide a point of interest, but the country also offers these opportunities: a farmer plowing a field, someone walking their dog, or some other option.

Nature and seasonal change

It's a living, breathing world out there, and even in the biggest urban jungle there may well be trees to take photos of in a traditional way, or with a slightly more abstract approach. If you're in the city, juxtaposing natural elements with the man-made urban environment can give striking results, while a lone tree can also produce a winning photo in more rural locations. Alternatively, use your macro lens for close-up photos of natural details.

Portraits

As well as taking portraits of friends and family at home, outdoor portrait photography is a no brainer. Taking a good portrait is often about choosing a background that is clean, and perhaps leads the eye to your model. There are lots of outdoor elements that meet these criteria, whether it's door frames, archways, paths, or the lines of trees or of buildings. You could also set the camera up on a tripod to take some self-portrait shots.

Night photography

Night photography can transform your neighborhood, so think about shooting light trails created by cars driving along the street, or star trails in the clear night sky. If you're in an urban area, try using the streetlights to light your photo—they can create great shapes, shadows, and silhouettes.

THE STREETS ARE ALWAYS FULL OF LIFE

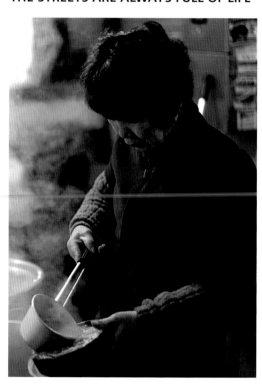

Street photography around almost any local neighborhood is often a photographic treasure trove. These photos were taken in the old downtown area close to my home.

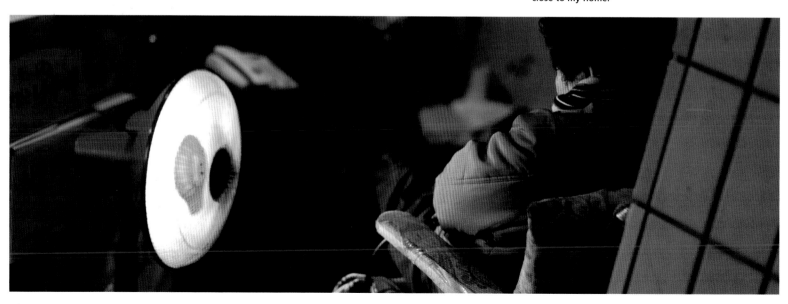

WE ALL HAVE DIFFERENT DREAMS

Portrait photography with a friend is not only a great way of gaining experience, but also a good way to spend a bit of quality time with your subject.

ON THE WAY HOME

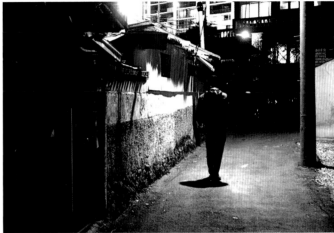

This photo was taken outside my front door and shows what can be achieved with nothing more than streetlights.

CHANGING SEASONS MEANS CHANGING SUBJECT MATTER

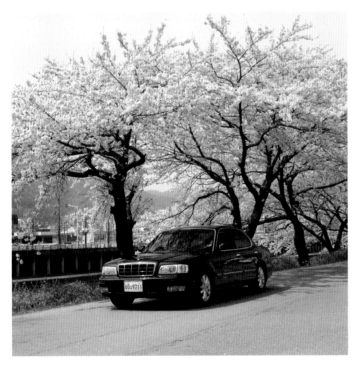

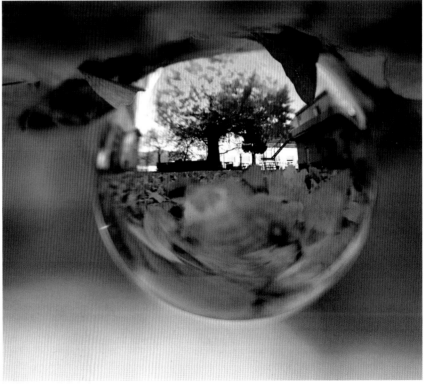

Spring and fall always offer new photographic opportunities, and great results can be had with a little imagination.

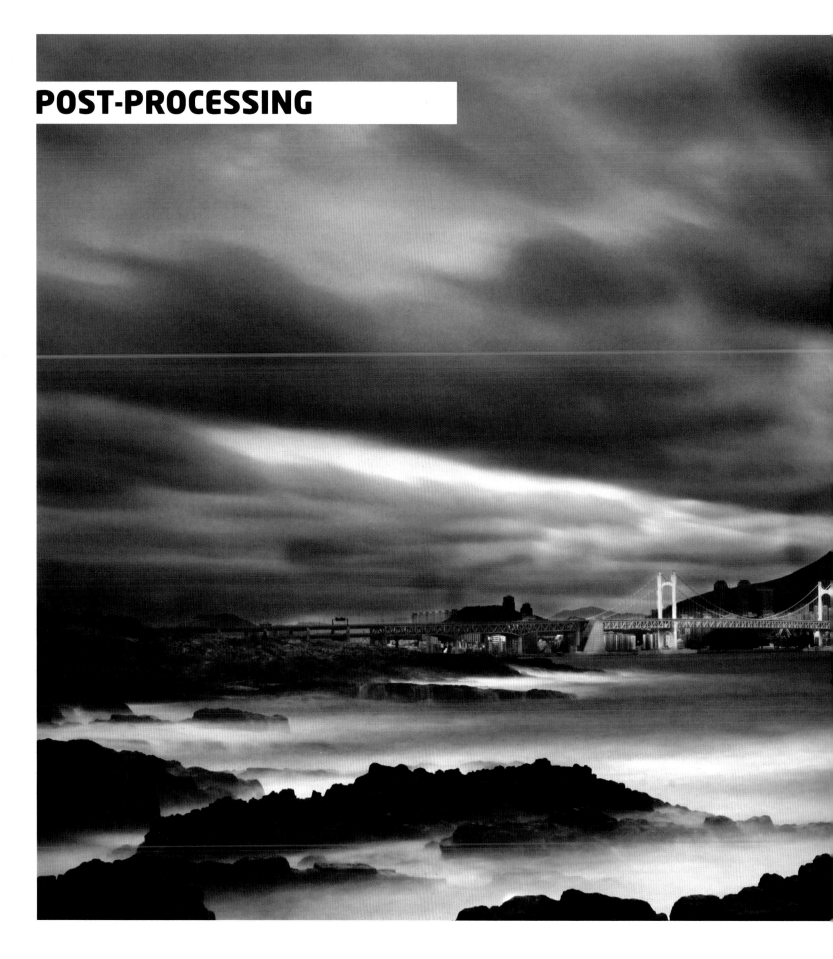

POST-PROCESSING

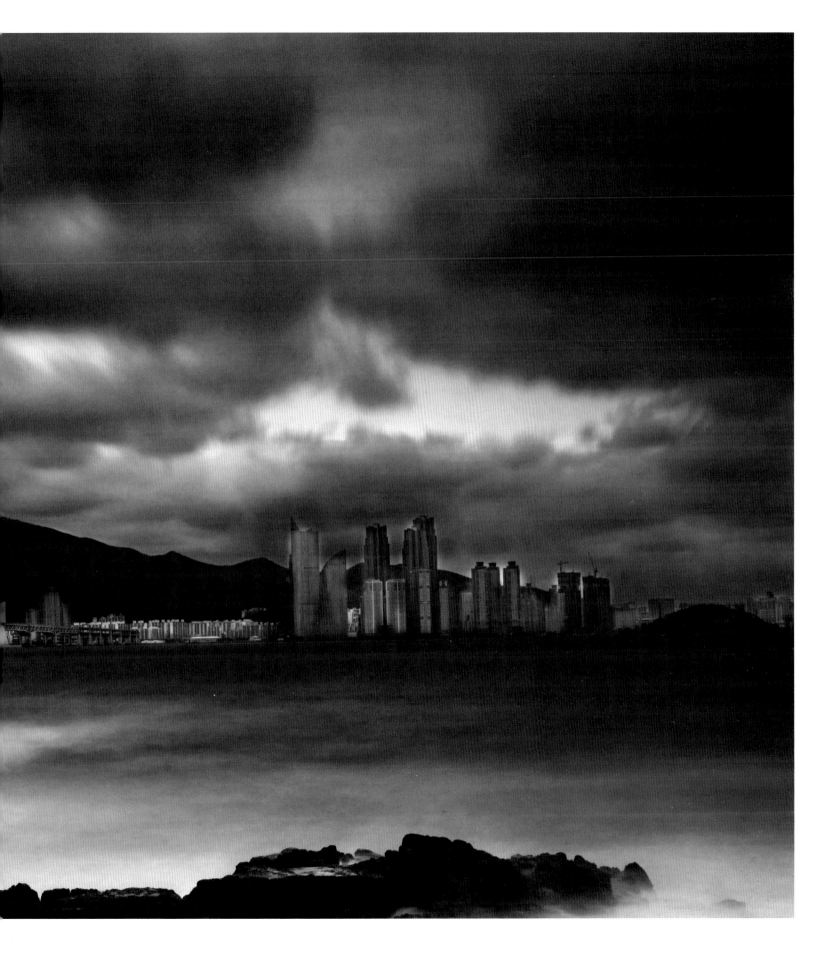

Black & white

For as long as there has been photography, there has been black and white, and a good black-and-white photograph has a mystical quality. The timeless black-and-white image is still with us in the digital age, although there is no need to retreat to a darkroom to produce your monochrome images. Most digital cameras have a black-and-white mode built in, but this should be avoided: as you will see, the best results are achieved by converting color images into black and white using your image-editing program. For this tutorial—and those that follow—I will be using Photoshop for the post-processing work, although most image-editing programs allow you to achieve the same, or similar, results.

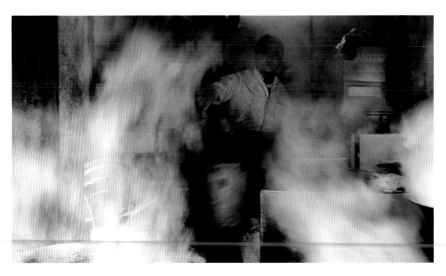

BEFORE

BLACK-AND-WHITE CONVERSION

1. The first step with most of the editing techniques covered in this chapter is to copy the image so you are working on a duplicate layer, rather than the image itself. This will protect the original image, in case you need to go back to it. To make a duplicate layer choose *Layer>Duplicate Layer* from the top menu, or press Ctrl+J (Windows) or Cmd+J (Mac). The image will appear on a duplicate layer called Layer 1.

2. To convert the image to black and white, choose *Layer>New Adjustment Layer>Black & White* from the main menu. This adds a new layer to the layers palette and converts your image to grayscale.

3. Use the color sliders in the Adjustments panel to optimize the black-and-white conversion. These sliders work in a similar way to using colored filters over the lens of the camera, so increasing the value of a color will lighten areas that are that color in the original image and darken opposite colors: increasing red will lighten reds and darken greens, for example.

When you are happy with the result, you can go on to adjust the contrast of your black-and-white image, or perhaps dodge and burn specific areas, as described on the following pages.

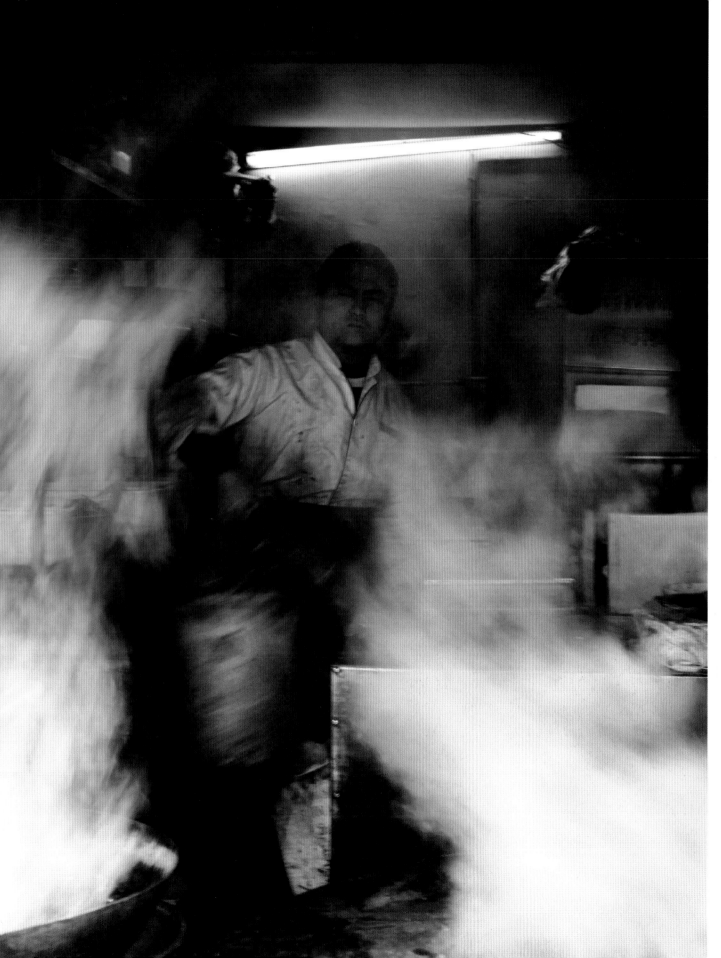

Dodging & burning

Getting the light balanced across a scene isn't always possible to achieve in-camera, which is where dodging and burning come in. These are both derived from traditional darkroom techniques that are used to make certain areas of an image lighter or darker. In this example, we will work on a landscape shot, using dodging and burning to balance the foreground and background, but the technique applies equally to all areas of black-and-white photography. Although Photoshop—and most other image-editing programs—have Dodge and Burn tools, the following technique is far more controllable and sophisticated.

BEFORE

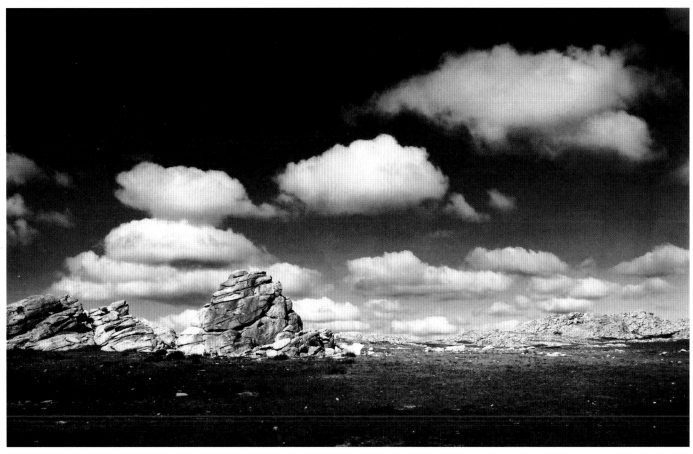

AFTER

1. The starting point for this technique is an image that has been converted to black and white as described on the previous pages. The contrast has been adjusted, and the image has been duplicated (*Layer>Duplicate Layer*) so that we can revert to the original image later on if necessary.

2. The next step is to lighten—or "dodge"—the areas of the photo that are too dark. To do this we're going to use a Curves adjustment layer, so choose *Layer>New Adjustment Layer>Curves* from the top menu. It may help if you label this layer "Dodge" when prompted.

3. Add two points to the curve in the Adjustments palette and raise them upward to produce a smooth curve as shown. Your picture will appear to be overexposed, possibly with some parts of the image blown out, but this is OK.

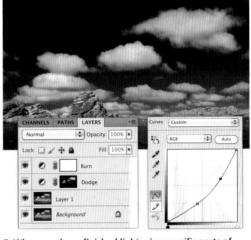

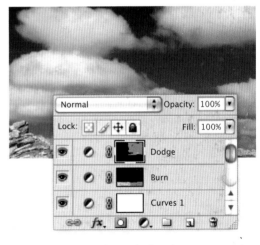

4. To selectively dodge the image, as opposed to the whole photograph, go to *Image>Adjustments>Invert*. This will make the Curves adjustment layer black (so the layer will become "invisible"). To reveal the Dodge layer, select the Brush tool and set white as your foreground color. You can then "paint" the Dodge layer to selectively lighten the image. As you do, the black layer mask will turn white where it has been painted out. You can control the intensity of the effect by varying the brush's Opacity in the tool bar options at the top of the screen.

5. When you have finished lightening specific parts of your image, you can create a "burn" layer to darken areas of the photograph that are too light. Repeat steps 2 and 3 to create a Curves adjustment layer, but this time label the layer "Burn" and pull the curve downward, as shown, to darken the image.

6. Finally, as in step 4, invert the Burn layer (*Image>Adjustments>Invert*) and use the Brush tool to paint it with white to reveal the darkened areas. Again, vary the opacity and size of the Brush for maximum control.

It is useful to remember that you can go back and re-edit the Dodge and Burn layers at any time—simply click on the adjustment layer icon and use white to reveal the Dodge or Burn effect, or paint with black to conceal it. With this image, I went on to give it a color tone once I had finished dodging and burning.

Increasing contrast

There are lots of occasions when increasing the contrast in an image is all it takes to transform something relatively humdrum into a picture with impact. Boosting the contrast of a color image is a great way of making the colors really pop, while boosting the contrast of a black-and-white image can really bring out the tones and shapes.

There are a number of ways to increase contrast, with the simplest being the "auto contrast" option found in most image-editing programs. You could also use the rudimentary contrast slider, but neither of these tools will offer the same level of control as the following method.

BEFORE

1. The first step is to make a duplicate layer to work on, so you can revert to the original image if you need to.

2. Next, choose *Layer>New Adjustment Later>Curves* to apply a Curves layer to the image. In the Curves dialog, click on the center of the curve to add an anchor point. Then, click on the upper right part of the curve and raise the line of the curve upward. **This will brighten the highlights in the image. Finally, lower the bottom left part of the curve to darken the shadow areas and increase the contrast overall. The curve you have created is known as an "S" curve.**

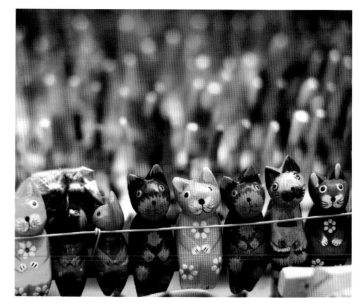

3. To really boost the contrast, you can make the slope of the curve steeper. There are some images where extreme contrast such as this can work well, but for most images a subtle change in contrast is the best way to go.

AFTER

Emphasizing color

As photographers, we're often trying to capture the color of the world around us. However, there are times when these colors can be a little lackluster—on a cloudy day, for example. When this happens, you might need to give the colors a little bit of a boost in post-processing. What we're going to look at here is how to emphasize specific colors, with a view to drawing the eye toward a certain part of the image. In this example, we will intensify the red areas in the image.

BEFORE

1. Working on a duplicate layer, start by selecting the color you want to enhance by choosing *Select>Color Range* from the menu. In the Color Range dialog, select the first of the three color droppers and click on the color you wish to enhance in your image. This color will appear in white in the Color Range dialog, indicating that it has been selected. Use the Fuzziness slider to fine-tune the selection, then press OK.

2. With your chosen color selected, choose *Layer>New Adjustment Layer>Brightness/Contrast*. When the New Layer dialog opens, check Use Previous Layer to Create Clipping Mask and then click OK.

3. You are now ready to selectively enhance your chosen color. Adjust the Brightness and Contrast sliders in the Adjustments panel until the colors appear as you want them, but note that subtlety is the key.

If you want to enhance other colors in the same image, repeat the process, choosing a different color with the Color Range tool.

AFTER

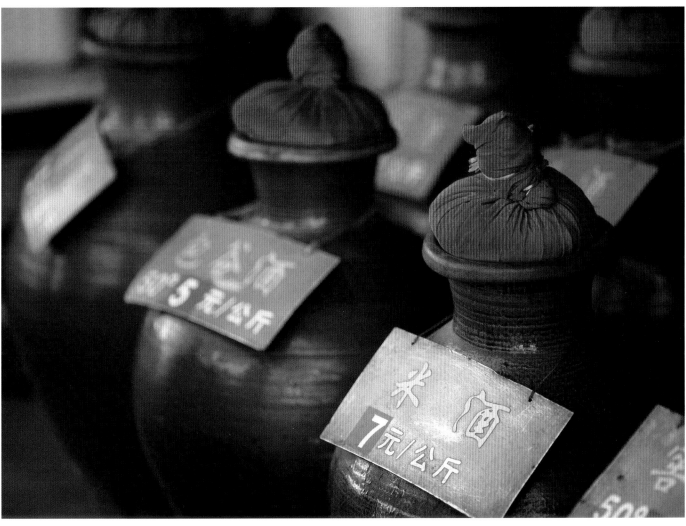

HDR

HDR has become more than a post-processing technique; it is now a photographic style. As outlined in chapter 3, HDR imaging essentially merges a set of photographs taken at different exposure settings into a single picture, to create a final shot with a high dynamic range. The process involves two distinct stages: capturing an exposure sequence, and then combining the images on a computer. When it comes to post-processing, Photomatix (from HDRsoft) and Photoshop are two of the programs that are most commonly used, and those are the two that I will be using here.

BEFORE (+1EV)

BEFORE (0EV)

BEFORE (-1EV)

HDR WITH PHOTOMATIX PRO

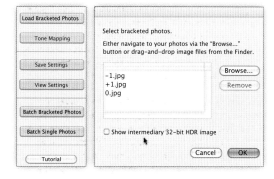

1. The first stage in generating an HDR image in Photomatix is to import your exposure sequence, so open the program and select Load Bracketed Photos from the options dialog. A window will open and you can either browse for the exposure sequence on your computer, or simply drag-and-drop the images into the window before clicking OK. In this example, I'm using a 3-shot exposure sequence, taken with an exposure increment of 1 stop.

2. You can now set your Preprocessing Options, which cover four key areas:

Alignment: If you check Align source images, Photomatix will analyze each image and attempt to make it a perfect match with the others in the sequence. This is especially useful if you shot your sequence without a tripod. There are two options for aligning your images—by correcting horizontal and vertical shifts or by matching features. Matching features is more accurate, but it takes significantly longer to process the images.

Ghosting: Ghosting can occur when elements in the scene move between frames in your exposure sequence—tree branches blowing in the wind or people walking through the frame, for example. This will result in a "ghost" image when the sequence is combined, unless you check Remove ghosts. You can ask Photomatix to identify and remove ghosts automatically, or with the Selective Deghosting tool, which enables you to target ghost areas manually.

Noise: Noise is emphasized in digital photographs when they are taken at a high ISO setting, a long exposure time is used, or the image is underexposed. Checking Reduce noise instructs Photomatix to automatically attempt to reduce some, or all noise in your images.

Reduce chromatic aberrations: A simple on/off option to reduce chromatic aberrations (color fringing) in your HDR images.

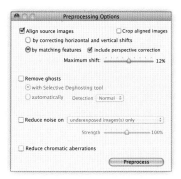

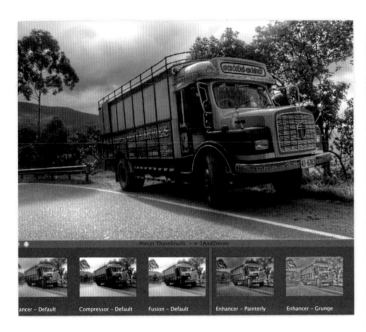

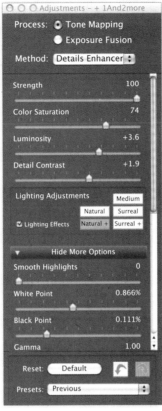

3. After you have accepted the Preprocessing Options, Photomatix will process your exposure sequence and generate a single HDR image. However, to optimize the tonal range you will need to tone map the picture.

Tone mapping is the most important step when it comes to producing an HDR image, and how you adjust the settings will define what type of HDR image you produce—naturalistic or hyper-real.

The easiest option at this stage is to select one of the preset tone-mapping options—simply click on one of the preset thumbnails to apply it to your image.

4. While the preset options provide a straightforward means of producing an HDR image, processing your images yourself is a better idea, as it will give you greater control over the end result. Photomatix offers a comprehensive range of tools that you can use to alter your image, and the most popular starting point is to set Process to Tone Mapping and the Method to Details Enhancer. Then, turn to the Adjustments palette and use the sliders and buttons outlined below to fine-tune your HDR image.

Strength: Controls the intensity of all of the other tools, so can be used to fine-tune the appearance of the HDR image overall.

Color Saturation: As the name suggests, this slider controls the intensity of the colors.

Luminosity: Affects the brightness and local contrast of your HDR image—a higher value reveals more shadow detail and brightens the image overall.

Detail Contrast: Increases contrast at a pixel level, giving images greater "punch" and also sharpening them slightly. As with the Color Saturation slider, do not overdo this.

Lighting Adjustments: If Lighting Effects is unchecked, a slider is provided, which affects how "natural" your HDR image looks. The higher the value, the more natural the HDR, while lower values can give HDR images a "painterly" feel. If Lighting Effects is checked, the slider is replaced by five preset options, ranging from Natural to Surreal.

White Point and Black Point: These are important settings that control the clipping points in the image. For most HDR images you will probably want to adjust the White Point to make sure the highlight areas are not blown out, and the Black Points to maximize shadow detail and improve the colors of the image.

Gamma: Adjusts the midtones in your HDR image, making them lighter or darker.

Temperature: The temperature slider allows you to fine-tune the white balance of your HDR image—increasing the temperature will "warm" your image, while decreasing the temperature will "cool" it.

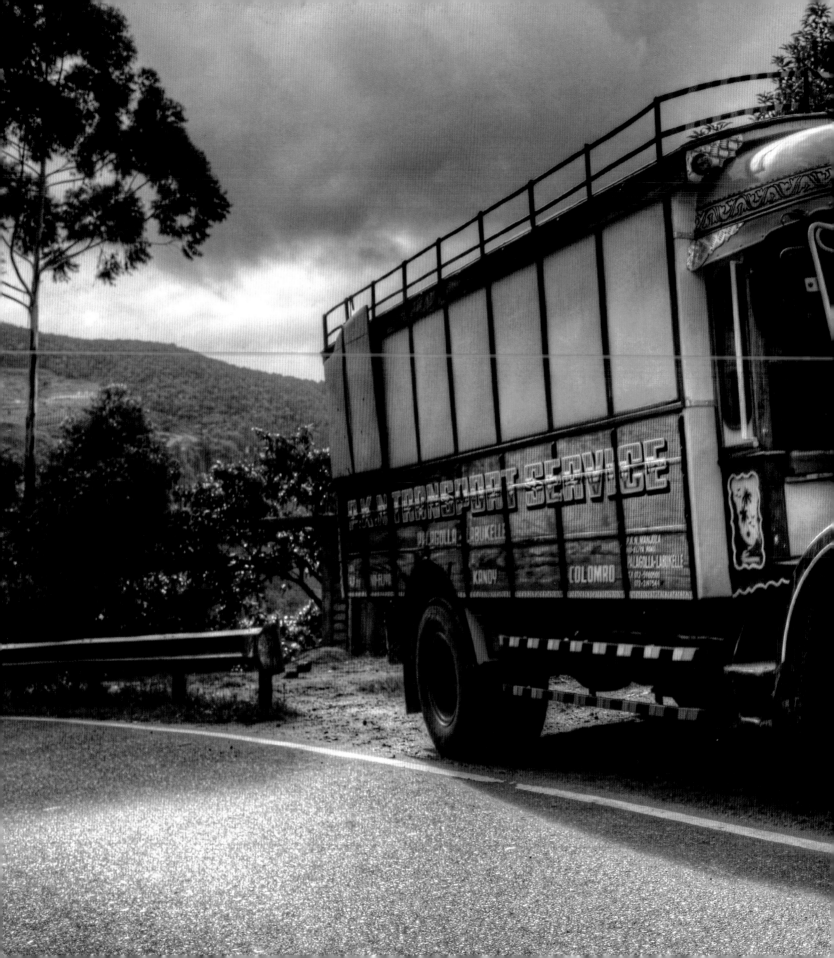

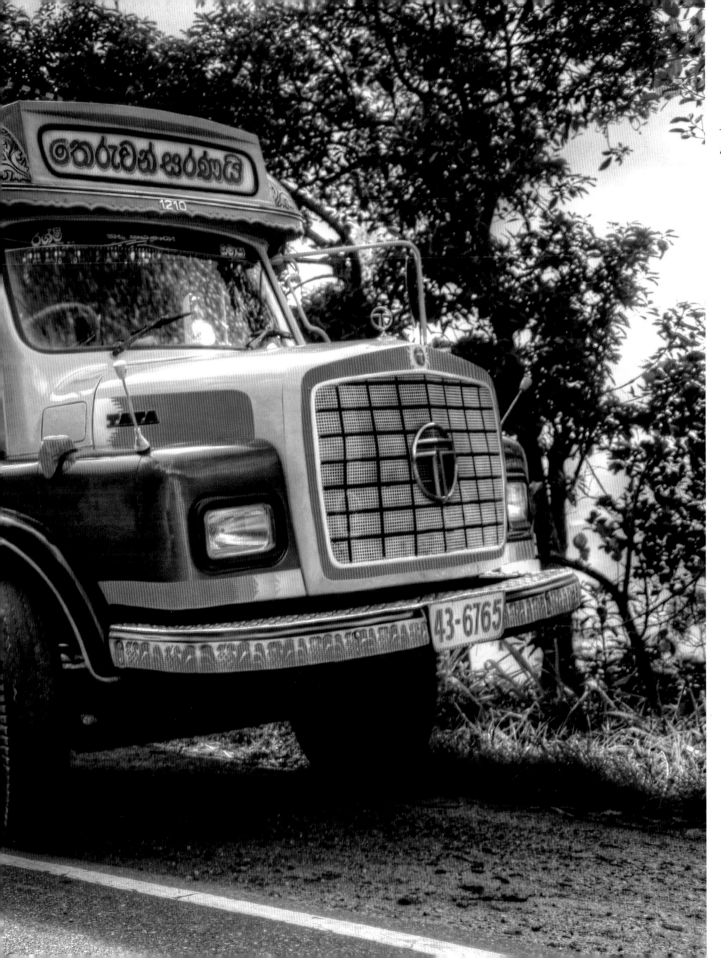

HDR WITH PHOTOSHOP

While Photomatix is the tool of choice for many HDR enthusiasts, Adobe has made huge improvements to the HDR processing offered by Photoshop, so if you own Photoshop CS5, you may not necessarily need to invest in any other software.

BEFORE (+1EV)

BEFORE (0EV)

BEFORE (-1EV)

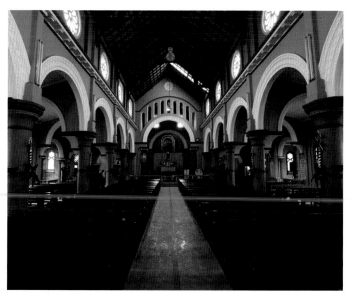

AFTER

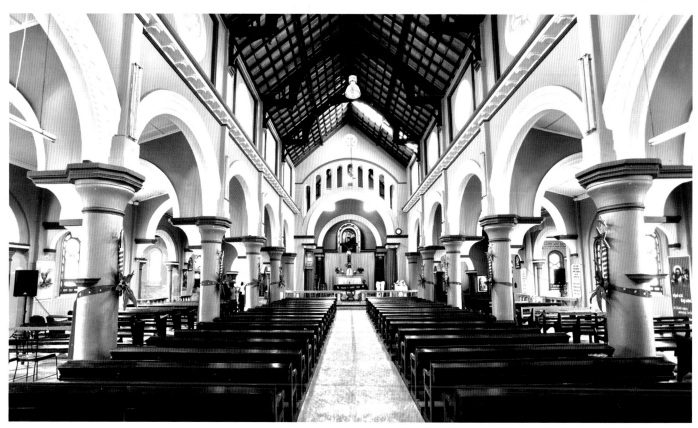

1. The first step is to open your exposure sequence, so choose *File>Automate>Merge to HDR Pro* from the top menu. In the browser window, navigate to the sequence you want to process. You may also want to check Attempt to Automatically Align Source Images, especially if you took the bracketed photos without a tripod. Then, press OK to continue and Photoshop will combine your images.

2. Your single HDR image will open in Photoshop's Merge to HDR Pro dialog window, which is where you can choose your tone mapping settings. There are a number of preset options available on the Preset dropdown menu at the top right of the dialog, but choosing Custom and changing the settings manually will give you more control.

 At this stage, decide whether you need to Remove ghosts (check the box if you do and then choose which of the images in your sequence you want Photoshop to use as the "master" image), and then set the Mode. Here I'm setting the Mode to 16 Bit and Local Adaptation—a combination that offers the optimum balance between image quality and control.

3. The Local Adaptation controls are split into three categories: Edge Glow, Tone and Detail, and Color/Curve. The precise settings for each of these will vary depending on your particular image, but the following will help you understand the effect that each of these has.

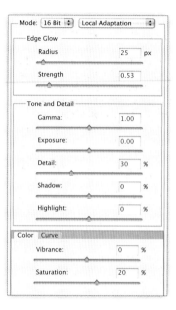

Edge glow
Radius: If you want your HDR image to be natural looking, use a low Radius—the higher you push this slider, the more extreme the picture will look. With high radius values you might also begin to see halos appearing around objects.

Strength: Controls the overall strength of the HDR processing, so acts as a "master control." Again, lower values will result in a more natural-looking HDR image.

Tone and Detail
Gamma: Controls the contrast to some extent—if you move the slider to the right you can start creating really surreal-looking images.

Exposure: As the name suggests, this slider determines the overall brightness of the image. With most images Photoshop will get close to the correct level of exposure automatically.

Detail: Sharpens or softens the image.

Shadow and Highlight: These sliders control the brightness of the darkest and lightest areas of the HDR image.

Color/Curve
Color: The Color tab provides two controls—Vibrance and Saturation. Vibrance controls how vivid the colors in the HDR image are, while Saturation controls how strong the colors are. Reducing the Saturation fully will create a black-and-white HDR image.

Curve: The Curve tab reveals a tone curve that works in the same way as Photoshop's Curves tool, allowing you to selectively control the contrast in your image.

4. With practice, you will quickly see how the various tools can be used to control and manipulate your HDR images, and when you find settings that you like you can save them for use at a later date. To save your setting, click on the menu icon at the top right of the dialog window and choose Save Preset. To apply the settings to another image, choose Load Preset from the same menu.

Selective softening

Soft focus works very well in some situations, and while it is possible to produce a soft-focus image in-camera using filters, post-processing offers much greater control over the effect. The most obvious use for softening is with skin tones, as soft skin—especially with female subjects—tends to shimmer and look more pleasing to the eye. Flowers can also look better when softened, but for this tutorial we're going to stick with softening skin.

As with many post-processing techniques, there are a plethora of ways to soften an image, but the following is one of the most useful. Using this technique to blur a portion of an image will achieve a soft-focus feel, without making the whole shot appear as if it is out of focus. Here, I'm going to use selective softening to give the model's face a slight glow.

BEFORE

1. The first step is to duplicate the background image layer so you can revert back to it if you need to: choose *Layer>Duplicate Layer* from the menu or press Ctrl+J (Windows) or Cmd+J (Mac).

2. To apply the softening effect, call up the Surface Blur filter (*Filter>Blur>Surface Blur*). The Surface Blur dialog allows you to set Radius and Threshold—for this large image Radius 20 and Threshold 200 produced the best result.

3. The Surface Blur filter will affect the whole image, so we're going to add a mask so that the blur only softens the model's face. In order to do this, choose *Layer>Layer Mask>Hide All* from the menu.

4. A "hide all" mask will mask the entire image, effectively canceling out the blur filter, so it needs to be edited. Start by clicking on the black mask icon next to the layer thumbnail in the Layers palette so you are working on the mask, not the image.

Then, select the Brush tool and set its Opacity to 30% or lower in the toolbar options at the top of the screen. "Paint" over the model's skin in white to start revealing the blurred effect and softening of the skin. It is important to avoid painting areas that you want to remain sharp.

AFTER

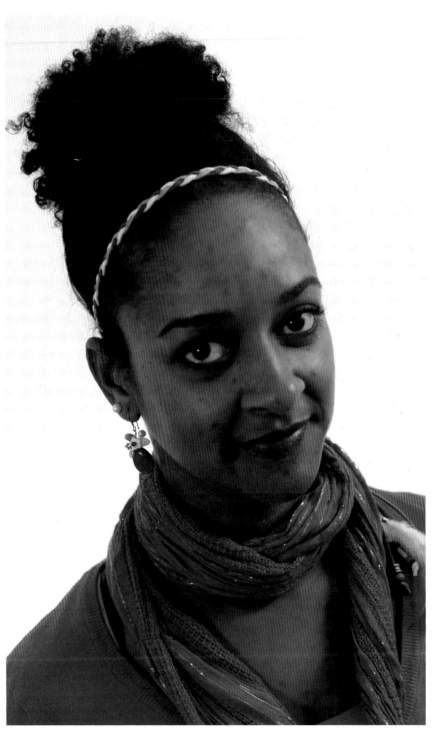

5. The final step is to adjust the Opacity of the mask layer to determine the level of overall softening. The lower the Opacity, the sharper the image will appear, as the underlying background layer will show through more strongly.

145

Selective sharpening

Having looked at how we can soften a picture, we're now going to take a look at how we can selectively sharpen to draw the viewer's eye to a certain part of the image. This technique can also be used to rescue a shot that is slightly out of focus: creating a few small areas that are heavily sharpened is often enough to trick the eye into thinking the entire image is sharp.

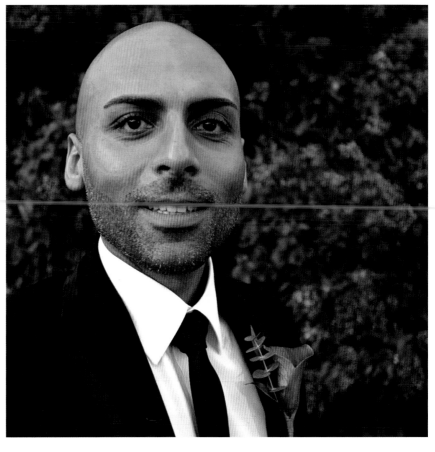

BEFORE

1. As with the previous techniques, start by creating a duplicate layer (Ctrl+J/Cmd+J) and then open the Unsharp Mask filter (*Filter>Sharpen>Unsharp Mask*). The precise settings for this filter will very depending on the size of your image, but here I've set an Amount of 200%, Radius of 5, and Threshold of 25. The result appears to be oversharpened, but it is only the key features—eyes, eyebrows, and lips—that matter here.

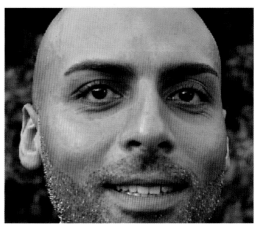

2. The sharpening is affecting the entire image, so we're going to add a mask to sharpen only the features mentioned above. From the top menu choose *Layer>Layer Mask>Hide All* to add a "hide all" layer to the image. This will effectively conceal the sharpening effect entirely.

3. To selectively sharpen the image you need to paint the layer mask with white, which will reveal the sharpened layer. Select the Brush tool and set its Opacity to 30–50% in the toolbar options at the top of the screen.

4. Select the black mask in the layers palette, and with white set as the foreground color begin to paint the areas that you want to appear sharp. In this example I want to enhance the eyes and lips. Zoom into the image and adjust the size of your brush for greater control.

The final result will have the natural sharpness of the camera and lens, but the key features—eyes and lips—really "pop."

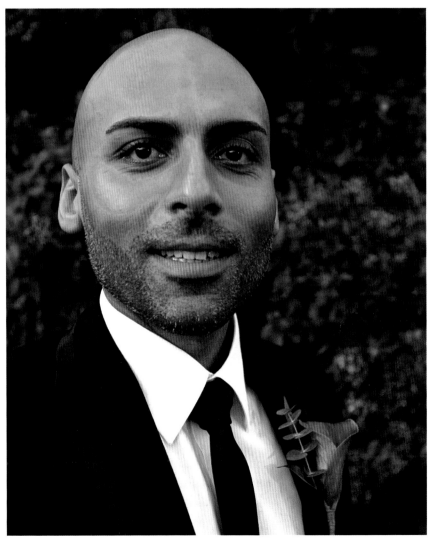

AFTER

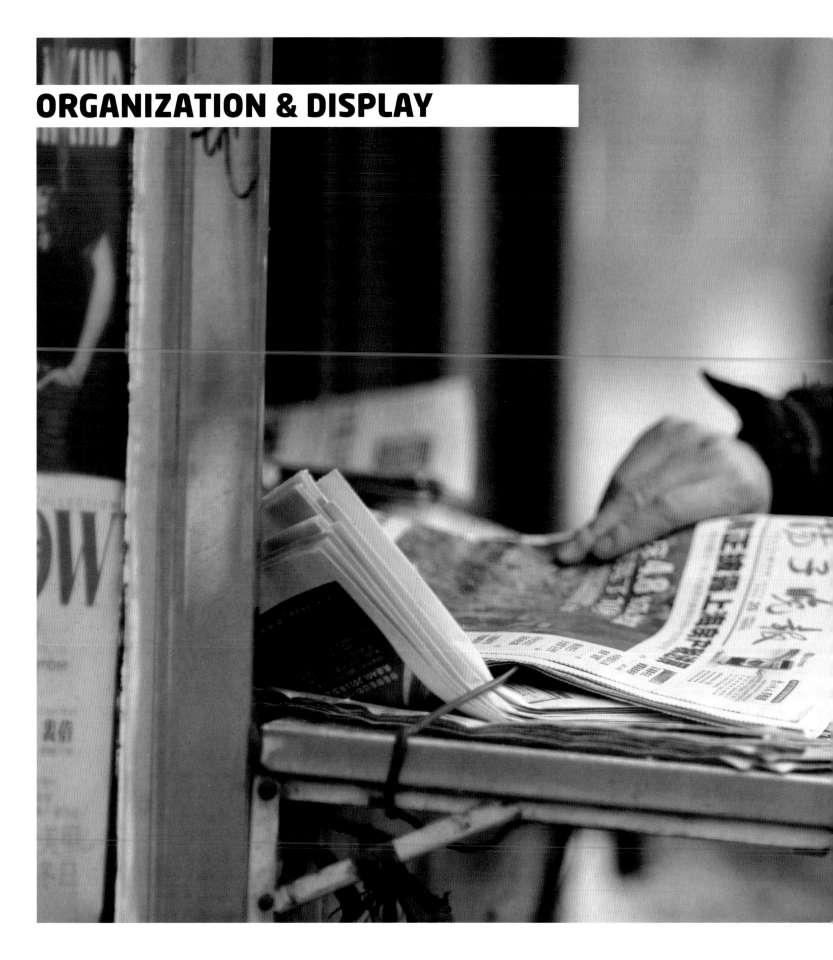

ORGANIZATION & DISPLAY

Preparation

Learning how to promote yourself and share your photographs with others can be a very important part of your development as a photographer, whether that means sharing your images with friends and family, or exposing them to a worldwide audience. Joining online communities is a great way of getting feedback on your work, but even if all you want to do is to show your images to friends and family, the careful selection and grouping of the photos you take is still important.

However, before you put your images on show you need to be sure of a few things. The first is to be certain that the post-processing you've done is adequate. In the previous chapter we looked at some specific techniques, but there is always room for fine-tuning, so double-check your images before they go on display to make sure they are as good as they can be. If you intend to upload your images to a website, you also need to consider how you are going to protect your work from someone taking it and using it without permission. This means thinking about resizing your images, adding a watermark, and possibly even registering your photographs with copyright authorities.

Post-processing

Before any image goes on show you need to ask yourself whether every last detail in the photo is perfect. Are there any distracting elements at the edges of the frame that could be cropped out of the shot? How about the dark areas of the photo—could they benefit from lightening so that a little more detail can be seen? And what about the color—is there a color cast that needs to be removed? You really need to be sure that you have got the post-processing right, so check each of your images before you upload or print it.

Resizing

Most digital cameras are now capable of taking high-resolution photographs that can potentially create huge prints, and are easily good enough for use in magazines. The problem with putting these images onto a website is that other people will potentially be able to use your pictures in this way without your permission. To help prevent this it is a good idea to resize your digital images so they only look good when displayed on a web page. A good size is somewhere between 600 and 1000 pixels on the longest size at a resolution of 72ppi (pixels per inch). All image-editing software will allow you to resize your images, but be sure to save your smaller file as a copy, to avoid overwriting the larger original.

Watermarks

To prevent people from taking your work and passing it off as their own you can add a watermark on your image. There are plenty of good programs you can use to watermark a photograph; Photoshop and other image-editing programs will do it, and there are dedicated programs that will watermark your pictures as well. A watermark placed near the center of the image offers the most protection, as it prevents anyone from cropping the image to exclude it, but this may well detract from the picture. Creative placement of the watermark may give you the best protection, while maintaining the esthetic of the image.

Copyright

As a photographer, you own the copyright to an image the moment you make the exposure, although if it comes to a legal battle it will help if your images have been registered at the copyright office. Most people simply add a copyright line to the EXIF data, or add a watermark (both of which are free), but if you want to register copyright in the U.S. visit www.copyright.gov. Alternatively, in the U.K., www.copyrightservice.co.uk provides good advice, although in both cases there is a fee for registering your work.

RESIZE
To prevent someone from accessing and using your high-resolution images, resize them so they are only of practical use when viewed on screen. All image-editing programs allow you to resize your photographs, but be careful not to overwrite the original file when you save it.

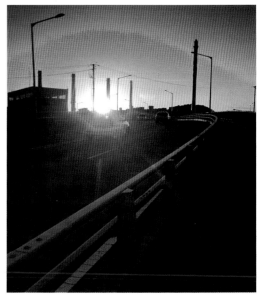

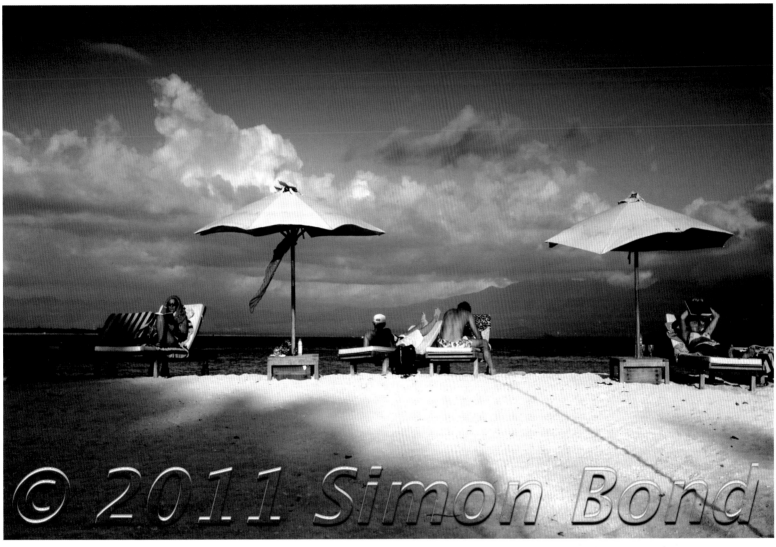

WATERMARK

Protecting your work with a watermark is a good idea for online content. Programs such as iWatermark make this a simple task, and you can personalize the watermark to suit your needs.

Grouping

The best way to show your images is as a "set." It is very easy to group a lot of similar images together, but this will diminish the overall impact of the series. Therefore, a little care is needed when choosing which pictures to put together—there is a definite skill to assembling a set of photographs that compliment one another. There are a number of ways of grouping photos, such as by place, theme, date, or "favorites":

Grouping by place: This can be by country, city, or perhaps even a particular street. Try mixing your photos up a little so the set contains a few portraits, landscapes, and detail shots to add variety.

Grouping by theme: There are many ways to group photos by theme, more than can be covered here. A few common examples might be to group portraits together, or landscapes, or perhaps images where the dominant color is blue—you can choose any theme you like.

Grouping by date: Most photo libraries automatically group images that are taken on the same date, and this can be a useful way of grouping and organizing your photographs.

Grouping by favorites: It is often a positive experience to group what you feel are your very best photos together, regardless of the subject or content. If you go back and do this on an annual basis, you may well see how you have improved as a photographer. Having a selection of your best work can also be helpful when you are trying to promote yourself.

When grouping your photographs it is worth thinking of them as mini portfolios of work. This means casting your eye over all the images you have that are suitable for a particular group and narrowing the selection down to a set of 20–30 of the best shots. If you're grouping photos, it must be assumed that you intend to show them to other people, so you want the pictures you select to have real impact. With this in mind, make sure your set has variety—if you have three great shots of what is broadly the same scene, be ruthless and pick just one.

GROUP BY THEME

Themes can be as specific or as general as you like. This set isn't just about China, for example—it's about portraits from China.

GROUP BY PLACE

One way to organize your photographs is by place. In this example, the photos were all taken in Indonesia—this folder in iPhoto shows my favorites from that trip.

GROUP BY DATE

At the end of the year it can be a useful exercise to go through and make a collection of what you feel are your best photos taken in the previous twelve months.

PRINTED ALBUMS

Once your photos have been grouped, why not print them out and put them into an album for both storage and display?

Sharing

There are many ways to share your photographs with other people. Traditionally, this might have involved printing your photographs and perhaps putting them in a photo album, but fewer people print their digital photos. This is a shame, because prints really are still one of the best ways to share your work; being able to touch and feel the photos is all part of the experience and prints often look better than an image on a computer monitor. That said, the digital age has made sharing photographs much more widespread and easier to do, allowing you to show your work to people on the other side of the world.

Smartphones, tablets, and laptop computers

Portable digital devices are great for showing and sharing digital images. They allow you to carry around a portfolio of work, and you never know when you might have a chance to show your work to someone like a magazine editor! They're also very handy to carry around and take to a bar or a coffee shop, where your friends can enjoy seeing your latest masterpieces. A smartphone is, of course, the most convenient in terms of size, but tablet devices and laptops (or netbooks) offer a larger screen size and therefore a clearer view of your work.

Social network sites

Social networking sites are an invaluable way of sharing photographs, and most are set up with this in mind. The two major sites at the time of writing are Facebook and Google+, both of which allow you to share photos with your friends. There are also websites geared specifically to the needs of photographers, such as Flickr and Picasa. Both of these sites contain a huge database of photographs from people around the world, which can be shared with friends and strangers alike.

Personal website

There are times when being independent of a big community can have benefits, and making your own website (or blog) allows for a much greater degree of control and personalization. What you need to consider when setting up your own website is that you will have to work much harder to get people to see your work—unless someone is specifically looking for you and your work, it is unlikely (but not impossible) that they will happen across your website by chance.

PERSONAL WEBSITE

Creating and maintaining your own website is a great way of showcasing your work, with the added bonus that the site can be tailored precisely to your needs.

SOCIAL NETWORKS

Websites such as Facebook and Flickr offer numerous ways for you to connect directly with people you know, and perhaps those you do not.

PRINTED IMAGES
Nothing beats an "old-fashioned" printed photo when it comes to sharing images—the look and feel of a tangible print is always appreciated.

Exposure

Once you have organized a great set of photos, and perhaps uploaded them to a social networking site or your personal website, the next step is to get people to see them. Adding photos to sites such as Flickr or Picasa is the easy part of the process—although your pictures will be "out there," you can't expect to get thousands of hits straight away. If the quality of your work is high, then there is no doubt that you will attract a certain number of people, but the real key is to become part of the community and interact with others. If you want someone to visit and look at your photos, commenting on other people's work is definitely the way to go—you reap what you sow, and if you don't sow, you won't reap.

It also helps if you tell your friends about your various Internet pages, as the more traffic you have, the higher it will feature on the various search engines, which will lead to even more hits. However, sometimes you have to blow your own trumpet a little, and with this in mind you might want to consider having some business cards made. Even if you don't consider photography to be your "business," a set of cards that have your images on them will provide you with an opportunity to show some of your photos to anyone you meet, no matter where you are. If you really want to push the boat out, then another strategy is to have some promotional books made—this couldn't be easier with online companies such as Blurb (www.blurb.com) doing the printing for you.

If you are serious about moving into publishing, then it is worth honing your writing skills. If you've taken some photos at a festival, for example, it can be a good idea to write about it as well. You may subscribe to the theory that "a picture is worth a thousand words," or that your pictures "speak for themselves," but newspaper and magazine articles rarely rely on pictures alone, so accompanying them with a written article is often more likely to result in you seeing your work in print.

If you truly believe that your images don't need to be accompanied by words, then perhaps you would prefer to consider holding an exhibition of your work instead? You'll need to have a strong concept and theme, but having an exhibition is a major aspiration for numerous photographers, both amateur and professional.

Tip

Upload photos a little and often. It's better to upload one picture a day, every day, than it is to put ten photos online and then not add anything for over a week. People like to see something new as often as possible, and this way they will be encouraged to revisit your work.

BUSINESS CARDS

Personalized business cards can be a great way of promoting yourself and getting more exposure.

PHOTO BOOKLETS

A great way to share your work is to design your own booklet. A number of companies can be found on the internet that offer this "mini photo book" service, some of which provide ready-made design templates for professional-looking results.

EXHIBITIONS

Organizing and holding an exhibition of your work is an immensely rewarding experience, although you need to have a strong concept if you want your images to hold together as a set.

PUBLICATION

Having your photographs published is a fantastic way of getting your work seen by a much wider audience, and it could earn you some money as well. Local newspapers and photography magazines are both good starting points.

Index

..

ACKNOWLEDGMENTS

I would like to thank the following, without
whom this book would not have been possible:

Jayoung Kim—my lovely wife who has been
very patient with me and helped me on my
photographic adventure.

Mr Ponsford—my first photography teacher,
who taught me how to use an SLR camera and
develop film. His encouragement gave me a lot
of energy.

My family—where would I be without my
family, who have always supported me in
everything that I do?

Ilex Photo—to all those who helped make the
book possible.

Derek Winchester—a fellow photographer and
fountain of knowledge.

Youngdoo Moon—one of the first online
photographers I met, and a photography lover
who kindly photographed my recent wedding.

..

PICTURE CREDITS

Courtesy of:
www.gettyImages.com: p45 (bottom left); p45
(bottom centre); p47 (top).

www.istockphoto.com: p68 (bottom).

www.shutterstock.com: p23 (bottom left); p23
(bottom right).